The John and Mable

RINGLING
Museum of Art
Guide to the Collections

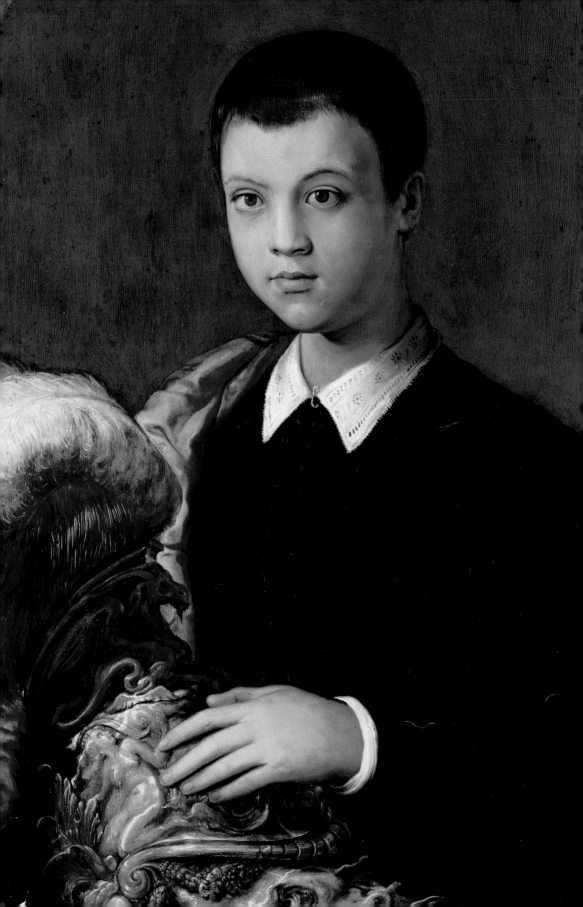

The John and Mable
RINGLING
Museum of Art
Guide to the Collections

Stephen D. Borys, Editor

The Ulla R. Searing
Curator of Collections

The John and Mable Ringling Museum of Art

The State Art Museum of Florida Florida State University

Copyright © 2008

The John and Mable Ringling Museum of Art
5401 Bay Shore Road
Sarasota, Florida 34243
www.ringling.org

The State Art Museum of Florida Florida State University

LCCN 2006932870 ISBN 978-0-916758-52-3: (paper)
ISBN 978-0-916758-55-4: (hardcover)

Library of Congress Cataloguing-in-Publication Data
The John and Mable Ringling Museum of Art :
a guide to the collections / Stephen D. Borys, editor.
Includes bibliographical references and index.
p. : ill. ; cm.
ISBN 978-0-916758-52-3: (paper) ISBN 978-0-916758-55-4: (hardcover)
1. The John and Mable Ringling Museum of Art—Catalogs. 2. Art—
Florida—Sarasota—Catalogs. I. Borys, Stephen D. (Stephen Donald)
II. John and Mable Ringling Museum of Art.
N742.S5 A53 2008 708.159/61 19

FRONTISPIECE: Detail from Francesco Salviati,
Portrait of an Aristocratic Youth, ca. 1543–1544 (see p. 45).
PAGE VI: Detail from Peter Paul Rubens,
The Meeting of Abraham and Melchizedek, ca. 1625 (see p. 63).
PAGE VIII: Detail from Carlo Dolci,
Saint John Writing the Book of Revelation, ca. 1647 (see p. 82).

PRODUCED BY WILSTED & TAYLOR PUBLISHING SERVICES
Project management: Christine Taylor Production assistance: Andrew Patty
Copyediting: Nancy Evans Proofreading: Andrew Joron and Melody Lacina
Design and composition: Tag Savage Text set in Whitman and Gotham
Printer's devil: Lillian Marie Wilsted Color supervision: Susan Schaefer
Printing and binding: Regal Printing Ltd., Hong Kong, through
Stacy and Michael Quinn of QuinnEssentials Books and Printing, Inc.

This publication has been generously assisted by Mrs. Alice W. Rau.
This publication has also been supported by the Museum Publication Grant Program
of Palm Beach | America's International Fine Art & Antique Fair.

Contents

Director's Welcome vii

Acknowledgments ix

The Use of This Guide xi

The Legacy of John and Mable Ringling 1

Museum of Art 17

 Ancient Art 18

 Asian Art 25

 Painting, Sculpture, and Decorative Arts 32

 Prints, Drawings, and Photographs 122

 Modern and Contemporary Art 140

Cà d'Zan . 149

Circus Museum 175

 Tibbals Learning Center 176

 The Contemporary Gallery 177

 Circus Models 178

 Posters and Photographs 184

 Props, Wardrobe, and Wagons 194

Historic Asolo Theater 201

Selected Museum Publications 208

Index of Artists 211

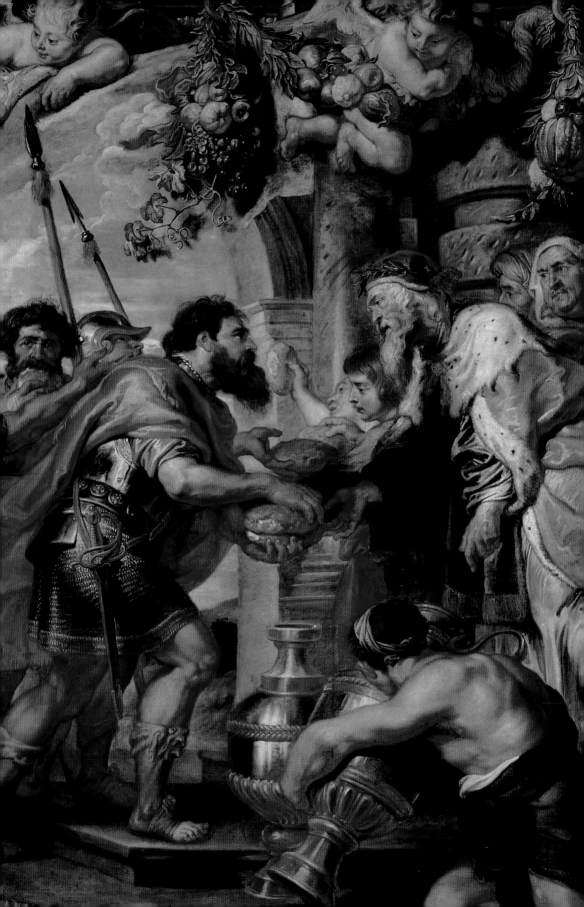

Director's Welcome

One of the most fantastical treasures of the Roaring Twenties, the Ringling estate has welcomed visitors to southwest Florida for nearly a century. The ornate Cà d'Zan mansion sits majestically on the shores of Sarasota Bay as an anglicized Venetian palace, where America's "Circus King" once entertained the elite of the age of Gatsby. The Museum of Art is home to one of North America's finest collections of Old Master paintings, featuring masterworks by Rubens, Titian, Hals, Velázquez, Tiepolo, and Gainsborough, among others. The Circus Museum, founded in the 1940s by the museum's first director, now hosts one of the most dazzling collections of circus memorabilia on public view in the country. And the Historic Asolo Theater, created in the 1790s for an Italian palace in a hilltop village just north of Venice, provides an elegant setting for live performances and film. To visit the Ringling is to step back in time, to a world of brilliance, beauty, and cultural splendor.

It was not always so. For decades the Museum struggled to stay solvent, and suffered years of slow decay as vital maintenance projects were set aside for lack of funds. In the 1990s, important restoration efforts began, leading to the complete refurbishment of the Ringling mansion and comprehensive repairs to the Museum of Art. A merger with Florida State University in 2000 led to the construction of four new buildings on the Ringling estate, doubling the size of the Circus Museum, expanding the Museum of Art, and adding an Education Building and a Visitors Pavilion to welcome guests. What emerged was an altogether new Ringling Museum—larger and more welcoming, with dramatically enhanced exhibitions and cultural programs.

The *Guide* you are about to read replaces a publication that has lasted for more than twenty years. It was handsome and informative, but descriptive of the old Ringling Museum. The rebirth of the institution also brings the need for a renewed look at its treasures.

We hope that your visit to the Ringling estate is one of wonder, delight, and aesthetic fulfillment—and that this new *Guide* contributes to your enjoyment and enlivens your memory of a truly wondrous place.

John Wetenhall, Ph.D.
Executive Director

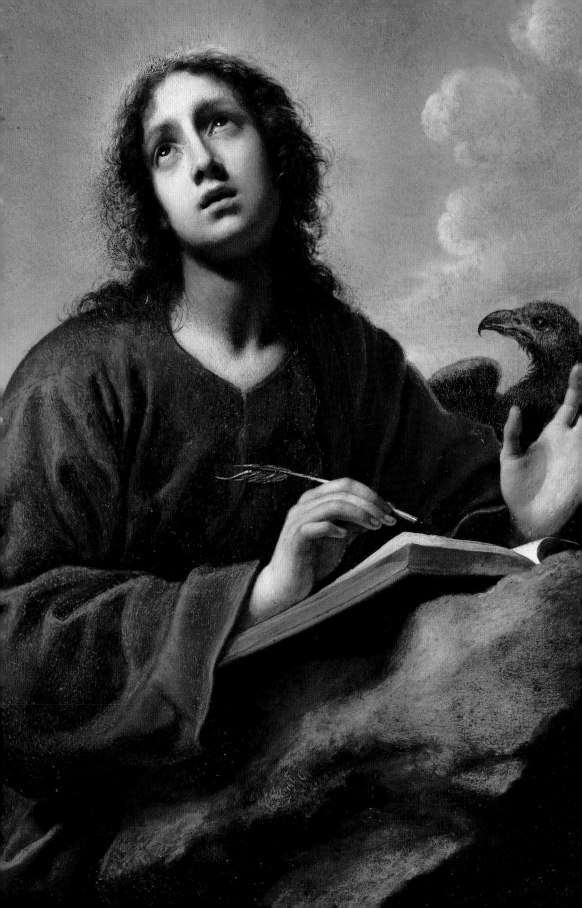

Acknowledgments

This *Guide to the Collections* is the first comprehensive guide to all of the collections at the John and Mable Ringling Museum of Art, including the Museum of Art, Cà d'Zan mansion, Circus Museum, and the Historic Asolo Theater. Many helpful catalogues, handbooks, and guides on the collections have been published over the decades, but this is the first publication that accompanies the visitor at every venue on the Ringling estate.

My first expression of gratitude is to the curators who have served at the John and Mable Ringling Museum of Art since its inauguration as the State Art Museum of Florida in 1936, the year of John Ringling's death. These custodians of the collection all rank as contributors to the ongoing study, documentation, and presentation of the art, and I remain in their debt for their collective contribution.

I am grateful to John Wetenhall, Executive Director, for his commitment to this publication and the new curatorial initiatives at the Ringling Museum, and to Teresa Koncick, Associate Director, for her support throughout its production.

This *Guide* represents a rewarding collaboration that drew on the research and writing of many of my colleagues at the Museum as well as other associates, and to them I offer my greatest thanks: Alexandra Libby, Jeannine Love, Ronald McCarty, Elisabeth Myers, Amy Poster, Seungyeon Sang, Rebecca Shields, Benita Stambler, and Joanna Weber in the Museum of Art; Liz Gray, Jennifer Lemmer Posey, and Debbie Walk in the Circus Museum; Linda McKee and Artis Wick in the Library; Dwight Currie at the Historic Asolo Theater; Michelle Scalera in Conservation; and Maureen Zaremba in Education. A special debt to Ashley Burke, Francoise Hack, and Heidi Taylor in Registration for coordinating new photography and imaging, and to art preparators Aaron Board, Michael Chomick, Matthew Harmon, and Dave Piurek for overseeing the movement of art. Jean Speaker, Gussie Haeffner, and Peg Thornton were always helpful in handling administrative tasks and challenges. Grant writer Susan Walker assisted with the securing of outside funding for the project. The successful realization of this publication depended heavily on the participation of all of these individuals, and each one shares in its authorship.

Among the Museum staff, I must single out Assistant Curator Alexandra Libby and Curatorial Fellows Elisabeth Myers and Rebecca Shields, who spent many hours researching, writing, and editing texts. Head Librarian Linda McKee was most helpful in the various editing stages, and Assistant Registrar Heidi Taylor went beyond the call of duty in arranging for the excellent photographic images.

Special thanks go to Christine Taylor and the staff at Wilsted & Taylor Publishing Services for their role in producing such an attractive and popular book. The intelligent layout of texts and images, and the elegant and accessible design are due in large part to the efforts of project manager Christine Taylor, copyeditor Nancy Evans, and designer Tag Savage. I am also grateful to Whitney Cox, Giovanni Lunardi, Terry Schank, and Jim Stern for their superb photography, which is evident throughout the publication.

This new *Guide* would not have been possible without the support of Mrs. Alice W. Rau, former chair of the Ringling Museum of Art Foundation Board of Directors, who made a generous contribution toward the cost of the publication. I would like to extend a special tribute to Mrs. Ulla R. Searing, one of the Museum's preeminent benefactors, who has also taken a special interest in my work, and most recently pledged the gift to endow my curatorial post. I am grateful to members of the Foundation Board who have supported me in my oversight of the Museum of Art and Cà d'Zan collections and exhibitions programs. I also express appreciation to Michael Mezzatesta, Director of the Palm Beach Fine Art and Antique Fair, whose organization awarded a funding grant for the production of this book.

Finally, I am indebted to my wife, Hazel Mouzon Borys, who has given me great encouragement, and whose interest and enthusiasm, along with our son, Roman's, for the Ringling Museum and its rich collections have inspired me throughout this project.

Stephen D. Borys, Ph.D.
Ulla R. Searing Curator of Collections
The John and Mable Ringling Museum of Art
Sarasota, Florida

The Use of This Guide

One of the great advantages of this guide is that it allows the Museum to share many of its works of art in one place at one time. However, not every work in this publication will be on display in the Museum venues at all times. Some may be on loan to other museums for exhibitions, and others may be undergoing conservation treatment. In the permanent collection galleries, paintings and sculptures are often rotated throughout the year for exhibition and study purposes. Works on paper (prints, drawings, and photographs) are highly sensitive to exposure to light, and in the interest of preserving them for future generations, they are exhibited only for brief periods.

For the convenience of the reader and visitor, dimensions of objects in the guide have been kept to a minimum. For two-dimensional works, such as paintings, height precedes width. With furniture, three dimensions are given: height, width, and depth. For sculptures and other three-dimensional works such as pottery and silver, only one dimension (height or diameter) has been provided.

Rather than following any order that reflects the physical location of the Museum buildings or the current display of the works of art and artifacts, this guide is organized by venue (Museum of Art, Cà d' Zan, Circus Museum, and the Historic Asolo Theater), and within these sections, the works are presented by media, chronology, country, and, in some instances, theme and context.

The Legacy of John and Mable Ringling

In preparing for the opening of his museum, John Ringling (1866–1936) asked his art advisor and the first curator, Julius W. Böhler, to produce a catalogue of the collection for visitors and scholars. Böhler never completed the book during or after Ringling's lifetime, and the Museum of Art opened permanently in 1932 without the publication that Ringling had desired. So determined was he to get his catalogue that Ringling postponed the opening of the Museum for over a year, waiting for the publication that never arrived. For a comprehensive guide, visitors would have to wait until 1949, when the distinguished art historian William E. Suida published a catalogue at the request of John Ringling North, the Museum's chairman of the board. In his preface, Suida praised the collection, acknowledging that in this realization of one man's vision, which united a superb group of paintings and sculpture with an exquisite architectural setting, he could think of few comparable examples outside of Italy (fig. 1):

> The John and Mable Ringling Museum in Sarasota, bequeathed to the State of Florida, ranks high among the art museums in America. Apart from the superior quality of individual works, the Sarasota museum possesses a trea-

Fig. 1 The Museum of Art east façade.

Facing Detail from Noël-Nicolas Coypel,
Portrait of Madame de Bourbon-Conti as Venus, 1731 (see p. 93).

Fig. 2 John Ringling in front of Cà d'Zan, ca. 1927.

sure to be found in very few other museums: the personality of the founder—for his enjoyment, his enthusiasm are perpetuated within.... The visitor is transported from his daily surroundings into a romantic world, and rendered susceptible to emotions and impressions that could hardly arise in a modern museum.... Has a dream of the Italian Renaissance become reality on the Gulf of Mexico? Do we breathe the air of Frascati or Tivoli? The building is broadly laid out with spacious galleries, its extended wings and arcades encircling a well-cared-for garden with steps and terraces, fountains and statues. The artistic quality of the architectural plan deserves our admiration.

John Ringling was born in McGregor, Iowa, on May 31, 1866, the fifth of seven sons and a daughter born to August and Marie Salome Ringling (fig. 2). Inspired by the traveling shows that passed through their small town, John and four of his brothers formed a partnership and created the Ringling Bros. Circus in 1884. After the show was converted from wagons to rail in 1890, the Ringling Bros. Circus was transformed into a national phenomenon, with more than one hundred rail cars crossing the country each season. When they acquired the Barnum & Bailey show in 1907, they also earned the title of "The Greatest Show on Earth." The Ringling brothers had become the leaders in the American circus industry, and John

Fig. 3 Mable Ringling,
ca. 1927.

Ringling was crowned the "Circus King." At the height of Ringling's career in 1925, the year his portrait appeared on the cover of *Time* magazine, his net worth was estimated at $200 million, securing his place as one of the fifteen richest men in the world.

John and his wife, Mable Burton Ringling (1875–1929), whom he had married in 1905, first vacationed in Florida at Tarpon Springs, near Tampa, in 1909, and also visited friends in Sarasota (fig. 3). Two years later, John and his brother Charles purchased more than 60 acres on Sarasota Bay, which included John and Mable's first home, Palms Elysian, and the present site of the Ringling Museum estate. Aside from his investments in banking, railroads, and oil, he saw an opportunity in the Florida land boom, and began buying and developing land on the Sarasota Keys. In the first six months of 1925 alone, more than $19 million in real estate transactions were recorded in the Sarasota community, $10 million of which comprised Ringling's investments. By 1927, he had also moved the winter quarters of the Circus from Bridgeport, Connecticut, to Sarasota.

In 1924, John and Mable Ringling commissioned New York architect Dwight James Baum to build their new residence in Sarasota (fig. 4). While *Cà d'Zan* translates from the Venetian dialect as "The House of John," the project was always listed on the plans as "the home of Mrs. John Ringling,"

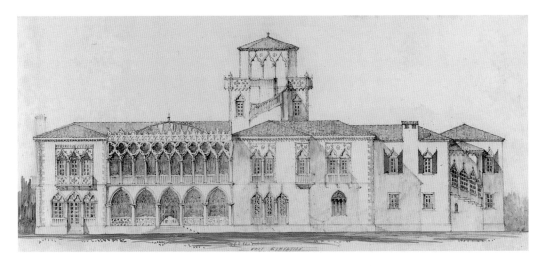

Fig. 4 Earl Purdy, for Dwight James Baum, *Early Cà d'Zan Plan, West Elevation*, ca. 1924. Watercolor on board, 19¾ × 44 in. (50.2 × 111.8 cm). Bequest of John Ringling, NN188.

and Mable was the principal contact for much of the construction and decoration. The house was completed in December 1925 at a record cost of $1.5 million, and the Ringlings moved in the next year. The 200-foot-long residence boasted 22,000 square feet of living space with thirty-two rooms and fifteen bathrooms, and it soon became the epicenter of cultural life in Sarasota, evoking the Venetian architecture admired by the Ringlings and their friends.

In terms of collecting, the Ringlings had already begun buying paintings, sculpture, and decorative arts for their apartment at 636 Fifth Avenue in New York City, and their summer house in Alpine, New Jersey, but the pursuit accelerated with their arrival in Sarasota. They were also inspired by the idea of creating a memorial museum for their growing collection, which John envisioned as an art center for the Southeast, since there was no major museum in this part of the country. With their annual trips to Europe in search of the latest circus acts, John and Mable developed a passion for all that the continent offered in terms of both art and architecture. John became a regular at the New York and London auctions, and enlisted the help of international dealers to help assemble his art collection, which focused on the Old Masters from the fifteenth to the eighteenth centuries.

In 1925, Ringling hired another New York architect, John H. Phillips, to design a building for his art collection that would take its inspiration from the Renaissance and Baroque palaces of Italy (fig. 5). Construction began in 1928, and on March 31, 1930, the John and Mable Ringling Museum of Art opened for a day, attracting more than ten thousand people, a number that exceeded the population of Sarasota. More than five hundred paint-

ings were displayed, many triple hung, in the Museum's twenty-one galleries. A year later, the Museum reopened for a week, but was then closed again in anticipation of the publication of the collections catalogue. The Ringling Museum finally opened permanently on January 17, 1932, becoming the official State Art Museum of Florida, and gaining the enviable reputation of being one of the most beautiful museums in the country.

Sadly, Mable Ringling did not live to see the opening of the Museum. She died on June 8, 1929, just a few months before the stock market crash. In December 1930 John married Emily H. Buck; the relationship proved ill-fated, however, and they were divorced in 1936. With his marital challenges, over-extended finances and market crash, and the years of the Great Depression, Ringling's own health and fortunes failed. On December 2, 1936, at the age of seventy, John Ringling died of pneumonia at his Park Avenue home in New York City. In his will, he left the Museum of Art, Cà d'Zan, and the collections to the people of Florida. It would take executors and government officials nearly ten years to sort out the estate. The Museum was finally presented to the state in 1946, the same year that A. Everett "Chick" Austin, Jr., was hired as the first director.

Fig. 5 J. H. Phillips, architect, *Air Plane View of the John and Mable Ringling Museum of Art, Sarasota, Fla., Showing Dormitory and School Addition*, 1928. Pencil and watercolor on paper, 11 × 23 in. (27.9 × 58.4 cm). Bequest of John Ringling, SN1546.110.15.

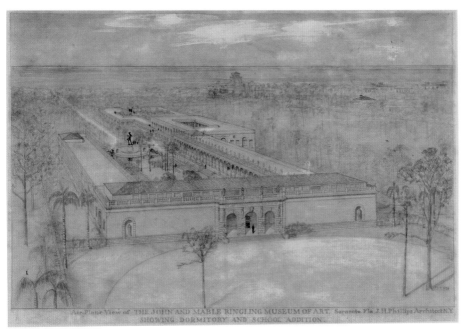

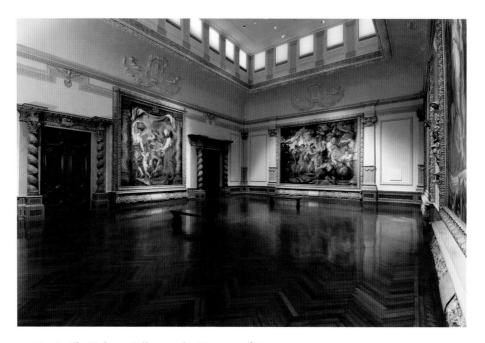

Fig. 6 The Rubens Gallery in the Museum of Art.

While some scholars have drawn parallels between John Ringling's careers as circus impresario and art collector, the two activities were in many ways separate. His role as circus king became his public side, and his role as collector and connoisseur reflected a more private side, though he clearly expected that both pursuits would be acknowledged in the circles of the cultural elite. Certainly his love of the Baroque, and his fascination with the drama and sensuous exuberance of the seventeenth century, provided an interesting counterpoint to the spectacle and the scale of the circus world. However, many of Ringling's most important acquisitions were small easel paintings and religious and decorative objects that required a certain level of intimacy for their contemplation and appreciation.

John Ringling assembled his collection in a surprisingly brief period of time, almost entirely between 1920 and 1930, acquiring more than five hundred paintings alone. The purchase of the Triumph of the Eucharist series by Peter Paul Rubens would be his personal triumph and the pinnacle of his career as one of the preeminent American collectors of his day (fig. 6). Although he benefited from the guidance of dealers like Julius Böhler and Joseph Duveen, and scholars like Max J. Friedländer, not to mention museum directors and auction houses, Ringling often acted on his own in pursuit of great art. The 1926 acquisition of four of the enormous tapestry cartoons from the Eucharist series, precisely three centuries after they were made, perhaps best personifies his role as collector and visionary.

Originally consisting of at least eleven large-scale compositions, the Eucharist series was Rubens's most complex tapestry cycle; it was commissioned by Isabella Clara Eugenia (1566–1633), infanta of Spain and Portugal, archduchess of Austria, and the daughter of King Philip II of Spain. Ringling located four of the cartoons in London after they had failed to sell at the 1922 sale of the Duke of Westminster's collection. Upon finalizing the purchase with the assistance of Böhler, Ringling wasted no time in instructing architect John H. Phillips to design a special gallery for them in the new museum. A fifth work from the series, *The Triumph of Divine Love*, was added to the collection when it came on the art market in 1980. Today, the cartoons compose the only extant large-scale painting cycle by Rubens outside of Europe, and they are joined in the Museum by several of his other works.

Ringling's passion for collecting art was centered on the Baroque period, in particular the Italian and Northern Baroque, with representation of all of the academic categories. In the current installation of the Old Master pictures, ten of the twenty-one permanent collection galleries are devoted to the seventeenth century, including six galleries for Dutch and Flemish art, and four galleries dedicated to Italian, French, and Spanish art (fig. 7). The overall representation of the European schools, from the fourteenth to the nineteenth centuries, is split roughly in thirds between the Dutch and Flemish, the Italian masters, and the French, British, and Spanish schools.

Several other important collections apart from the core group of the Old Masters were acquired by John Ringling, and subsequently by the Museum since his death. More than two thousand ancient Mediterranean objects, including Cypriot, Greek, Roman, and Etruscan pieces, mainly pottery, glass, and stone sculptures, make up the Ancient Art collection. A group of Chinese and Indian ceramics and bronzes has been augmented in recent years by two major gifts of Asian art. Decorative arts were always a passion of Ringling's, and examples from many schools and periods spanning the last six centuries can be found alongside works from the Émile Gavet Collection of late Medieval and Renaissance decorative arts. A modest group of Old Master prints and drawings and modern works, including photographs, constitute the works on paper collection. Ringling also assembled a small collection of late-nineteenth- and early-twentieth-century art, which has provided the impetus for later acquisitions in the area of modern and contemporary art.

Installed in the courtyard gardens of the Museum and throughout the grounds of the estate are more than sixty bronze and stone casts of famous

Greek, Roman, and Renaissance sculptures. Most of the sculptures were ordered by Ringling on a 1925 trip to Italy with Julius Böhler, when he visited the Chiurazzi Foundry in Naples. Ringling originally intended to show the sculptures in the courtyard of an art school adjoining the museum, while others would be installed at the Ritz-Carlton Hotel he was building in Sarasota. Budget overruns forced him to eliminate the art school from the plan, and the hotel was never completed. However, the sculpture court remained in John Phillips's master plan, and it was finally built in 2007 as part of the Searing Wing. The art school, today called the Ringling College of Art and Design, was erected down the road from the Museum, and opened the same year, in 1932.

In 1926 Ringling acquired two period-styled rooms from the Fifth Avenue mansion built in 1893 for Mrs. William Backhouse Astor and her only son, John Jacob Astor IV. Architect Richard Morris Hunt had designed the exterior of the mansion in the French Renaissance style, but its interiors were decorated in a wide variety of historical vocabularies by the Parisian

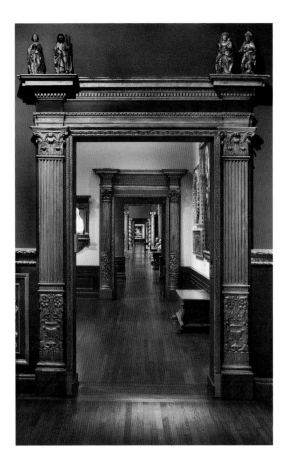

Fig. 7
Looking along the
North Wing from
the Early Northern
European Gallery.

interior design firm Jules Allard et Fils. Ringling purchased two adjoining rooms, Mrs. Astor's Cream Salon and the Library of Mr. John Jacob Astor IV (converted from a dining room), at the sale of the New York City residence prior to its demolition, which was ordered by Vincent Astor in 1926.

Two years later, Ringling bought directly from Mrs. Alva Erskine Smith Vanderbilt Belmont about 320 objects from the Émile Gavet Collection of Medieval and Renaissance paintings, sculptures, decorative arts, furniture, gems, and cameos. Alva Vanderbilt had acquired about half of the original 1000-piece Gavet Collection in Paris in 1889 in preparation for the 1892 opening of Marble House, her Newport residence, also designed by Richard Morris Hunt and decorated by Jules Allard et Fils.

The nucleus of the Ringling Museum's collection of Ancient art centers on John Ringling's sensational 1928 purchase of more than 2200 objects from the Cesnola collection in the Metropolitan Museum of Art. During the 1860s and 1870s, General Luigi Palma di Cesnola, the American consul to Cyprus, amassed a large collection of Cypriot art. A flamboyant self-promoter, Cesnola became the first director of the Metropolitan Museum of Art in 1879, and his collection of antiquities was showcased when the institution first opened its doors on Fifth Avenue. Ringling also acquired one hundred ancient glass pieces at the same sale from the collection assembled by Julien Gréau, the French archaeologist, which had been given to the Metropolitan Museum by J. P. Morgan.

In January 2006, the noted Sarasota art collector and philanthropist Dr. Helga Wall-Apelt pledged funds for the establishment of the Helga Wall-Apelt Gallery of Asian Art and Endowment. The Helga Wall-Apelt Asian Art collection, totaling more than one thousand pieces, reflects a lifetime of collecting interests, from a pan-Asian approach to Buddhist sculpture to later Chinese jades and stone carvings, and a comprehensive group of Asian photographs and contemporary works. In addition to funds for the creation of an Asian art wing, the Wall-Apelt gift supports a curatorial post, research and publications, public programs, exhibitions, and acquisitions. The Gallery will also house the Koger Collection of Chinese ceramics, which was acquired in 2001 through a generous gift of Nancy and Ira Koger. The internationally known collection of almost four hundred objects represents nearly five thousand years of Chinese history and extends from the Neolithic period in 2500 B.C. to the nineteenth century.

More than a decade after John Ringling's death, the other side of his legacy was brought to life: the American circus and its history. The Museum of the American Circus was established in 1948 by director Chick Austin, and was the first of its kind in the country to document the history

of the circus. With the influx of circus people living in and retiring to Sarasota, there were great incentives and gains in building the collection. The Circus Museum contains an important group of rare circus handbills, posters and art prints, photographs, circus papers and records, costumes and performing props, and parade wagons and other circus equipment. With the generous support of Howard Tibbals, a circus historian and collector, the Tibbals Learning Center was opened in 2006, doubling the size of the Circus Museum and offering new exhibits for visitors (fig. 8). The spaces feature video and poster galleries, displays of circus props and costumes, a visual history of the European and American circuses from antiquity to the present day, and two miniature circus models. Created by Tibbals over a period of more than fifty years, the Howard Bros. Circus model is a replica of the Ringling Bros. and Barnum & Bailey Circus, circa 1919–1938, and brings to life the heyday of the American tented circus. Comprising more than 44,000 separate pieces, including 8 main tents, a 57-car train,

Fig. 8
The Tibbals
Learning Center.

152 wagons, 1,300 performers and workers, and 800 animals, the ¾-inch-to-the-foot scale model occupies a 3,800-square-foot area. Also displayed in the Tibbals Learning Center is the 148-foot-long Dunn Bros. Circus model, built by Harold Dunn and highlighting the handcrafted horse-drawn floats used in circus parades.

The Museum's Historic Asolo Theater is one of the most important European architectural interiors brought to the United States in the last century (fig. 9). The Theater was constructed by Antonio Locatelli in 1798 for a palace built in Asolo, Italy, to honor Caterina Cornaro, the exiled fifteenth-century queen of Cyprus. Remodeled by Francesco Martignago in 1855, it remained in use until 1931 when it was converted to a film theater. The eighteenth-century decorative panels were purchased by the Venetian art dealer Adolph Loewi, from whom Chick Austin acquired them for the Museum in 1949. The Theater was installed in the Museum (Gallery 21) in 1952, until a freestanding structure could be built in 1958, which remained in operation until 1990. In 2006, after a major restoration, the Asolo was reinstalled in the new John M. McKay Visitors Pavilion, where it serves as a venue for a variety of performances and events (fig. 10).

The Ringling Museum of Art Library is one of the largest art museum libraries in the Southeast United States, containing more than seventy

Fig. 9 The Historic Asolo Theater, seen from stage right.

Fig. 10 The John M. McKay Visitors Pavilion.

Fig. 11 The Reading Room in the Ringling Museum of Art Library.

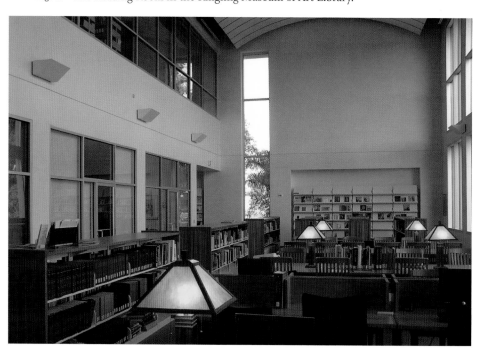

thousand holdings, including books, current and historical periodicals, and exhibition and auction catalogues (fig. 11). John Ringling's personal art library is housed in a special reading room within the Library. This collection of rare books, illustrated folios, art historical treatises, and annotated catalogues is a lasting testament to Ringling's passion for collecting. From the 1,500 titles listed in the estate inventory, more than 500 titles from the art book collection survive, including celebrated volumes on many of the artists represented in the collection.

The Archives at the Museum represent an important group of institutional records and manuscript materials pertaining to the history of the Museum of Art, the Ringling family and estate, and the American circus. These documents include: the John Ringling Papers (including more than seven hundred auction catalogues); public records relating to the Museum; the circus collection of scrapbooks, programs, tickets, and route books; photographs, postcards, posters, videos, and films on the Museum and circus; and the papers of individuals and institutions associated with the Museum and the circus.

In February 2007, the Ringling Museum opened the doors of its newest art galleries, the Ulla R. and Arthur F. Searing Wing, which was the fourth building to open on the 66-acre estate in a period of fourteen months, marking the completion of the Museum's five-year building and endowment campaign (fig. 12). John H. Phillips's original master plan for the Museum of Art also came to fruition with the construction of the Searing Wing, its loggia and façade merging seamlessly with the original Museum structure. The new galleries, named after the New York and Sarasota philanthropists Ulla and Arthur Searing, provide an additional 25,000 square feet of exhibition space, and are situated around an open court, which will house a site-specific work by artist James Turrell.

Since the Ringling Museum opened to the public over seventy-five years ago, there have been several additions and changes to the 66-acre estate. Yet much of what William E. Suida described about the collections and grounds in the first guide has remained the same. The handsome Italianate structures and their artworks retain their beauty and charm, and the elaborate gardens and vistas reflect much of the original plans laid out by John Ringling and his architects (fig. 13). Perhaps the most significant change has been the restoration, expansion, and enrichment of the collections and buildings, and the bold exploration into other cultures and periods, including Asian art, and art of the current and last centuries. The Circus Museum has increased substantially in its holdings, the Historic Asolo Theater has been returned to its former glory, the Searing Wing offers new exhibition

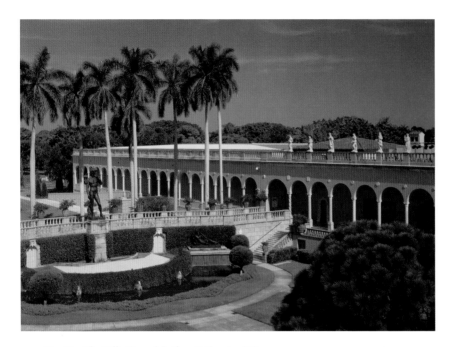

Fig. 12 The Ulla R. and Arthur F. Searing Wing.

Fig. 13 The Ringling estate in 2007 (looking south).

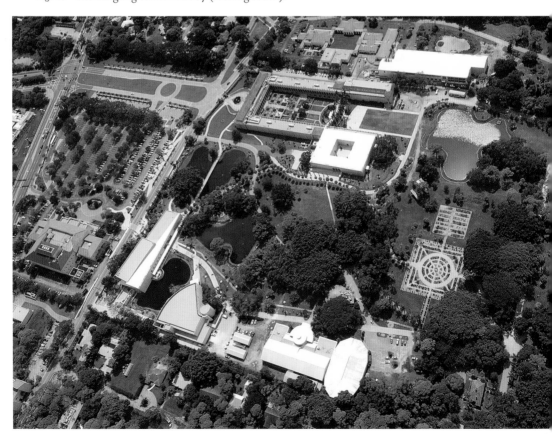

opportunities, and the Museum's curatorial, education, conservation, and registration departments are now located in a new facility.

The four buildings added to the Ringling estate in the last two years— the Tibbals Learning Center, the John M. McKay Visitors Pavilion, the Education Building, and the Searing Wing—have doubled the size of the Museum, ranking it among the twenty largest art museums in North America. In its affiliation with Florida State University, to which the Museum's governance was transferred in 2000, the Ringling has become one of the largest university art museums in the nation.

In an address John Ringling gave the year of the Museum's formal dedication in 1931, he said: "I hope this museum will promote education and art appreciation, especially among our young people. It is my earnest hope and desire that these works of art may be a lasting inspiration to all the people of Florida and to our visitors, and that they may come and enjoy them." Today The John and Mable Ringling Museum of Art continues to celebrate the legacy of its two founders, enabling a diverse audience to experience and enjoy a world-renowned collection of fine art, the Cà d'Zan winter residence, the Circus Museum, and the Historic Asolo Theater, all of which are featured in this new *Guide to the Collections*.

Stephen D. Borys, Ph.D.
Ulla R. Searing Curator of Collections

Museum of Art

Upon entering the Museum of Art, the visitor is afforded one of the most breathtaking views found in any museum in North America. Inside the marble entrance lobby, facing west, one looks out to Sarasota Bay, the vista interrupted only by a garden courtyard furnished with sculptures and fountains set between towering palms and flowering plants. In this marvelous setting, the result of the collaborative visions of collector and architect, visitors move freely between the interior and exterior spaces, enjoying the art, architecture, and gardens of the Ringling estate.

Twenty-one galleries are dedicated to the permanent collection, and these rooms are arranged in a U-shaped plan, with the north and south wings joined by an entrance lobby at the east end, and linked by a bridge over the courtyard at the western termination of the two wings. The galleries enclose an exquisite courtyard where an impressive group of Chiurazzi sculptures and fountains cast from famous ancient and Renaissance works are displayed. An expansive loggia, constructed with antique and modern stone columns and architectural fragments, extends along both wings and connects to the new Ulla R. and Arthur F. Searing Wing, which is used mainly for temporary exhibitions. The Searing galleries also enclose a courtyard, where the installation of a site-specific work by American artist James Turrell is planned.

Architect John H. Phillips's enfilade design allows the visitor to proceed from gallery to gallery, taking in the remarkable depth and diversity of John Ringling's collection. Reflecting Ringling's primary focus on the Baroque period, ten of the twenty-one galleries feature seventeenth-century European paintings, sculpture, and decorative arts. The remaining spaces exhibit works from the fourteenth to the nineteenth centuries, with one gallery devoted to Cypriot, Greek, and Roman antiquities. Aside from the first two galleries where Rubens's five immense painted cartoons from the Triumph of the Eucharist series are displayed, works of art are installed chronologically, by country and school. The Museum's modern and contemporary art, and works on paper, are exhibited temporarily in the Searing Wing. The Asian art collection is also shown in the Searing Wing; however, this growing collection will eventually be presented in the new Helga Wall-Apelt Gallery of Asian Art, adjacent to the south wing of the Museum of Art.

Facing Detail from Reginald Marsh, *Wonderland Circus, Sideshow, Coney Island,* 1930 (see p. 118).

Jug

Cypriot, Early Cypriot, ca. 2500 B.C.
Red polished ware ceramic
19¾ × 12 in. (51.6 × 30.8 cm)
Museum purchase, 1974, SN74.2

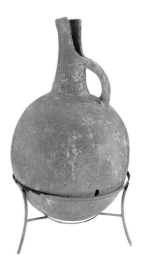

This jug was found in Lapatsa, tomb 15, on Cyprus.
It dates to the earliest phase of Cypriot pottery in the
Bronze Age (ca. 2500–1050 B.C.). In this period all pot-
tery was made by hand rather than by a potter's wheel,
and the main types were black and red polished wares.
The Ringling piece was painted with a red slip and then
burnished to create a shiny polish. Red polished ware was
introduced into Cyprus by immigrants from Anatolia on
the coast of modern Turkey, who settled there around the
middle of the third millennium B.C. Although this exam-
ple is unadorned, oftentimes linear motifs were incised
and filled with lime to decorate the vessel. The shapes
include mostly jugs with a cutaway neck and flat base.

Storage Amphora

Cypriot, Archaic, ca. 750–600 B.C.
Painted ceramic
30½ × 21½ in. (77.5 × 54.6 cm)
Bequest of John Ringling, 1936, SN28.154

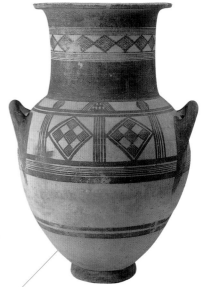

A storage amphora could be used to hold oil,
olives, or wine. As in mainland Greece, a Geomet-
ric style of decoration developed on Cyprus—
vestiges of which remained when the Oriental-
izing style was beginning elsewhere in the Greek
world. This amphora is white with vertical and
horizontal stripes and lozenges with cross-hatching,
all common motifs in Geometric painting. Areas of
solid white or black can also be seen, again common
to the Geometric style.

Male Figure with Leopard Skin

Cypriot, Archaic, ca. 600–540 B.C.
Limestone
48½ × 19 in. (123.2 × 48.3 cm)
Bequest of John Ringling, 1936, SN28.1914

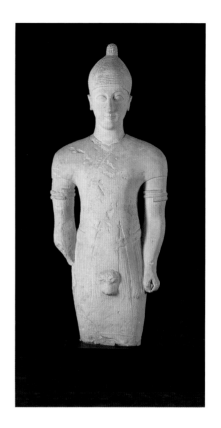

This figure was excavated from one of the two temples in the ancient walled city of Golgoi. The carefully incised, almond-shaped eyes are typical of Archaic art, which predates the canonical forms of Classical Greek statuary. Also characteristic of this period is the thin, upturned mouth—a feature known as the "Archaic smile." The figure's frontal pose and clenched fists—typical Egyptian motifs— also illustrate the influence of Egyptian sculpture in the Mediterranean. Yet the asymmetry of the lower body suggests a slight forward step of the left leg, a feature that foreshadows the Classical *contrapposto*. This figure of a young man resembles the *kouroi* (marble statues of young men or boys set up as grave markers) of Archaic Greece, but unlike these stat-ues, which were nude figures, he is fully clothed and wears a helmet and spiral arm bracelets.

Relief of a Banqueter

Cypriot, Classical, 400–300 B.C.
Limestone
17¼ × 15 in. (43.8 × 38.1 cm)
Bequest of John Ringling, 1936, SN28.1910

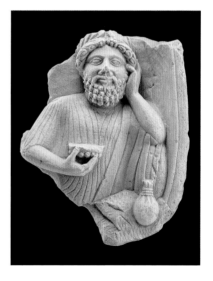

This funerary relief depicts a bearded man reclin-ing on a couch and leaning against a pillow. He holds a drinking saucer in his right hand and what appears to be a money bag hangs from his left arm. The sculpture is a Cypriot version of a common type of funerary relief, which depicted the deceased in the afterlife enjoying an eternal banquet. It is remi-niscent of other examples from the ancient world, including the painted panel of banqueters from the Tomb of the Diver from the Greek colony of Posidonia in southern Italy. At the same time, it is distinctly Cypriot. Although a late Classical work, it has been carved in a stylized manner that is characteristic of Cypriot sculpture. At a time when sculptors in mainland Greece aimed to represent the human body in great detail and to render drapery accurately, the folds of fabric in Cypriot works are not fully modeled but are represented in a linear manner.

Alabastron

Mediterranean, Classical,
500–300 B.C.
Core-formed blue glass
5 × 1½ in. (12.7 × 3.8 cm)
Bequest of John Ringling, 1936,
SN28.1562

Double Unguentarium

Roman, Imperial, 300–400 A.D.
Blown blue-green glass
7¼ × 2½ in. (18.4 × 6.4 cm)
Bequest of John Ringling, 1936,
SN28.1439

Double Unguentarium

Roman, Imperial, 300–400 A.D.
Blown blue-green glass
4¾ × 1³⁄₁₆ in. (12.1 × 3 cm)
Bequest of John Ringling,
1936, SN28.1474

The earliest glass vessels were made by a technique known as "sand-core," in which molten glass was worked around a clay core, producing an opaque appearance. Decorative patterns could be applied by using glass threads of a contrasting color. The *alabastron* was made by this technique and features designs made by thin white glass threads. Blown glass was a later development invented around the first century B.C. Centers of production existed all over the Roman world, including the island of Cyprus. Glass vessels were often modeled after large ceramic amphorae or jugs, but most glass containers were used for perfumed oil. The two double *unguentaria* are examples of the later technique. These pieces are from a collection of ancient glass assembled by the French archaeologist Julien Gréau that was given to the Metropolitan Museum of Art by J. P. Morgan and later sold at auction to John Ringling in 1928.

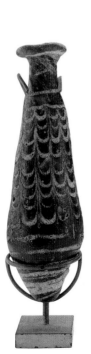

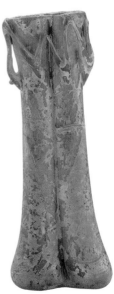

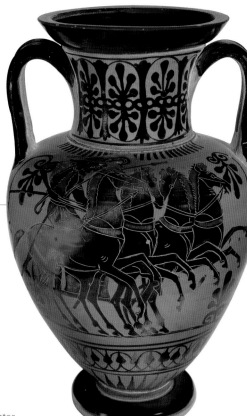

Amphora

Attributed to the Edinburgh Painter
Ancient Greek, Classical, ca. 500–480 B.C.
Black-figure ceramic
10½ × 6½ in. (26.7 × 16.5 cm)
Gift of Manuel Ortiz, Jr., 1955, SN1487

The Edinburgh Painter worked in the early fifth century B.C. near the end of a long tradition of black-figure painting—a technique that was perfected in Athens during the sixth century B.C. To supplement the black silhouettes of the figures, red paint was added to highlight details such as the crests of helmets and the manes of horses. The Ringling vase shows a lively *quadriga* (four-horse chariot) carrying an armored woman on the main face, while the reverse shows two warriors and two bystanders. The painter's skill is exemplified in the quick-paced movement of the horses and their excited expressions. Although the figures are not fully three-dimensional, the use of incised lines creates the impression of volume in the horses' bodies. The tall and slim proportions of the figures, the profile eyes, and the incomplete anatomical articulation place this amphora in a transitional period from Archaic to Classical.

Kylix (Drinking Cup)

Ancient Greek, Archaic, ca. 500–475 B.C.
Red-figure ceramic
5⅛ × 11⅓ in. (13 × 28.4 cm)
Bequest of John Ringling, 1936, SN46.3

A *kylix* is a drinking cup that was frequently used at banquets called *symposia*. The Ringling cup is decorated with a banquet scene in which a young man reclines on a dining couch propped up by a pillow as he holds two cups of wine. His head turns to look behind him as if he is engaged in conversation with another person just beyond the borders of the painting. Numerous works of art, in addition to literary sources such as Plato's *Symposium*, testify to the importance of this social activity for ancient Greek men. The symposium typically included a dinner with wine, conversation, music, and readings from literature for entertainment.

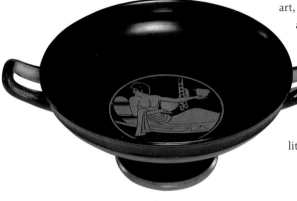

Column Krater

Attributed to the Varrese Painter
Ancient Greek, Apulia, Classical, ca. 350 B.C.
Red-figure ceramic
22 × 18 in. (55.9 × 45.7 cm)
Gift of Mrs. Charles J. Espenshade, 1964,
SN1693

A *krater* is a large vessel for mixing wine and water. This example from Apulia, a prosperous Greek settlement in southern Italy, shows a seated Amazon or Oscan warrior with two attendants. It reveals the new possibilities for painting that could be achieved using the red-figure technique, which became the standard during the Classical period. By painting the features of the figures on a lighter-colored ground, as opposed to the black-figure technique, the painter was able to use subtle shading or faint lines to suggest three-dimensionality. Also noteworthy is the drawing of the figures and drapery to create a real sense of the body underneath the fabric and to represent the soft folds of fabric with the suggestion of movement, particularly in the tunics, which appear to flutter in the wind.

Hydria (Water Jar)

Ancient Greek, Classical, ca. 350 B.C.
Black-glazed ware ceramic
18 × 11¼ in. (45.7 × 28.6 cm)
Bequest of John Ringling, 1936, SN28.836

A *hydria* is a vessel for carrying water. Toward
the end of the Classical period in the second
half of the fourth century B.C., the tradi-
tion of red-figure painting in Athens came
to an end and plain black glazed pottery
without figural ornamentation was made.
The aesthetic impact of this *hydria* comes from
its simplicity and elegance of form, rather than
elaborate painted decoration. Pottery shapes had
always imitated those of metal vessels, but the
resemblance became even more striking. It is clear
that potters continued to take pride in their work
and to produce high-quality objects even as the art
of vase painting was on the decline.

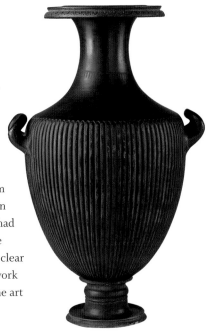

Gallery 20 Ancient art displayed in the Astor Library.

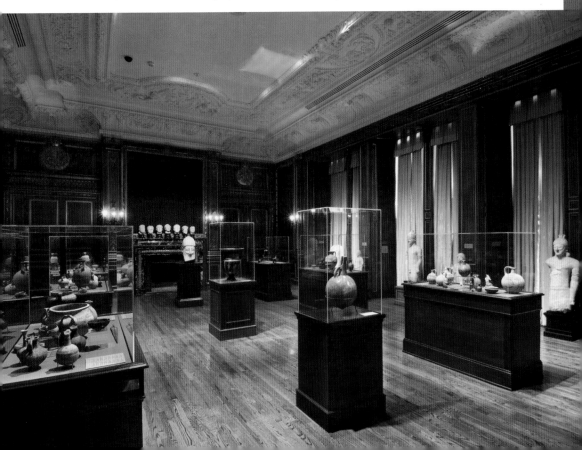

Balsamarium (upper right)

Etruscan, Classical, ca. 400–300 B.C.
Bronze
4⅝ in. (10.16 cm)
Gift of Joseph and Jacqueline Corben,
2001, SN11048.1

Equestrian Figure (lower right)

Etruscan, Classical, ca. 400–300 B.C.
Bronze
3⁹⁄₁₆ in. (7.62 cm)
Gift of Joseph and Jacqueline Corben,
2001, SN11048.3

Mirror Cover with Head of Athena (lower left)

Ancient Greek, Classical, ca. 400–300 B.C.
Bronze
4¼ in. (10.16 cm)
Gift of Joseph and Jacqueline Corben,
2001, SN11048.2

In addition to large-scale bronze statuary, numerous small-scale domestic objects and votives were produced in the ancient world. In antiquity the Etruscans were well known as skilled craftsmen in bronze. The *balsamarium* in the form of a female bust-length figure is a container used for perfumed oil. In the head, there is a hole through which oil could be poured and a cover, which is molded to form part of the figure's hair. Female figures such as this one might represent a goddess, possibly Aphrodite. The equestrian figure was probably a votive offering dedicated to a deity. The figure is a warrior wearing a helmet, chest armor, and a short tunic incised with a geometric motif. The Etruscans had been making solid-cast bronze figurines since the seventh century B.C., but in the fourth century, they reached a high point in production. The mirror cover is a fine example of Greek bronze work. It represents the goddess Athena in repoussé, a technique in which a thin sheet of metal was engraved from behind to produce an image in relief from the front.

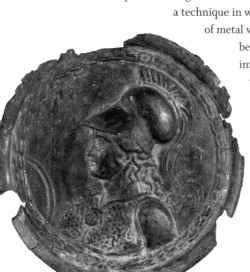

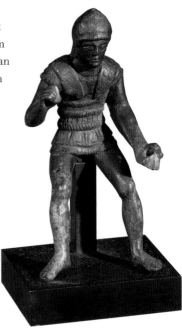

Seated Bodhisattva Maitreya

Gandharan, mid second to third century A.D.
Gray schist
9½ × 13 in. (24.1 × 33 cm)
Bequest of John Ringling, 1936, SN5429

Gandhara, occupying parts of present-day Pakistan, India, and Afghanistan, played a significant role in the emergence of Indian Buddhism and its art. Located in the northwestern part of India, the region of Gandhara was a center of intercultural trade along the Silk Road that linked China, South and Central Asia, and the Mediterranean. Sculpture of the Gandharan region therefore reflects contact with foreign cultures and international taste. This small relief depicts the Buddhist divinity Maitreya, who is destined to become a Buddha in the future. According to Gandharan Buddhist iconography, Maitreya holds a water vessel and is seated on a lion throne. The figure's elaborate knotted hairstyle is also an identifying feature of the Maitreya bodhisattva, as well as the princely features of stylized necklace, pendant earrings, and a jeweled armlet.

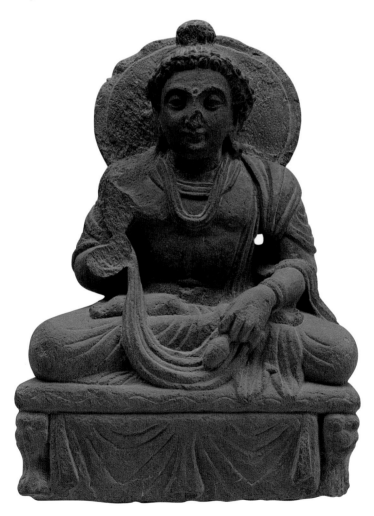

The Presentation of the Four Bowls

Gandharan,
second century A.D.
Gray schist
8 × 17 in. (20.3 × 43.2 cm)
Bequest of John Ringling,
1936, SN5401

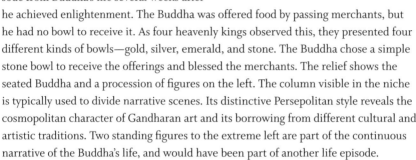

This relief from the Gandharan region depicts an episode from Buddha's life several weeks after he achieved enlightenment. The Buddha was offered food by passing merchants, but he had no bowl to receive it. As four heavenly kings observed this, they presented four different kinds of bowls—gold, silver, emerald, and stone. The Buddha chose a simple stone bowl to receive the offerings and blessed the merchants. The relief shows the seated Buddha and a procession of figures on the left. The column visible in the niche is typically used to divide narrative scenes. Its distinctive Persepolitan style reveals the cosmopolitan character of Gandharan art and its borrowing from different cultural and artistic traditions. Two standing figures to the extreme left are part of the continuous narrative of the Buddha's life, and would have been part of another life episode.

Caparisoned Horse

Chinese, Tang dynasty, eighth century
Glazed earthenware
19⅜ × 19 in. (49.2 × 48.3 cm)
Gift of Ira and Nancy Koger, 2001, SN11122.4

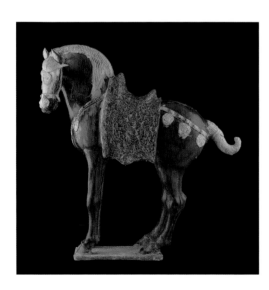

It was not until the Tang dynasty (618–906 A.D.) that the horse became a major image in Chinese art. With the patronage of emperors, the possession and representation of horses signified imperial power and, in particular, military superiority. This white clay tomb figurine of a spirited horse, decorated with polychrome glaze, shows the Tang taste for equine beauty. Found in tombs of emperors and royal families, Tang dynasty burial ceramics were to be used by the deceased in the afterlife to recreate their proper earthly lifestyle. The massive body of this horse, heavy in relation to its long fine legs, reflects the mixture of Arabian and other breeds, brought as tribute to the imperial court. The elaborate saddle blanket, which simulates fur, and ornamented bridles reveal a spectacle of contemporary Tang horse gear.

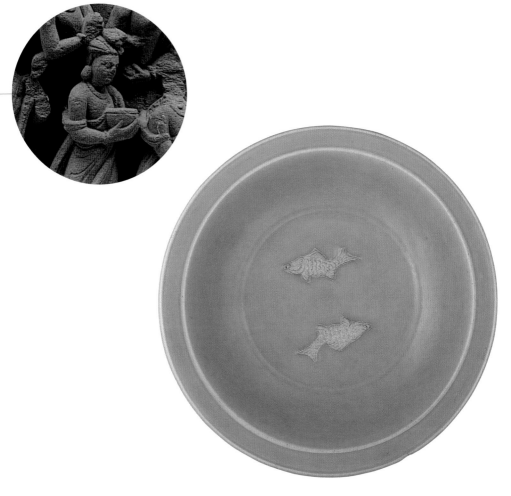

Dish with Two Unglazed Carp

Chinese, twelfth to early fourteenth century
Porcelain
2¾ × 7¾ in. (7 × 19.7 cm)
Gift of Ira and Nancy Koger, 2001, SN11122.39

This type of bluish-green or celadon glaze was mainly produced in regional kilns such as those at Longquan in southwestern Zhejiang province of China, during both the Song (960–1279 A.D.) and the Yuan (1279–1368 A.D.) dynasties. With a long tradition of celadon wares, this region became a major center of China's ceramic production, fashioning items for the imperial courts and for export throughout Southeast Asia and beyond. As the potters developed new methods of using mold-impressed applied motifs, many such wares featured decorative designs or inscriptions. The outside of this dish is carved or molded with a lotus-petal pattern. The double-fish motif in unglazed relief on the surface was popular in southern China and is characteristic of the Longquan decorative technique. According to Chinese tradition, the pair of fish symbolizes marital harmony.

He Chaozong

Chinese, active ca. 1610–1620

Guanyin as the Protector of Mariners (upper left),
Chinese, Ming dynasty, early seventeenth century

Porcelain
20⅛ × 6¼ in. (51.1 × 15.9 cm)
Gift of Ira and Nancy Koger, 2001, SN11122.84

Wen Chang, God of Literature (lower left),
Chinese, Ming dynasty, early seventeenth century

Porcelain
15 × 6 in. (38.1 × 15.2 cm)
Gift of Ira and Nancy Koger, 2001, SN11122.83

White-glazed porcelains such as this, mainly produced in Dehua in Fujian province, were well known as *blanc de Chine* in the West and highly praised for their fine technique in representing figural models. Included within the genre are devotional objects representing Buddhist or Daoist deities. Their modest size indicates that they were meant to be placed on a private altar or used in another domestic setting.

The elegant figure of bodhisattva Guanyin (upper left) epitomizes the artistic excellence of a *blanc de Chine* figure. The deity stands on a base rendered as waves. Her left foot, revealed from beneath her robes, extends to the waves, representing her role as the protector of mariners. A square seal of He Chaozong, a prominent potter of the Ming dynasty, is stamped on the back of the figure.

In the *blanc de Chine* figure at the lower left, He Chaozong represents the god Wen Chang seated on a rocky throne, holding a *ruyi* or "good wish" scepter. He wears the long robes of a scholar and an official's hat, and has a sober expression indicating his role as judge.

Because of his exceptional writing, Wen Chang was canonized during the Tang dynasty (618–906 A.D.) and recognized as god of literature in the thirteenth century. According to Daoist myth, the Jade Emperor assigned him the tasks of keeping a record of men of letters, including their titles and honors, and giving rewards and punishments to each according to merit. Wen Chang has also been associated with China's civil service examinations, and revered for bringing success to those seeking official positions.

Vase with Dragon Handles

Chinese, Qing dynasty, reign of Kangxi, 1662–1722
Porcelain
12¼ in. (31.1 cm)
Gift of Ira and Nancy Koger, 2001, SN11122.247

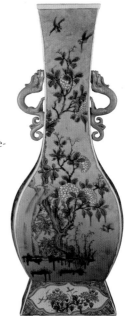

The sumptuous polychrome porcelain decorations on this vase reflect the tastes of the Qing (1644–1911) emperors and their imperial families. The introduction from Europe of a new technology that mixed white with colorful enamels allowed artists to achieve a high degree of realism, treating surfaces as if they were paintings. In this outstanding example, a popular Chinese motif, "Flowers of the Four Seasons," is represented by four flowers— peony, prunus, lotus, and hydrangea—one on each of the four sides. These symbolic flowers are augmented with conventional rocks, flying birds, and archaic dragons, the latter serving as handles. The potters under the Qing emperor Kangxi, a great patron, were admired both in the imperial court and outside China, where their works were collected for their high degree of technical perfection.

Goose with Lotus

Chinese, eighteenth century
Nephrite
7½ × 12½ in. (19.1 × 31.8 cm)
Promised gift of Dr. Helga Wall-Apelt, 2006, TR2006.2779.9

Nephrite, a type of jade, is composed of alternating tones of green, gray, white, and yellow. This elegantly composed goose is shown in a seated position with its head turned backward and the stem of a lotus in its beak. Various types of birds have symbolic meanings in Chinese art. The motif of the goose with a lotus flower refers to the idea of the goose mating for life, which is symbolic of marital felicity. The Chinese word expressing this concept is also a homophone of lotus (*lien*). The lotus signifies abundant progeny, adding to the marital significance of this sculpture. It represents the expectation in traditional Chinese culture that a marriage will produce many children, especially sons to carry on the family name.

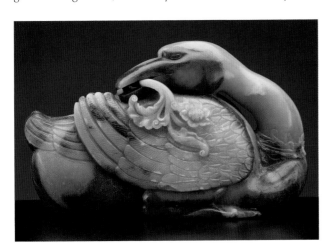

Bamboo Brush or Scroll Holder

Chinese, late eighteenth to nineteenth century
Nephrite
16 × 14 in. (40.6 × 35.6 cm)
Promised gift of Dr. Helga Wall-Apelt, 2006,
TR2006.2779.2

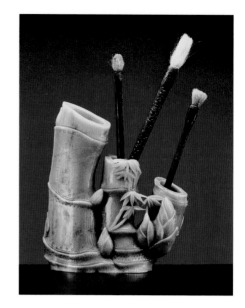

From early times, Chinese jade was part of
the burial tradition of royalty and elites and
was fashioned into elaborate ritual objects. As
these ceased to be used in burial practice, many
scholars in China collected and appreciated
ancient jades symbolic of the country's glorious
past. Since jade as a mineral was associated
with integrity, durability, and permanence,
jade artwork was considered representative
of Confucian moral values. This brush or scroll
holder reflects the artist's skill through its realis-
tic expression of a botanical theme. Shaped like
a bamboo branch, the brush holder represents a different stage of life in each
of its three stalks. Because bamboo symbolizes the righteous literati, it was a pop-
ular subject for the functional objects that graced the studios of Chinese scholars.

Multi-Armed Avalokitesvara

Vietnamese, seventeenth to eighteenth century
Wood with lacquer and polychrome
42 × 26 in. (106.7 × 66 cm)
Promised gift of Dr. Helga Wall-Apelt, 2006,
TR2007.2813.112

This imposing seated divin-
ity can be identified as
Avalokitesvara. It is a type
often found in Buddhist temples
in the provinces of northern
Vietnam. The pose and style of
the figure reflect the traditions of Chinese monks who
brought the practice of venerating Avalokitesvara to
Vietnam as early as the thirteenth century. Constructed
through traditional carving and painted with
many layers of lacquered paste and oil, the fig-
ure is portrayed in the ceremonial dress
and elaborate crown of a court official
or royalty. His idealized facial features,
stylized posture, and multiple arms with
hands held in specific gestures repre-
sent the many manifestations of
the bodhisattva, one who cares for
other earthly beings. Among the
distinctive attributes of the arms framing
the figure are a sutra and a lotus poised in two
of the lower hands, while two hands are held
together at the chest in a gesture of respect.

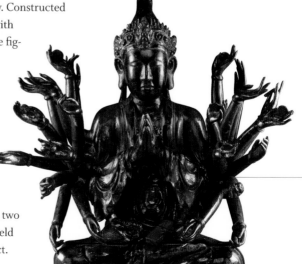

Guardian Lion

Khmer, ca. fourteenth century
Sandstone
31¾ × 12¾ in. (80.6 × 32.4 cm)
Promised gift of Dr. Helga Wall-Apelt, 2006, TR2007.2813.39

Guardian animals are a familiar motif in Asian art. This object exhibits many of the characteristics of sculpture of the ancient Khmer empire, which dominated much of Southeast Asia, centered in what is now Cambodia. This kingdom, famous now for its royal capital at Angkor Wat, built large temple complexes with highly refined sculpture reflecting Buddhist and Hindu traditions at various times. Flourishing between the sixth and sixteenth centuries, the kingdom had a golden age that extended from the tenth through the thirteenth centuries. Since few written records survive, accurately dating these objects is difficult. Influenced by the art and symbolism of India, Khmer sculpture tends to be more fluid and spare. This lion would have stood outside a temple. Its fierce facial expression, rendered by protruding eyes and teeth, was designed to ward off evil spirits.

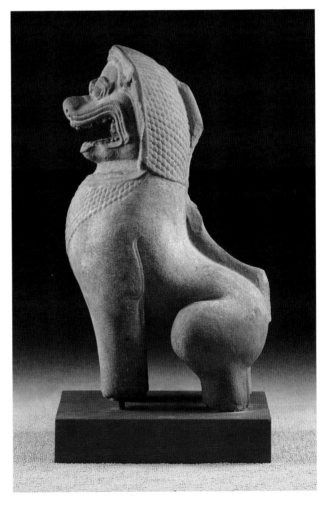

Giovanni del Biondo

Italian, 1356–1399

Madonna and Child with Saints and Angels,
ca. 1380–1390

Tempera on panel
55¼ × 29½ in. (109.2 × 74 cm)
Bequest of John Ringling, 1936, SN6.a

Bicci di Lorenzo

Italian, 1373–1452

Saint Francis Receiving the Stigmata, ca. 1425

Tempera on panel
22½ × 34½ in. (57.2 × 87.6 cm)
Bequest of John Ringling, 1936, SN6.b

In this late Gothic altarpiece, Giovanni del Biondo depicts a *sacre conversazione*, or sacred conversation, in which the Madonna and Child are flanked by saints. Set against a shimmering background, the Virgin Mary and Christ Child gaze upon each other in a composition characteristic of the Renaissance, yet the heavy use of gold and flattened treatment of the figures are reminiscent of the Byzantine style. To either side of the panel are four saints and two angels identified by their accoutrements. Directly below the work is a console painting by Bicci di Lorenzo, which would have supported another painting like the one above. This picture depicts Saint Francis receiving the stigmata, a popular subject for artists in the *quattrocento*, or 1400s. Together the paintings represent a synthesis of late Gothic linearity with the heightened color and realism of the early Renaissance.

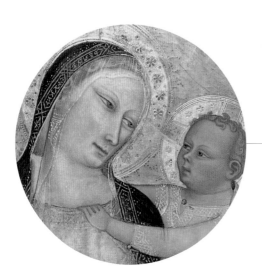

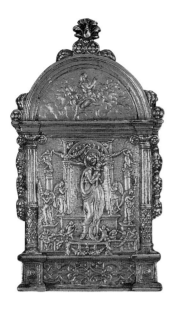

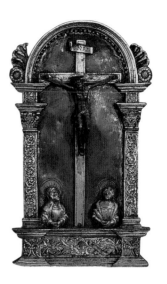

Pax with Virgin and Child in Niche with Putti (left)

Italian (Padua), fifteenth century
Bronze-gilt
7⅝ × 4⁵⁄₁₆ in. (19.4 × 11 cm)
Bequest of John Ringling,
1936, SN7080

Pax with Crucifixion (right)

Italian, sixteenth century, ca. 1525
Bronze-gilt, silver, and copper
6¹³⁄₁₆ × 4¼ in. (17.3 × 10.7 cm)
Bequest of John Ringling,
1936, SN7081

Originally in the twelfth and thirteenth centuries, the pax (meaning peace) was kissed during private devotion. By the fourteenth century, however, the pax had become part of the congregational celebration of the Mass, and symbolized the kiss of peace formerly bestowed directly to the pax. It was traditionally of tablet form, and made of glass, ivory, wood, or precious and gilded metal, as with the two examples shown here.

Andrea della Robbia

Italian, 1435–1525/1528

Madonna and Child, ca. 1490

Glazed terra-cotta in a painted and gilded frame
26⅞ × 19⅝ in. (68.3 × 49.8 cm)
Bequest of John Ringling, 1936, SN1393

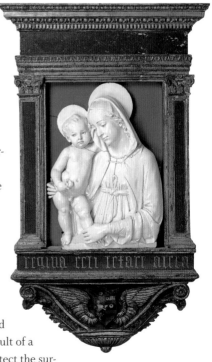

In the fifteenth century, Italian sculptors used much more than stone to create devotional and personal images. Although most equate Renaissance sculpture with Michelangelo's marble work and the bronzes of Donatello, many artists, such as Andrea della Robbia, often used terra-cotta, a less expensive material, to craft smaller images for display in private residences and churches. For this *Madonna and Child*, Andrea would have sculpted the work using soft clay from the Arno riverbed. After the firing process, the white varnish of the figures would have been created by adding tin to a standard glaze, while the blue of the background was the result of a mixture of glaze and cobalt. The colored glazes protect the surface of the otherwise fragile terra-cotta and, in the case of the figures, approximate the appearance of polished marble.

Domenico Ghirlandaio

and workshop

(Domenico di Tommaso Bigordi)
Italian, 1449–1494

*Madonna and Child with Saint John
and Three Angels*, ca. 1490

Oil on panel (tondo)
37 in. (94 cm)
Bequest of John Ringling, 1936, SN20

Domenico di Tommaso Bigordi, called Ghirlandaio—a nickname derived from his father's skill in making garlands—was among the first early Renaissance artists to depict traditional biblical scenes through a contemporary lens. Rather than clothing the Virgin Mary and angels in more classical antique drapery, for example, here Ghirlandaio presents the Madonna as a contemporary matron adorned with fashionable jewels and embroidery. Similarly, the view through the window is an accurate view of Venice, a rather unusual setting for a Florentine painting, suggesting that perhaps the work was commissioned by a Venetian patron. This painting is believed to have been a collaborative effort between Ghirlandaio and his two brothers, Benedetto and Davide, who shared his workshop.

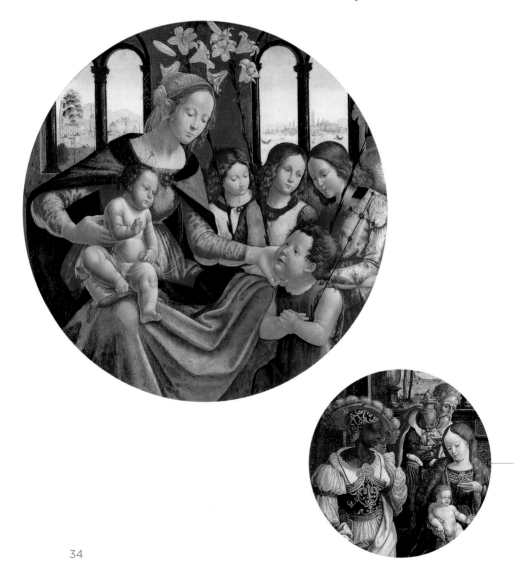

Reliquary Head

German, fifteenth century
Copper-gilt and semiprecious stones
15¾ × 14¹⁵⁄₁₆ in. (40 × 37.9 cm)
Bequest of John Ringling, 1936, SN1099

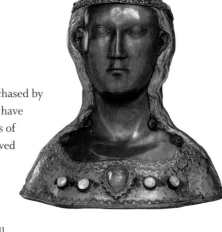

Originally part of the Émile Gavet Collection purchased by
John Ringling in 1928, this reliquary is thought to have
been produced in Cologne, Germany, for the relics of
Saint Ursula. She was a fourth-century saint believed
to have been martyred along with a number of
other young virgins by the Huns in Cologne.
A hinge at the top of the head, nearly disguised
by the flowing arrangement of the hair, indi-
cates that the relic was a portion of the saint's skull.
Another relic may have been contained in the heart-shaped piece of rose quartz
on the chest. The remarkable craftsmanship is testimony to the creator's devotion,
while the inlaid jewel headband and garment and elegant repoussé metalwork indi-
cate that this work was probably commissioned by a prominent individual.

Circle of **Pieter Coecke van Aelst**

Flemish, 1502–1550

Christ Arrested in the Garden of Gethsemane
(left wing), *The Adoration of the Magi* (center),
Christ Carrying the Cross (right wing), ca. 1525

Oil on panel
36 × 40¼ in. (91.4 × 102.2 cm), triptych
Bequest of John Ringling, 1936, SN203

This small portable altarpiece is associated with
the oeuvre of Pieter Coecke, one of the leading
Antwerp painters of the sixteenth century. Like
other triptychs by Coecke, the Ringling panels
feature classical ruins set against a hazy atmo-
spheric landscape. The setting was a staple for
Adoration scenes of the so-called Antwerp
Mannerist painters. In the center panel the
Christ Child is adored by three kings in splendid costume, befitting their position and exotic
origins: Europe kneeling in the foreground, Africa to the left, and Asia to the right. The flanking
panels illustrate scenes from the Passion—the arrest in the Garden of Gethsemane on the left and

the carrying of the cross on
the right—which emphasize
Christ's calm and dignity
amidst the chaotic crowds.
When closed, the altarpiece
reveals a poignant represen-
tation of the Annunciation,
with the angel Gabriel and
Virgin Mary carried out in
grisaille—gray tones that
imitate sculptural relief.

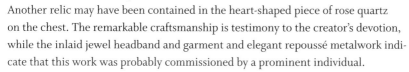

MUSEUM OF ART | PAINTING, SCULPTURE, AND DECORATIVE ARTS

35

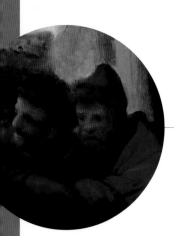

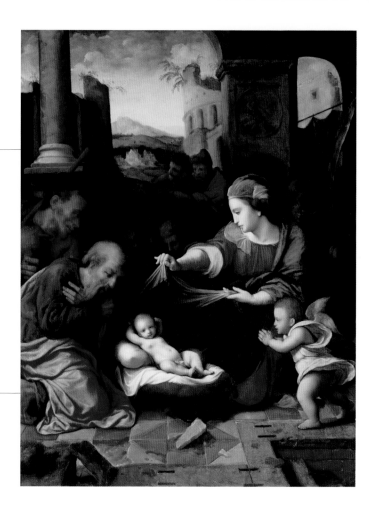

Cornelis van Cleve

Flemish, 1520–1574

Nativity, 1540

Oil on panel
42⅞ × 32⅝ in. (108.9 × 82.9 cm)
Bequest of John Ringling, 1936, SN201

Here a beautiful and serenely profiled Madonna lifts a veil to reveal the Christ Child. The Madonna and Child are rendered more divine than the rest of the group by means of painterly qualities. Their alabaster whiteness contrasts with the ruddier tones of Joseph and the shadowy browns of the gathering shepherds. Although there is no record of the artist having traveled to Italy, this interpretation of the familiar biblical story is clearly indebted to the masters of the Italian Renaissance. Throughout this work van Cleve adopts several Italian conventions: the use of classical architectural elements, the smoky atmospheric background landscape, and dramatic chiaroscuro are all present in this work. Van Cleve references motifs by Italian painters, including Michelangelo, whose *David Beheading Goliath* from a pendentive in the Sistine Chapel can be seen in a roundel above the Virgin Mary, and Raphael, whose *Madonna of the Diadem* (Musée du Louvre, Paris) was among the first to explore the theme of the Madonna of the veil.

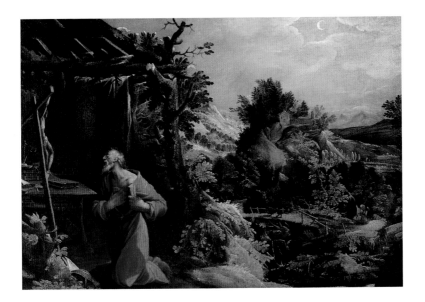

Paul Bril

Flemish, 1554–1626

Saint Jerome in the Wilderness, ca. 1595–1600

Oil on canvas
35 × 49⅝ in. (88.9 × 126 cm)
Museum purchase, SN707

Flemish by birth, Paul Bril moved to Italy in 1575. Inspired by his brother, who had achieved great artistic success at the Vatican, he spent the majority of his career painting in Rome. Although best known for his Arcadian landscapes, here Bril presents us with a work in which a human figure is the key element. Also uncharacteristic is the sense of calm serenity that permeates the scene— Bril's scenes from this period are usually tempestuous. Regardless, the artist imbues the work with a quiet drama and provides a convincing impression of the isolated and pious hermit Saint Jerome. The red mantle, evoking his devotion and piety, captures the viewer's eye, while the nocturnal setting underscores his solitude. Because of his self-sacrifice and ardent devotion to Christianity, Saint Jerome was among the most popular saints of the Counter-Reformation.

Gallery 3 Late Gothic and Renaissance Art in Northern Europe.

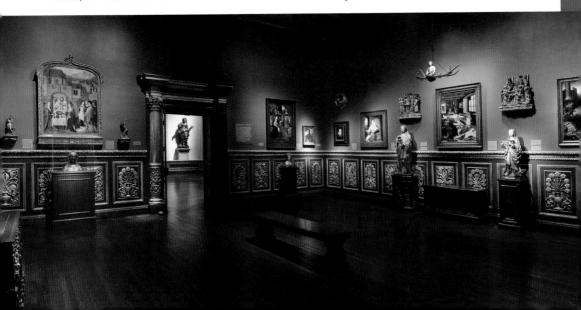

Astronomical Compendium (left)

French (Paris), sixteenth century
Bronze-gilt
2³⁄₁₆ × 3⅝ in (7.1 × 9.2 cm)
Bequest of John Ringling, 1936, SN7078

Astronomical Compendium (center)

German, sixteenth century
Bronze-gilt
2⅞ × 3¹⁵⁄₁₆ in. (7.3 × 10 cm)
Bequest of John Ringling, 1936, SN7064

Miniature Tower Clock (right)

German, sixteenth century, ca. 1575
Copper-gilt, bronze-gilt, silver, and enamel
6⅜ × 3¾ in. (16.2 × 9.5 cm)
Bequest of John Ringling, 1936, SN7067

An astronomical compendium is an instrument used for telling time and performing different astronomical calculations. Most compendia have at least one form of sundial, and often a compass, tables of latitude, and a perpetual calendar. Popular in Germany and France in the sixteenth century, they were usually constructed as extravagantly as possible, with gilt decoration and engraving. The French bronze-gilt drum form case (left) is engraved with a stylized arabesque ornament, the whole raised on three peg feet. This was originally a clock case, the small door being used to access the fusee (pulley) for winding, and was later converted by the addition of a sundial. The German compendium (center) is enclosed within a cast pierced frieze of winged female forms and stylized foliage, and, like the French piece, it was converted with a sundial, the clock mechanism being removed. The German tower clock (right) runs the stackfreed (eccentric wheel), and has a later horizontal silver dial enameled and engraved with a floral and foliate band within a chapter ring of Roman numerals.

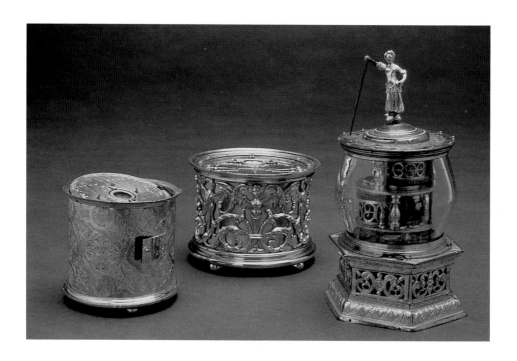

Lucas Cranach the Elder

German, 1472–1553

Cardinal Albrecht of Brandenburg as Saint Jerome, 1526

Oil on panel
45¼ × 35¹⁄₁₆ in. (114.9 × 89.1 cm)
Bequest of John Ringling, 1936, SN308

Lucas Cranach was a devoted follower of the Protestant Reformation's leader Martin Luther, yet he was often commissioned to paint portraits of the Catholic clergy. In this portrait of Cardinal Albrecht of Brandenburg—one of Luther's fiercest opponents—Cranach simultaneously captures the personalities of both the sitter and the saint whose guise he assumes using crisp linearity, deep spatial recession, and rich symbolic content. Jerome was a devout scholar whose fourth-century translation of the scriptures from Hebrew and Greek into Latin became recognized by the church as the official version of the Bible. He was also one of the great fathers of the early Christian church. Cardinal Albrecht appropriates not only the saint's loyal feline companion and costume—seen draped over the table in the foreground—but, more important, also his famed achievement and piety.

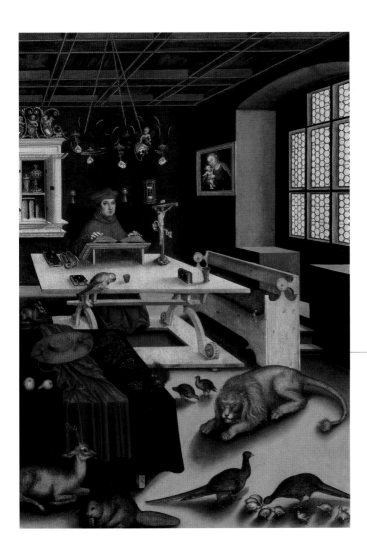

Baccio d'Agnolo

(Bartolommeo d'Agnolo di Donato
Baglione)
Italian, 1462–1543

Throne from the Strozzi Palace, ca. 1511
Carved, inlaid, and gilded woods
(principally walnut)
117 × 102½ × 36¾ in.
(297.2 × 260.4 × 93.3 cm)
Bequest of John Ringling,
1936, SN1514

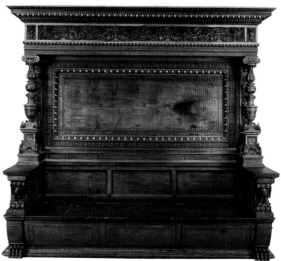

This elaborately carved wooden
throne was likely commissioned to
celebrate the marriage in 1508 of
two prominent Florentine citizens,
Filippo Strozzi and Clarice de' Medici.
Indeed, the motifs from the two
families' insignias—the Strozzi crescents and the Medici
palle, or spheres—are integrated into the elaborate carv-
ing. Designed by Baccio d'Agnolo, a Florentine architect,
the *trono* reflects the façade of a building, with columns on
either side of the bench leading to a decorated frieze and
cornice. The fantastic animal forms and intricate foliage
are reminiscent of the decoration of the Palazzo Medici,
designed by Michelangelo, a friend and contemporary of
Baccio d'Agnolo. Used for storage, the *cassapanca*, or rect-
angular bench at the base of the *trono*, became a popular
furniture design in the fifteenth century.

Gallery 4 Early Renaissance Art in Italy.

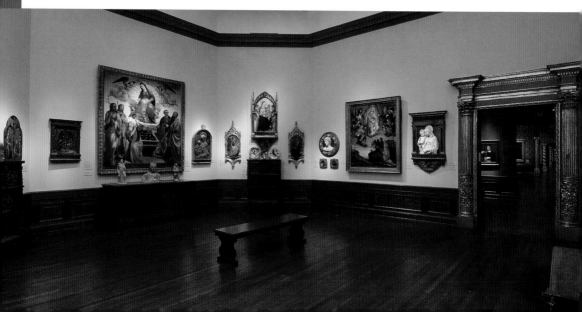

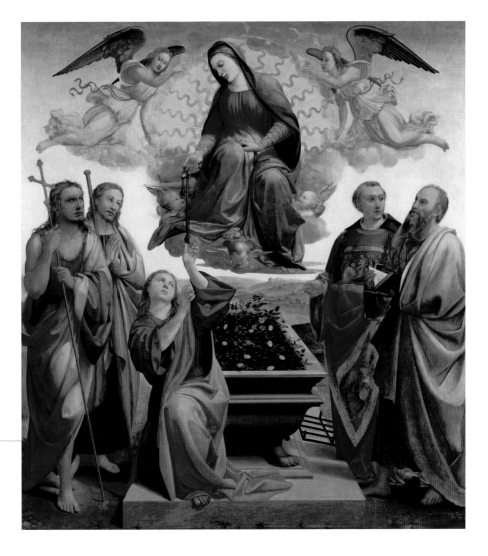

Francesco Granacci

Italian, 1469–1543

The Assumption of the Virgin, ca. 1515

Oil on panel
90 × 81 in. (228.6 × 205.7 cm)
Bequest of John Ringling, 1936, SN24

According to Christian legend, upon
her Assumption the Virgin presented
her belt, or girdle, to Saint Thomas as
proof of the miraculous event. This holy
relic became very popular, particularly
in Florentine art, because it was believed
to be housed in a chapel in the city of
Prato, fifteen miles from Florence. Painted for the Medici Chapel in San Piero
Maggiore, Florence, this altarpiece was highly regarded in its time, even winning
the praise of the great Italian critic Giorgio Vasari. He compared the figure of
Thomas to the hand of Michelangelo in his seminal text *The Lives of the Artists*.
As the Virgin Mary rises toward heaven seated on a throne held aloft by three *putti*,
she gazes down at Thomas, who reaches out for the girdle. Saints John the Baptist,
James, and Bartholomew all witness this holy event with appropriate reverence,
and Saint Lawrence gestures at the tomb where the Virgin's body had rested, now
replaced by a bed of blooming roses—one of her many symbols.

Gaudenzio Ferrari

Italian, ca. 1475/80–1546

The Holy Family with a Donor,
ca. 1520–1525

Oil on panel
58½ × 44 in. (148.6 × 111.8 cm)
Bequest of John Ringling,
1936, SN41

One of the great Italian painters of
the Piedmontese school, Gaudenzio
Ferrari is best known for his eclec-
tic style. He was highly influenced
by artists such as Lorenzo Lotto,
Albrecht Dürer, and more notably
Leonardo da Vinci. Ferrari's art
blends Italian Renaissance natural-
ism with northern Renaissance color
and emotional intensity, creating a
style that is as powerful as it is per-
sonal. Depicting the Christ Child
as a real infant—with his soft flesh
and outstretched arms, calling for
his mother who lovingly gazes upon him—the artist dem-
onstrates both his talent for conveying the human side of
the divine and his indebtedness to Leonardo's precept that
gesture and expression reflect the soul.

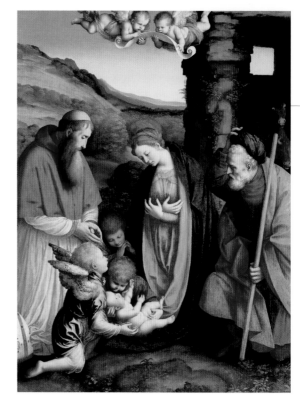

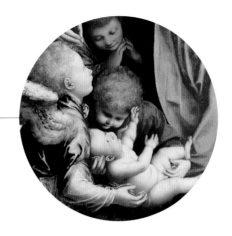

Piero di Cosimo
Italian, 1461/62–ca. 1521

The Building of a Palace, ca. 1515–1520
Oil on panel
32½ × 77½ in. (82.6 × 196.9 cm)
Bequest of John Ringling, 1936, SN22

This painting is thought to relate to a series by Piero di Cosimo illustrating events documenting the evolution of mankind. Here, the mastery of construction techniques has led to the erection of a magnificent palace. Represented in a series of vignettes are numerous craftsmen engaged in the various building trades. As such, it may represent the origins of architecture, or stand as an allegory of the art of building. Whatever the subject or intent, the painting is a clearly an exercise in linear perspective, the artistic technique codified by Leon Battista Alberti in his 1435 publication *De Pictura* (*On Painting*) in which the artist uses an imaginary grid of lines, which converge at a central vanishing point, to achieve proportion and perspectival accuracy.

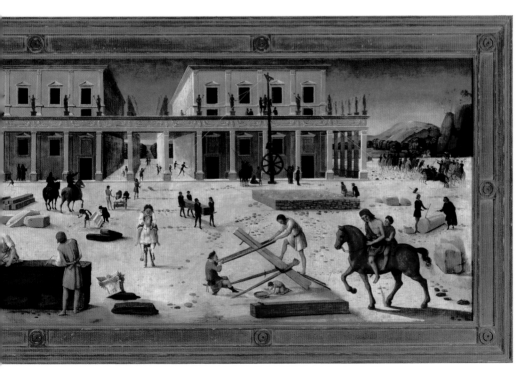

Workshop of **Giorgio Andreoli**
Italian, ca. 1465–1555

Plate with a Dead Child, ca. 1525
Tin-glazed earthenware (maiolica)
10½ in. (26.7 cm)
Bequest of John Ringling, 1936, SN7022

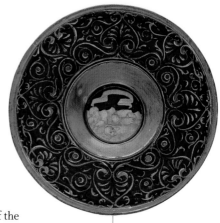

The Ringling collection includes several pieces of maiolica from Gubbio, an artistic center in Umbria known for developing lusters from finely ground particles of metal, based on a technique imported from Spain. The imagery in the center of the dish is possibly a *memento mori,* or a reminder of death, with the sleeping or dead child and skull alluding to the fragility of life. Such elaborately decorated dishes were meant to be commemorative rather than utilitarian. Giorgio Andreoli, a famous potter active in Gubbio, developed new colored lusters, or glazes, including the deep reds and yellows visible in the decorated band surrounding the central scene on the plate.

Attributed to **Alfonso Lombardi**
Italian, ca. 1497–1537

Portrait Bust of an Unknown Man in Armor, ca. 1525–1535
Terra-cotta
22½ × 22¼ in. (57.2 × 56.5 cm)
Bequest of John Ringling, 1936, SN5385

This impressive portrait bust is believed to be the work of Alfonso Lombardi, an Italian sculptor who occasionally collaborated with Michelangelo Buonarroti. Clad in period armor, the sitter is likely a northern Italian patrician—possibly from the Emilia-Romagna region. Embossed with coiled foliate tendrils, a Medusa head on the cuirass, and a lion mask over the right shoulder, the back and breastplate reveal splendid antique ornamentation. The sitter's physiognomy and demeanor similarly recall classical portraiture. The furrowed brow, cropped beard and hair, aquiline nose, and strong posture perhaps indicate that this man anticipated being identified with antique ideologies and morals such as wisdom, decorum, and fortitude.

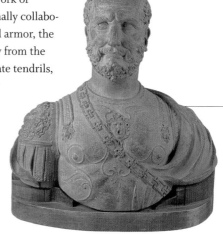

44

Francesco Salviati

(Francesco de' Rossi)
Italian, 1510–1563

Portrait of an Aristocratic Youth,
probably *Gian Battista Salviati,*
ca. 1543–1544

Oil on cradled wood panel
27⁷⁄₁₆ × 19 in. (69.7 × 48.3 cm)
Gift of Mr. and Mrs. E. Milo Greene,
1961, SN733

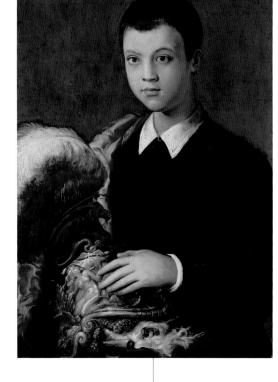

Francesco Salviati, born Francesco de'
Rossi, was one of the great Florentine
Mannerists. Having trained under the
painter Giovanni Bugiardini (a pupil of
Domenico Ghirlandaio) and the Medici
sculptor Baccio Bandinelli, Salviati
developed an artistic style in which his
highly finished painted surfaces had the
effect of bringing his sitters to life. He
soon caught the attention of Cardinal
Giovanni Salviati in Rome and received
his first commission from the cleric,
whose name he later adopted. Although
this sitter was originally thought to represent a child of the
Medici family, he has since been tentatively identified as Gian
Battista Salviati, nephew of Cardinal Salviati. The youth demon-
strates his allegiance to the Medici family by holding a helmet
decorated with symbols of Cosimo de' Medici. Executed in a
distinctly Mannerist style, the subject's skin resembles porcelain
and his fingers are elongated to emphasize sophistication.

Guglielmo della Porta

Italian, ca. 1510–1577

The Deposition, ca. 1555

Gilded bronze
16¾ × 12 in. (42.5 × 30.5 cm)
Bequest of John Ringling, 1936, SN7181

This panel is one of several bronze versions produced after a marble relief by Guglielmo della Porta now in Milan. The design, based on a drawing by Guglielmo in Düsseldorf (Staatliche Kunstakademie), may have been intended for a side altar in Saint Peter's Basilica in Rome, where the artist did most of his work. Born into a family of sculptors, stone masons, and architects, Guglielmo became known for his wide-ranging artistic talents. During his varied and prolific career he was also a restorer, a copier of antiquity (not unusual for the time), a painter, and a metalworker (he took over the Papal mint in 1547). His series of bronze reliefs was especially influential for northern European sculptors in Rome.

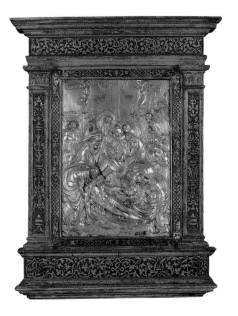

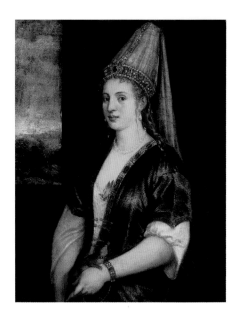

Titian

(Tiziano Vecellio)
Italian, ca. 1485–1576

La Sultana Rossa, ca. 1555

Oil on canvas
38 × 30 in. (96.5 × 76.2 cm)
Bequest of John Ringling, 1936, SN58

The mid-sixteenth-century critic Giorgio Vasari described the sitter of this painting as Roxelana, the wife of Sultan Suleiman the Magnificent, the longest-serving ruler of the Ottoman Empire. Her conical headdress, traditionally worn by royal Ottoman women, is adorned with sapphires, pearls, diamonds, and rubies, and both her turban and robe are woven with gold threads. Despite Vasari's identification and the sitter's elaborate dress, it is more likely that this is a portrait of a young Italian woman who has simply donned the exotic costume for the sitting—a common device of the day. The rich color, painterly style, and poetic treatment of the female form make this work distinctly Titian's. The presentation, too, is typical of Renaissance artists, who often painted their sitters in three-quarter-length profile and employed a dark background in order to isolate the subject in the foreground and expand the visual space into the distance.

Giovanni Battista Moroni

Italian, ca. 1520–ca. 1578

Portrait of Mario Benvenuti, ca. 1560

Oil on canvas
45½ × 35½ in. (115.5 × 90.2 cm)
Bequest of John Ringling, 1936, SN106

Giovanni Battista Moroni was one of the great portraitists of the sixteenth century; he studied with Titian's pupil Alessandro Bonvicino, called Moretto da Brescia. He was often commissioned as an alternative to Titian when patrons could not secure the more famous of the two artists. Here, Moroni depicts his sitter in full armor, underscoring the dignity of his profession. According to the inscription on the marble pedestal, Mario Benvenuti was a military commander under the Holy Roman Emperor Charles V, although nothing more is known about the sitter. The artist frequently included inscriptions to identify his sitters, and the protruding brick wall was among his favorite devices for interrupting the neutral background. Thick daubs of white paint create the gleam of light on the otherwise smooth texture of the armor and lend a fine silvery tonality to the work—an effect that has become Moroni's hallmark.

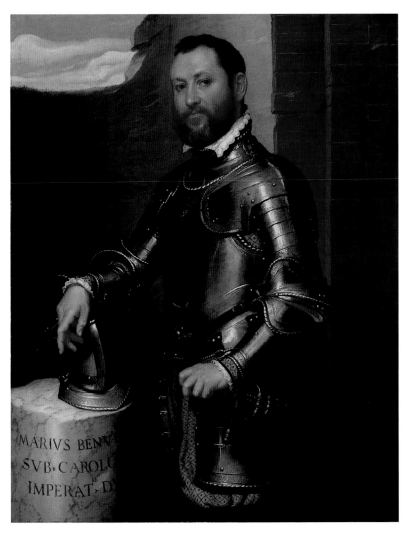

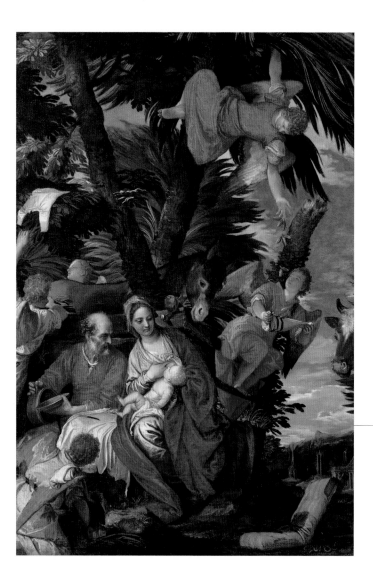

Paolo Veronese

(Paolo Caliari)
Italian, 1528–1588

The Rest on the Flight to Egypt, ca. 1580

Oil on canvas
93 × 63½ in. (236.2 × 161.3 cm)
Bequest of John Ringling, 1936, SN82

One of the great masters of the Venetian school, Paolo Veronese combined rich color with bold brushstrokes in order to create contrasts and patterns that animated his compositions. Here, the artist displays his virtuosic understanding of color theory and brushwork in this idyllic vision of the Holy Family. Perhaps best known for domesticating the biblical, Veronese amusingly shows angels performing mundane household tasks such as drying garments on tree branches. The artist also reveals a sophisticated understanding of how to balance the domestic and the divine. The playfulness of this scene is undercut by references to Christ's eventual death: tree branches crossing above the Virgin's head allude to the cross upon which Christ was crucified, the vessels held by Joseph foreshadow the Eucharistic sacrament, and the palms of the date tree refer to the palms laid down at Jesus' feet upon his return to Jerusalem.

Jacopo Bassano

Italian, ca. 1510–1592

An Allegory of Fire, ca. 1585

Oil on canvas

55 × 71⅝ in. (139.7 × 181.9 cm)

Bequest of John Ringling, 1936, SN86

An Allegory of Water, ca. 1585

Oil on canvas

55 × 71⅝ in. (139.7 × 181.9 cm)

Bequest of John Ringling, 1936, SN87

The Ringling Museum is rich in works by the Bassano family—a family of painters that emerged in the early 1500s and continued in production for the next two generations. In these two allegories, many of the key elements that define sixteenth-century Venetian painting are present: innovative use of color and light, liberated brushwork, and *impasto* (the generous layers of paint on the canvas). Scenes incorporating a variety of peasants and animals were a highly appreciated specialty of the Bassano workshop. In *An Allegory of Fire,* Jacopo depicts a blacksmith's forge with domestic utensils crowding the foreground. In *An Allegory of Water,* the setting is a contemporary fish market. Connecting the allegory to everyday life in sixteenth-century Venice, he shows fishmongers and their buyers bargaining over the most recent catch. A profusion of seafood is disposed throughout while other activities alluding to water, such as boating and washing clothes, are evident in the middle distance.

Leandro Bassano

Italian, 1557–1622

Portrait of a Man, ca. 1585

Oil on canvas
23¾ × 18¼ in. (60.3 × 46.4 cm)
Bequest of John Ringling, 1936, SN91

Leandro Bassano was a member of a family of artists working in the Veneto region surrounding Venice in the 1500s. Although he was trained by his father, Jacopo, Leandro's technique diverges from the dense *impasto* and robust brushstrokes of his father's hand. Rather, his work is based strongly on drawing: he applies finer and smoother strokes, creating a directness and naturalism that inspired the work of later seventeenth-century Italian painters, including Caravaggio and the Carracci. Leandro also introduces a palette largely limited to black, white, and flesh tones, later adopted by Dutch portraitists such as Frans Hals and Rembrandt. Although the sitter is unidentified—except for the inscription at the right that indicates he was twenty-nine years of age at the time the portrait was painted—Leandro has nonetheless communicated both his dignity and his humanity.

Gallery 6 Renaissance Art in Venice and Northern Italy.

Two-Handled Drug Vase

Italian, sixteenth century
Tin-glazed earthenware (maiolica)
14¾ in. (37.5 cm)
Bequest of John Ringling, 1936, SN7161

This two-handled vase is an example of the Faenza workshop, which became the most influential manufacturer of maiolica in Renaissance Italy. It was the custom in Italy to display elaborate services of drug vases in the pharmacies, which were also popular meeting places. The portrait on this vase is set against a hilly landscape, painted with rich color and directness, and framed in a delicately scrolled arch. The elegant vessel is defined by large handles and a sturdy circular base ringed with stylized leafage. At the bottom of the vase, an inscription reads: *Zucar Borrgiudt-Zucaro-Borragino-di-Giulebbe-Distallate* (distillate of borage sugar julep). Faenza drug pots and vases were often decorated with women in contemporary dress.

Another name for a censer in the Western church is a thurible, from the Latin *thuribulum* and the Greek *thyos*, meaning incense. In its design, the censer allows for both controlled burning and the escape of scented smoke. The architecturally inspired censer, which takes the form of a Gothic church, has a cover in the form of two rows of pierced Gothic windows alternating with flying buttresses, which rise to a steepled roof. The spherical censer was probably meant to be used and displayed on an altar. The upper portion is crested with the cast figure of a Roman soldier clad in armor, and opens with a five-part hinge to a cup-lined lower portion. The sphere is cut and pierced with elegant scrollwork and a band of pseudo-cabochon jewels, and raised on an engraved base.

Censer

Italian, fifteenth century
Copper-gilt
12 in. (30.5 cm)
Bequest of John Ringling, 1936, SN7077

Censer

Italian, sixteenth century
Bronze-gilt
9⅝ in. (24.4 cm)
Bequest of John Ringling, 1936, SN7075

Portrait of Giovanna d'Austria

Italian, sixteenth century
Wax relief and copper-gilt case
5⅛ × 3½ in. (13 × 8.9 cm)
Bequest of John Ringling,
1936, SN1443.3

Portrait of a Noblewoman

Italian, sixteenth century
Wax relief and copper-gilt case
6¼ × 4 in. (15.9 × 10.2 cm)
Bequest of John Ringling,
1936, SN1443.4

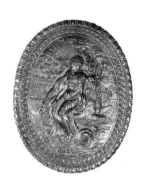

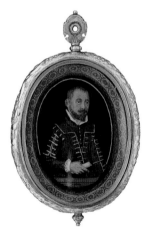

Portrait of Giulio Genuiono

Italian, seventeenth century
Wax relief and copper-gilt case
6¾ × 4¼ in. (17.1 × 10.8 cm)
Bequest of John Ringling,
1936, SN1443.10

Along with an impressive array of decorative arts, painting, and sculpture, John Ringling acquired a group of charming wax portraits in his 1928 purchase of the Émile Gavet Collection. Small and portable, these miniature likenesses were often given as gifts either during the sitter's lifetime or as memorials after death. Such objects were placed in elaborate metal gilt cases and bore inscriptions or dedications, as does the portrait of Giulio Genuiono, a seventeenth-century Neapolitan jurist. Wax modeling had been a common practice for centuries among goldsmiths, sculptors, and architects, who often rendered preliminary, small-scale models in wax of larger works to be made in other media. Many portraits, such as the two depicting Italian noblewomen in elegant costumes, show an acute attention to jewelry, suggesting that the first practitioners of wax portraits were goldsmiths.

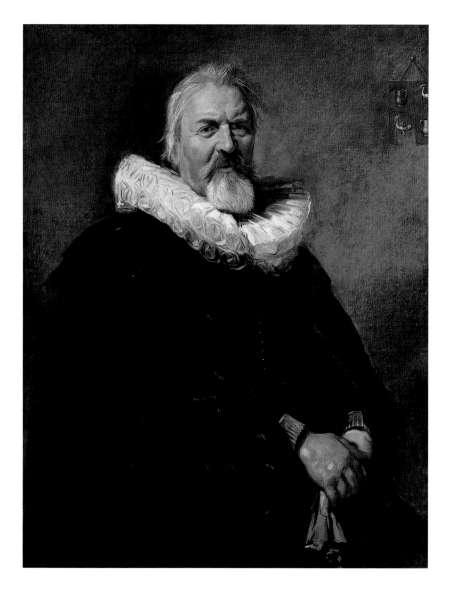

Frans Hals

Dutch, ca. 1581–1666

Portrait of Pieter Jacobsz. Olycan, ca. 1639

Oil on canvas
43¾ × 34⅛ in. (111.1 × 86.7 cm)
Bequest of John Ringling, 1936, SN251

Here, with a seemingly endless variety of tonal nuances, set by a quick brush, Frans Hals portrays Pieter Jacobsz. Olycan, one of Haarlem's leading citizens. A wealthy brewer who served as the city's mayor and a member of the States General governing Holland, Olycan had Hals paint him and his family at least nine times, including a pendant portrait of his wife, Martige, now in the Rijksmuseum, Amsterdam. In the Ringling painting, a rich cloak and opulent collar identify Olycan as a man of power. However, it is the furrow of his brow and slight part of his lips that call attention to the strength of his character. Combined with the rapid brushstrokes of the face and hands, which bring life and spirit to the composition, Hals reveals the elements that made him among the most respected portraitists of his day.

Jan Davidsz. de Heem

Dutch, ca. 1606–1684

Still Life with Parrots, ca. 1645

Oil on canvas
59¼ × 46¼ in. (150.5 × 117.5 cm)
Bequest of John Ringling, 1936, SN289

Although Dutch by birth, Jan Davidsz. de Heem spent most of his artistic career working in the Flemish city of Antwerp. There he became associated with the Baroque style of Rubens and was influenced by the brilliant still lifes of Frans Snyders. Claimed by both the Dutch and Flemish schools, de Heem in fact bridges the gap between the two traditions, combining the opulence and exuberance of the Flemish Baroque with the precision and illusionism of Dutch painting. It has been suggested that this is a *vanitas* painting—a moralizing piece in which objects such as peeled fruit and ticking timepieces serve to remind the viewer of the worthlessness of earthly pleasures and the transience of life. However, it may also reflect the beautiful objects being imported and exported by Holland, the economic epicenter of Europe at the time. Regardless, with his sumptuous colors and illusionistic precision de Heem invites the viewer to simply enjoy this visual feast.

Hendrick Cornelisz. van Vliet

Dutch, ca. 1611–1675

Interior of the Pieterskerk in Leiden, 1653

Oil on canvas
55¼ × 55¼ in. (140.3 × 140.3 cm)
Bequest of John Ringling, 1936, SN288

With its abundance of Gothic churches, Delft became one of the leading producers of paintings of architectural interiors, including this work by Hendrick Cornelisz. van Vliet. Artists such as van Vliet favored small views seen from across the nave with a series of columns dominating the composition, displaying the Dutch fascination with space and illusionism. With their understanding of perspective and artistic precision, the Delft painters were able to convincingly render each scene as "real." These were not, however, completely faithful reproductions, but were often contrived interiors meant to invite the viewer to contemplate their illusion and in so doing reflect upon their potential meaning. The man in the center of van Vliet's painting looks at a freshly dug grave, perhaps contemplating his mortality and the brevity of life, while a woman on the right shows a tomb to a child, suggestive of how time on earth should be spent wisely. Similarly, a group of children play, seemingly unaware of their sacred surroundings, and a dog urinates, perhaps symbolizing an animal's lack of understanding.

Karel Dujardin

Dutch, 1626–1678

Hagar and Ishmael in the Wilderness, ca. 1662

Oil on canvas
73¾ × 56¼ in. (187.3 × 142.9 cm)
Bequest of John Ringling, 1936, SN270

Considered one of the leading Dutch "classicists" who favored subjects from antiquity painted in lively composition, with bold colors, Karel Dujardin is often identified by his use of harmonic colors and idealized physical types for his figures. This was in stark contrast to the muted palette and tonal sensibilities employed by his fellow countryman and contemporary Rembrandt van Rijn. This large-scale work depicts a story from the Old Testament in which an angel appears to save the outcasts Hagar and Ishmael (her son with Abraham) from death in the wilderness where they had been sent at the request of Abraham's wife, Sarah. Rather than depicting the drama of their suffering, however, Dujardin has chosen to show the moment when they have been saved, highlighting Hagar's beauty and serenity.

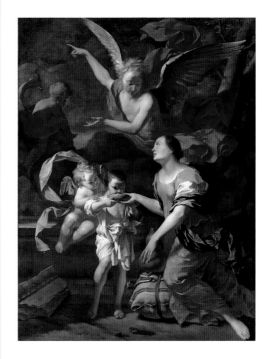

Adam Pynacker

Dutch, ca. 1620–1673

Landscape with Hunters, ca. 1665

Oil on canvas
32¼ × 27¾ in. (81.9 × 70.5 cm)
Museum purchase, 1971, SN896

One of the outstanding Dutch painters of the Italianate style, Adam Pynacker created breathtaking landscapes that took his viewers from darkened corners of the woods to luminescent mountainscapes. Like many landscape painters from Holland, Pynacker traveled to Italy, where he spent three years in Rome and toured the Roman *campagna*. Unlike those of his Dutch countrymen, however, Pynacker's Italian-inspired depictions of nature were rustic and wild, merging northern terrain with the light and atmosphere of Italy. Imaginary views such as this work were popular in Holland, offering their owners an escape from the world of commerce and trade. In this landscape, the artist's wondrous mastery of light and contrast creates a dramatic image as craggy birch and flowering vines play against a golden sky. The white highlights on the tree trunks and leaves in the foreground similarly produce a luminous effect, while the middle and backgrounds are bathed in softer tones.

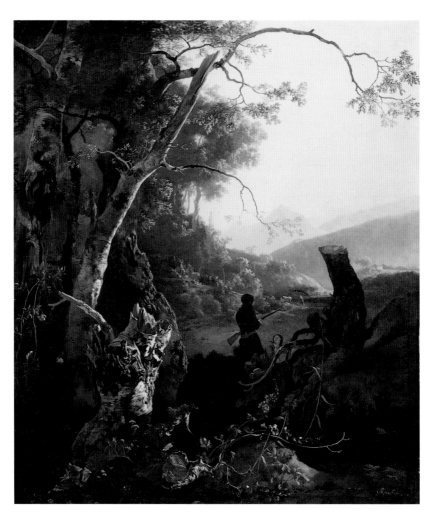

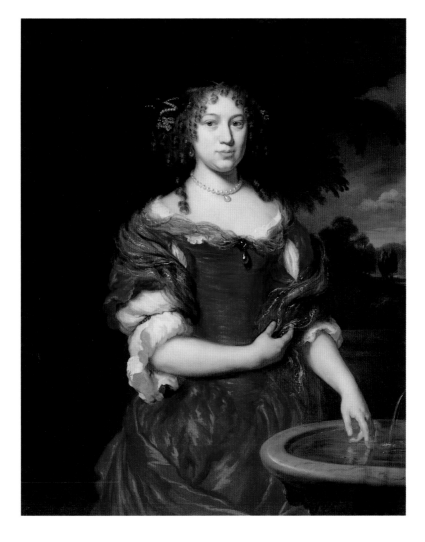

Nicolaes Maes

Dutch, 1634–1693

Portrait of Anna Hofstreek, 1674

Oil on canvas
45¼ × 36¼ in. (114.9 × 92 cm)
Bequest of John Ringling, 1936, SN265

Nicolaes Maes began his career as a pupil of Rembrandt van Rijn, and his early subjects from everyday life display a muted palette with wide, rough brushstrokes. However, by the 1660s he changed his style dramatically. Gaining an increasingly aristocratic clientele, Maes began to specialize in idealized portraiture, employing elegant poses and pastoral landscapes reminiscent of those found in the portraits by Anthony van Dyck. Here, the woman dips her hand in a fountain, enacting an emblematic image of innocence and purity. Maes's delicate brushwork and shimmering highlights accent the luxurious and skillfully rendered textiles and jewels, culminating in a display of prosperity and social identity.

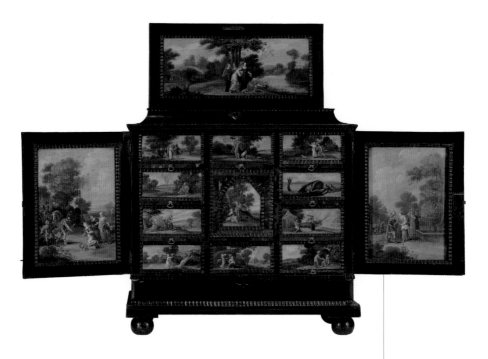

Attributed to **Frans Francken II**

Flemish, 1581–1642

*Cabinet Decorated with Scenes
from the Old Testament,* ca. 1600

Ebony finished wood with oil
on panel decoration
28 × 28¼ × 13¾ in. (71.1 × 71.8 × 34.9 cm)
Museum purchase, 1974, SN1950

During the seventeenth century, especially in
Northern Europe, wealthy patrons began to
build collections of small, precious items, such
as jewelry, miniatures, and relics. Subsequently,
the demand emerged for elegant cabinets to
store and display these treasures. The doors of
this collector's cabinet open to reveal ten small
paneled drawers painted with scenes from the
Old Testament. Behind the central door is a
recess decorated with a typically Dutch black-
and-white checkered floor and mirrored walls
flanked with gilded columns, possibly intended
as a reliquary. The hinged top conceals a storage
well, and a long document drawer is installed
beneath the central compartments. While the
cabinetmaker is unidentified, the paintings have
been attributed to Frans Francken II, an artist
active in Antwerp who was known as a painter
of small cabinet pictures.

Abraham Janssens

(Abraham Janssen van Nuyssen)
Flemish, ca. 1575–1632

*Cephalus Grieving over
the Dying Procris*, ca. 1610

Oil on canvas
49½ × 41¾ in. (125.7 × 106 cm)
Museum purchase, 1999, SN11035

Favoring scenes from history and mythol-
ogy, Abraham Janssens's work is best
characterized as a blend of realism and
classicism in which monumental and
harshly lit figures occupy the extreme
forefront of the picture plane. In this
work, he depicts the climactic moment
of the ancient love story of Cephalus
and Procris as told by Ovid in *The
Metamorphoses*. Cephalus, a great hunter, accidentally killed his beloved Procris one day in
the woods after mistaking her for a wild animal. Here, grief-stricken and horrified, he attends
to his dying wife. The dramatic moment of discovery is heightened by Janssens's use of sharp
lighting, sculptural figures, and a cold, smooth approach to the depiction of human flesh.

Anthony van Dyck

Flemish, 1599–1641

Saint Andrew, 1621

Oil on panel
25½ × 20¼ in. (64.8 × 51.4 cm)
Bequest of John Ringling, 1936, SN227

Anthony van Dyck, once a studio assistant to Peter
Paul Rubens, was only twenty-two years old when he
painted this work. Although many of Rubens's tech-
niques can be found within the younger artist's work,
including the lively brushwork and dramatic lighting,
he nonetheless developed his own personal style. Van
Dyck's unique sensitivity to the subject and gift for
introspection are evident as he captures the moment
prior to the saint's death in which he is overcome
with sorrow and compassion. In addition to tightly cropping the image, van
Dyck uses the play of light and shadow to underscore the saint's psychological
state, illuminating only the face and hands and leaving the rest of the compo-
sition in darkness. Although van Dyck clearly reveled in his ability to handle
paint, he also did not hesitate to leave sections of the painting unfinished,
illustrating the expressive nature of his workmanship.

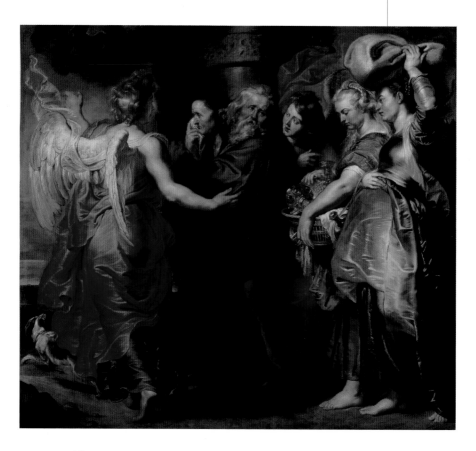

Peter Paul Rubens

Flemish, 1577–1640

*The Departure of Lot and His
Family from Sodom*, ca. 1613–1615

Oil on canvas
86¾ × 96 in. (220.3 × 243.8 cm)
Bequest of John Ringling, 1936, SN218

In this Old Testament scene from the book of Genesis, Lot and
his family are led by angelic messengers away from their home in
the sinful city of Sodom before it is destroyed by God. In this work,
Peter Paul Rubens displays his mastery of gesture, facial expression,
and emotion. The family's suffering is made palpable when looking at
the figure of Lot, who struggles against the angel's guidance, unable
to turn away from his home. Vibrant draperies and brilliant effects
of light offer a counterpoint to the sorrow and adversity of the event.
All the activity and sentiment associated with the family's depar-
ture from Sodom is brought together in a wonderful combination
of elegant poses and rich colors.

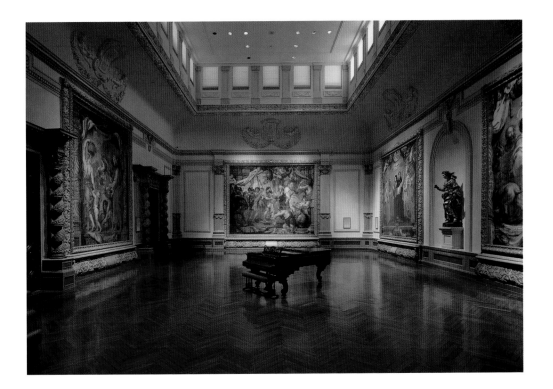

The Triumph of the Eucharist

Peter Paul Rubens was one of the greatest painters of the seventeenth century, and his art came to define the splendor and style of the High Baroque. He had major commissions from almost every Catholic country in Europe, and his artistic genius found consummate expression in the Triumph of the Eucharist cycle. Rubens's royal patron, Isabella Clara Eugenia (1566–1633), Infanta of Spain and Portugal, Archduchess of Austria, and the daughter of King Philip II of Spain, wanted a series of tapestries on the subject of the Eucharist for the Convento de las Descalzas Reales in Madrid. Commissioned around 1625, the cycle relates to the celebration of the Eucharist or Mass in the Roman Catholic Church.

The cycle's eleven (and possibly as many as sixteen) paintings illustrate a religious epic comprising Old Testament prefigurations, allegorical victories of the sacrament over paganism and heresy, groups of evangelists and saints defending the Eucharist, and triumphal processions of Faith, Divine Love, and the Church. The Ringling Museum owns five of the original cartoons (full-scale mirror compositions painted on canvas) produced by Rubens and his studio to be copied by the weavers at the tapestry manufacturer.

The original set of tapestries commissioned by the Infanta remains in the convent in Madrid; however, the painted cartoons were dispersed after her death in 1633. In 1818, the Duke of Westminster purchased four of the cartoons for Grosvenor House in London, and it was from the Duke's descendants that John Ringling bought them in 1926. *The Triumph of Divine Love* was acquired separately by the Museum in 1980. These works represent the only extant large-scale painting cycle by Rubens outside of Europe.

Peter Paul Rubens

Flemish, 1577–1640

The Triumph of Divine Love, ca. 1625

Oil on canvas
152 × 204 in. (386.1 × 518.2 cm)
Museum purchase, 1980, SN977

In its rich colors and expressive brushwork set within a dynamic space, *The Triumph of Divine Love* illustrates the essence of Rubens's art. In it, surrounded by a halo of flying *putti*, Charity, the personification of Love, stands on a chariot drawn by two lions and holds a small child in her arms, recalling tender images of the Virgin and Infant Christ. Although it is the least explicit of the Ringling's Eucharist images—the only precise reference to this theme is the pelican piercing its breast to feed its young, symbolizing both Christ's sacrifice and the Catholic dogma of transubstantiation—*The Triumph of Divine Love* offers a balance between devotion and propaganda. The *putti* display various symbols of sacred (divine) and profane (natural) love; and the underlying theme of the triumph over heresy can be found in the *putto* who crouches below the chariot, setting his torch to the intertwined snakes, symbols of sin and evil.

Peter Paul Rubens

Flemish, 1577–1640

The Meeting of Abraham and Melchizedek, ca. 1625

Oil on canvas
175¼ × 224¾ in. (445.1 × 570.9 cm)
Bequest of John Ringling, 1936, SN212

In this, the largest cartoon of the Eucharist
cycle, we see depicted a passage from the
Old Testament book of Genesis (14:17–24)
in which the victorious general Abraham
returns from his victory over the four
kings and is welcomed by the High Priest
Melchizedek, who offers him bread and wine
for his exhausted army. In return, the patriarch
gives the high priest a tithe from the spoils gained in
battle. The presentation represented here is a prefigura-
tion of the Eucharist. Rubens has placed Melchizedek on an altar-like
landing deliberately to mimic the pose of a priest at Mass while young
men assist with the distribution of bread. Above their heads Rubens
has included a garland of fruit with bunches of grapes, which, together
with the gold and silver containers of wine and the basket of bread
below, provide yet another liturgical symbol.

Peter Paul Rubens

Flemish, 1577–1640

The Gathering of the Manna, ca. 1625

Oil on canvas
192 × 162 in. (487.7 × 411.5 cm)
Bequest of John Ringling, 1936, SN211

This subject, taken from the Old Testament book of Exodus (16:13–36), represents the miraculous feeding of the Israelites during their forty-year journey through the wilderness to Canaan. According to the story, manna, pictured here as white pellets, fell from heaven each morning, providing a bread substitute for the Israelites to eat along with flocks of quail that came in the evening. Rubens shows Moses at the right in a red robe, dramatically raising a hand to the sky as if to summon the precious substance from Heaven, while a woman and man carry baskets brimming with manna, and others gather the food as it falls. Like the bread and wine offered to Abraham by Melchizedek, the manna foreshadows the Catholic sacrament of the Eucharist. Invoking the drama of the Baroque, Rubens conceived the series to be a tapestry within a tapestry: the scene is suspended by two *trompe l'oeil* ropes, "hung" between Solomonic columns, and appears to spill over the bottom apron of the stage.

Peter Paul Rubens

Flemish, 1577–1640

The Four Evangelists, ca. 1625

Oil on canvas
173 × 176 in. (439.4 × 447 cm)
Bequest of John Ringling, 1936, SN213

The institution of the Eucharistic sacrament at the Last Supper was recorded by the evangelists in the New Testament gospels. Here, Rubens harnesses the theatricality of the Baroque by presenting his figures in a procession that underscores the significance of this doctrinal subject. At the far left is Luke, identified by the ox, a traditional symbol of sacrifice. Mark stands next to him with his gospel under one arm and a lion at his side, representing the Christ of the Resurrection. Near the center of the composition is Matthew, and above him, the angel who provided the divine inspiration for his writing. Beside him is John, who gazes up at the eagle, thought to be able to look directly into the sun, paralleling John's vision of the Apocalypse. At the front of the stage are a dolphin, shell, and cornucopia, symbols of the influence of the evangelists over land and sea, and the abundance that the gospels offer to humankind.

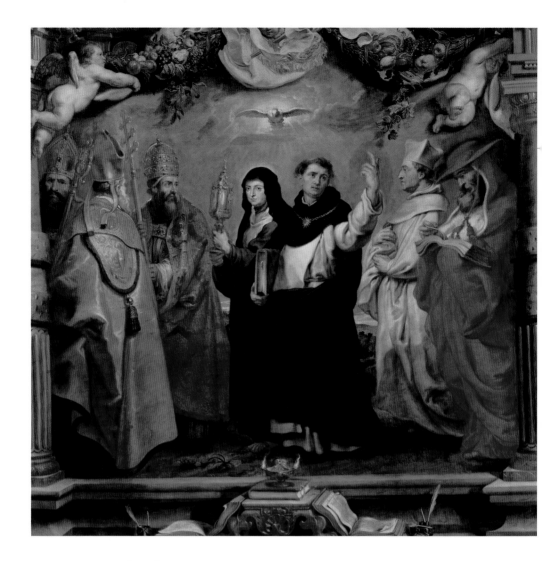

Peter Paul Rubens

Flemish, 1577–1640

The Defenders of the Eucharist, ca. 1625

Oil on canvas
171 × 175 in. (434.3 × 444.5 cm)
Bequest of John Ringling, 1936, SN214

In this grand display of color and light, Rubens has depicted seven saints from the history of the Catholic Church. At the left, Saints Augustine, Ambrose, and Gregory the Great are pictured in elaborate copes and miters, while at the center we see Saint Clare holding a monstrance, which displays a consecrated communion wafer, and dressed in the habit of the Poor Clares —the female branch of the Franciscan Order. Rubens has painted Saint Clare as the Eucharist series' great patroness, the Infanta Isabella Clara Eugenia (the Eucharist commission was conceived to decorate the Convent of the Discalced Clares in Madrid and Saint Clare is among the Infanta's patron saints). Beside her is Saint Thomas Aquinas, who gestures upward to a dove, the symbol of the Holy Spirit; Saint Norbert, a German bishop saint; and Saint Jerome, who holds the Latin Bible, known as the Vulgate, which he translated. Below the apron of the stage is a burning lamp surrounded by books, ink pots, and quill pens, all referencing the writings of the Church fathers.

Peter Paul Rubens

Flemish, 1577–1640

Portrait of Archduke Ferdinand, 1635

Oil on canvas
45¾ × 37 in. (116.2 × 94 cm)
Museum purchase, 1948, SN626

Peter Paul Rubens was one of the most versatile and influential artists of the seventeenth century. As a painter he produced numerous altarpieces, historical and mythological scenes, landscapes, and portraits. In this work, Rubens presents us with the Infante Ferdinand, the younger brother of King Philip IV of Spain. Ferdinand assumed the governance of the Southern Netherlands upon the death of his aunt, the Archduchess Isabella Clara Eugenia of Spain (who commissioned the Triumph of the Eucharist series). After spending considerable time at the royal palace in Madrid, Rubens became very familiar with Titian's portraiture and often turned to the Italian artist for inspiration. In addition to his daring use of color and dynamic brushwork, Rubens was also influenced by Titian's mastery of psychological characterization. Here he has shown Ferdinand in direct visual contact with the viewer. This resolute gaze combined with the military costume presents Ferdinand as both a sophisticated and confident leader— no doubt a tribute to his recent military victory over the King of Sweden at Nördlingen in 1634.

Nicolas Régnier

Flemish, ca. 1590–1667

*Saint Matthew and
the Angel*, ca. 1625

Oil on canvas
42½ × 48¾ in. (108 × 123.8 cm)
Bequest of John Ringling,
1936, SN109

Born in Flanders near the French
border, Nicolas Régnier studied
in Antwerp under Abraham
Janssens, from whom he most
likely acquired his taste for large-
scale figures and statuesque con-
tours. He then moved to Rome
around 1615 and worked in the
workshop of Bartolomeo Manfredi, a pupil of Caravaggio. There he began to develop the
artistic techniques that would shape his career, including the tenebrist (or shadowy) man-
ner, half-length format, and lifelike figures. In this work, Régnier depicts the angel guid-
ing Matthew's pen across the page, as if the apostle were a scribe taking dictation from the
divine messenger. Juxtaposing passages of light and dark lend a sense of mystery and spiri-
tuality to the scene, while the naturalistic depiction of Matthew anchors this earthly event.

Influenced by his mentor
Pieter Brueghel the Younger
and close friend Peter Paul
Rubens, Frans Snyders's art is
varied and bold. Although his
early works focus primarily
on floral and fruit arrange-
ments, Snyders became one
of the finest animal painters
of his day. Here, exquisitely
rendered peacock and swan
feathers intermingle with
luscious fruits and other
spoils of the hunt while a cat

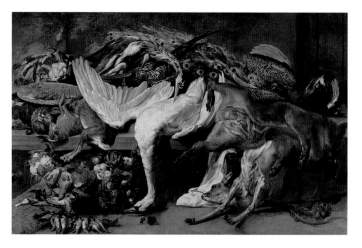

patiently waits underneath the table for its opportunity
to steal a treat from the bountiful stock. This impres-
sive, large-scale depiction is emblematic not only of
Snyders's artistic style and virtuosic understanding
of color and line, but also of numerous seventeenth-
century patrons who often commissioned works that
would reflect their own wealth and prosperity.

Frans Snyders

Flemish, 1579–1657

Still Life with Dead Game, ca. 1625–1630

Oil on canvas
66⅜ × 103 in. (168.6 × 261.6 cm)
Bequest of John Ringling, 1936, SN234

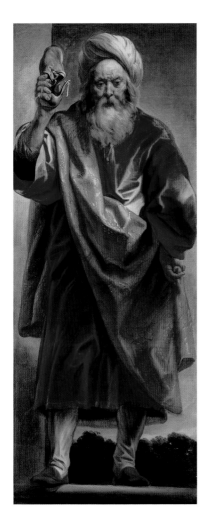 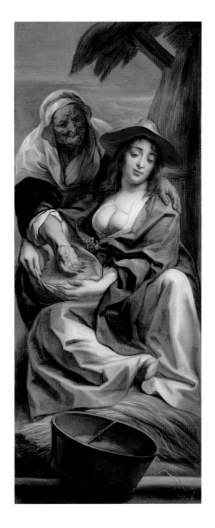

Jacob Jordaens

Flemish, 1593–1678

Boaz, ca. 1641

Oil on canvas
76½ × 30¼ in. (194.3 × 78.1 cm)
Museum purchase, 1984, SN987

Ruth and Naomi, ca. 1641

Oil on canvas
76½ × 30¼ in. (194.3 × 78.1 cm)
Museum purchase, 1984, SN988

The subject of these two works by the Flemish painter Jacob Jordaens draws from the Old Testament book of Ruth. According to the text, Ruth was a beautiful young woman fiercely devoted to her family. Upon her husband's death, she moved with her mother-in-law Naomi to the Bethlehem area, and, in order to keep from starving, she worked the land of Naomi's relative Boaz. Impressed with her good conduct and fidelity, Boaz began to court her with gifts of grain from his fields and later presented his shoe to her, a traditional gesture signifying the proposal of marriage. In these companion pieces Jordaens shows his indebtedness to Rubens, with whom he occasionally collaborated. He utilizes Rubens's signature brushwork and lively colors in conjunction with his own understanding of physiognomy and lighting. Based on the size of the figures and steep illusionistic perspective, these paintings were most likely originally installed above a doorway or flanking a window.

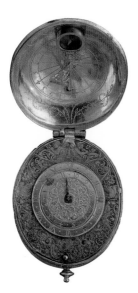

M. Beron

French (Angers), active ca. 1627

Oval Saddle Watch, ca. 1630

Copper-gilt and silver
3⅛ × 2 × 1¼ in. (7.9 × 5.1 × 3.2 cm)
Bequest of John Ringling, 1936, SN1436.7

Cruciform Pendant Watch

German, seventeenth century, ca. 1625–1650
Rock crystal, enameled gold
2½ × 1⁹⁄₁₆ × ¹⁵⁄₁₆ in. (6.4 × 4 × 2.4 cm)
Bequest of John Ringling, 1936, SN1436.1

In the fifteenth and sixteenth centuries, the boom in maritime exploration and advances in science and technology, such as Galileo's discovery of the properties of the pendulum, created the foundation for the invention of portable timepieces. German and French watchmakers initiated the trend, creating small, decorative pocket watches worn on a chain around the neck or suspended from the belt. Cases were pierced in elaborate patterns to allow the wearer to hear the striking of the movement, and covers were often made of rock crystal to allow the dial to be seen without the case being opened. The saddle watch is molded into an oval shape, a popular design in the early seventeenth century. In subsequent decades, faceted or lobed crystal shapes came into vogue, as illustrated by the cruciform pendant watch. Ringling acquired his collection of elaborately ornamented timepieces when he purchased the Émile Gavet Collection from Alva Vanderbilt Belmont in 1928.

Simon Vouet

French, 1590–1649

Time Discovering the Love of Venus and Mars, ca. 1640

Oil on canvas
57½ × 42½ in. (146.1 × 108 cm)
Bequest of John Ringling,
1936, SN360

Trained in Italy, Simon Vouet returned to his native France to become court painter to King Louis XIII. His treatment of light and approach to the composition respond to the spirit of the Caravaggesque; however, his palette of warm blues, golds, and greens reveals his roots and response to the French style in the seventeenth century. As recounted by the ancient Roman writer Ovid in *The Metamorphoses*, Venus was married to the disfigured Vulcan. She later had an affair with Mars, the god of war, that resulted in the birth of Cupid. Suspecting her infidelity, Vulcan set a trap for the lovers, and they were literally caught in the act with the help of Chronos. Vouet shows the winged Chronos, who is the personification of time (with sickle in hand), at the left, holding the net that has ensnared Cupid. At the center of the composition is Venus, who looks at Mars while caressing his face. The helmeted Mars returns her gaze with a frown in this moment of embarrassment and anger.

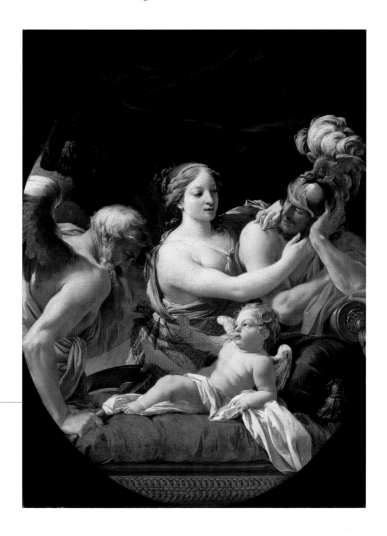

Nicolas Poussin

French, 1594–1665

The Ecstasy of Saint Paul, 1643

Oil on panel
16⅜ × 11⅞ in. (41.6 × 30.2 cm)
Museum purchase, 1956, SN690

In this painting, Nicolas Poussin faced the tasks of flattering his major patron, Paul Fréart de Chantelou, and competing with the celebrated Renaissance artist Raphael. Chantelou owned Raphael's *Vision of Ezekiel* and intended to hang Poussin's painting next to the earlier work. The figure of Paul was intended to complement the figure of Ezekiel, the Old Testament prophet, and to honor the artist's patron. The subject of the *Ecstasy of Saint Paul* is inspired by Paul's Second Letter to the Corinthians, in the New Testament. In one passage, Paul hears words not spoken by humans and he is raised up by angels to the third heaven. In ecstasy, Paul spreads his arms and gazes upward. This is a small painting, yet the artist is able to convey the mysticism and the spirituality of the subject. The blue sky that surrounds the figures retains a mystical light and consumes the entire panel, leaving only a discreet reference to the landscape at the bottom of the composition.

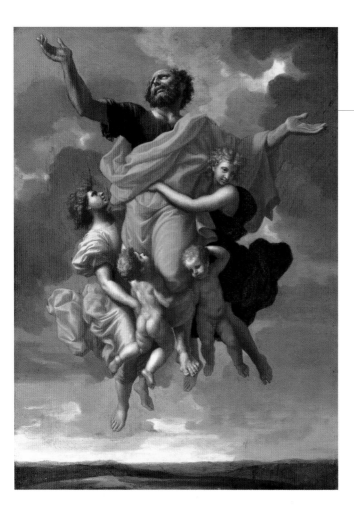

Nicolas Poussin

French, 1594–1665

The Holy Family with the Infant Saint John the Baptist, 1655

Oil on canvas
78¼ × 51½ in. (198.8 × 130.8 cm)
Bequest of John Ringling, 1936, SN361

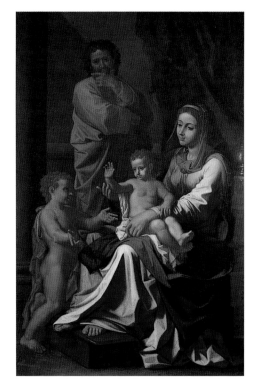

Nicolas Poussin's greatest contribution to seventeenth-century painting was his ability to combine dramatic narrative and human expression within a balanced composition. He also succeeded in creating a structure for the spiritual and the human in art. The statuesque figures of the Holy Family are examples of Poussin's late style, called the "Magnificent Manner." In this phase of his career, the artist continued to look to classical sculpture for models while embracing a nearly abstract geometry in his compositions. There is solidity to the sculptural group, and a profound sense of balance. At the same time, the artist has still managed to convey the tender expression of the Madonna and Child, and the gentle interplay between Christ and John: John who knows and recognizes him as the savior. Resting on Mary's lap, the Christ Child majestically raises his hand to bless John as Joseph looks on in the pose of a Greek philosopher.

Claude Jacquet

French, active after 1632–d. 1661

Harpsichord, 1652

Carved, painted, and gilded wood
35¼ × 89¼ × 32¼ in. (89.5 × 226.7 × 81.9 cm)
Bequest of John Ringling, 1936, SN1108

The Ringling Museum owns one of the earliest French harpsichords found in public collections in North America. The side panels of the case are decorated with figures in classical costume surrounded by scrollwork, painted in the monochromatic technique known as *grisaille*. The lid opens to reveal an idyllic landscape with Apollo, the god of music, pursuing Daphne. To the left is a design consisting of portrait heads in oval and circular medallions, interspersed with elaborate scrollwork. Though little is known about the maker, Claude Jacquet managed a Parisian studio devoted to the production of instruments for both the aristocracy and prominent musicians. The gilded stand, a later piece, is carved separately from the case and is decorated in the ornate Louis XV style.

Jean Tassel

French, 1608–1667

The Judgment of Solomon, ca. 1650

Oil on canvas
31¾ × 25½ in. (80.6 × 64.8 cm)
Museum purchase, 1957, SN702

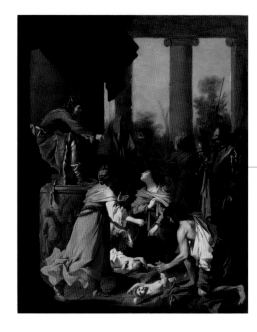

Jean Tassel was in Rome in 1634, where
he associated with Nicolas Poussin and
Sébastien Bourdon. He also absorbed
the sculptural forms of Raphael and
the chiaroscuro of Caravaggio, fusing
them in this depiction of the Judgment
of Solomon, a scene from the bibli-
cal First Book of Kings. According to
the story, one woman, upon the death
of her child, had abducted the baby
of another mother, who woke up to
find the dead infant in place of her own. Here, both women argue before Solomon,
who judges that the child still living should be cut in half and divided between the
women. The true mother pleads with Solomon, and her child is returned to her.

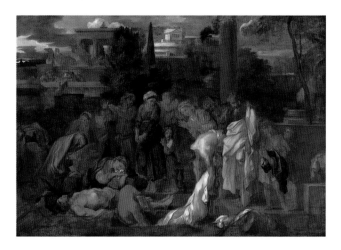

Sébastien Bourdon

French, 1616–1671

Burying the Dead
(from The Seven Acts of Mercy),
ca. 1660

Oil on canvas
48½ × 68⅜ in. (123.2 × 173.7 cm)
Bequest of John Ringling,
1936, SN372

In 1648, Bourdon became
one of the twelve *anciens* of
the Académie royale, which
helped to secure his place
in the history of French
academic painting along with artists like Charles Le Brun and Nicolas Poussin. Bourdon's
mature work, including the seven paintings that make up The Seven Acts of Mercy series
in the Ringling Museum, incorporates many of the compositional and stylistic elements
developed during his Roman years in the 1630s. However, these works also reflect the
classicizing style he adopted from his French contemporaries. In the *Burying of the Dead*
from the series, Bourdon depicts the scene where Tobit buries those slain by the Assyrian
King Sennacherib, as recorded in the Apocryphal book of Tobit. The antique dress and
poses of the figures, presented in a frieze-like arrangement, as well as the idealized archi-
tectural landscape, are evidence of the French Classical style that Bourdon embraced.

Johann Liss

German, 1597–1631

The Vision of Saint Jerome, ca. 1625

Oil on canvas
80¾ × 61¾ in. (205.1 × 156.8 cm)
Bequest of John Ringling, 1936, SN311

One of many northern painters inspired by the rich tradition of Venetian painting, Johann Liss achieved renown in his day for his fluid brushwork, brilliant palette, and dynamic compositions. This altarpiece is likely the first of several versions of a famous work by Liss, the best known of which is in the Venetian church of San Nicolò Tolentino. In it, Saint Jerome, the fourth-century scholar who translated the Bible into Latin, is shown receiving angelic messengers who point to the heavenly source of his inspiration while guiding his hand. The lion, Saint Jerome's faithful companion, hides beneath his feet in a frenzied swirl of earthy reds, browns, and blacks. The elaborate composition is made cohesive through the placement of figures and drapery as well as in the decorative massing of clouds and sky.

Francesco Albani

Italian, 1578–1660

Saint John the Baptist in the Wilderness, ca. 1600

Oil on copper
19⅜ × 14⅝ in. (49.2 × 37.1 cm)
Bequest of John Ringling, 1936, SN115

Francesco Albani began his career in Rome as Annibale Carracci's assistant, adopting his master's predilection for situating his works in impressive landscapes. For centuries, the subject of Saint John the Baptist in the wilderness, where the saint lived in seclusion until emerging to perform baptisms in the Jordan River, had provided artists with an opportunity to showcase their skills in landscape painting. Dating to his stay in Rome from 1601 to 1617, this work is painted on copper—a popular support for smaller cabinet paintings in the sixteenth and seventeenth centuries. Because of the rise of printmaking, metal plates used for etchings and engravings were increasingly common materials in artists' studios, and the luminosity afforded by copper enticed many artists to use it as a support in lieu of a canvas or wood panel.

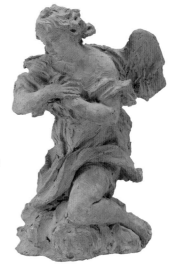

This small terra-cotta angel is a *bozzetto*, or study, for a large-scale marble sculpture that was designed for the high altar of the Church of Sant'Agostino in Rome. Bernini's studio assistant, Giuliano Finelli, exe-

Studio of
Gian Lorenzo Bernini
Italian, 1598–1680

Kneeling Angel, ca. 1626

Terra-cotta
6½ × 10½ × 6½ in.
(16.5 × 26.7 × 16.5 cm)
Museum purchase, 1960, SN5445

cuted this work, although the master was responsible for the design and, as the contractual party for the commission, Bernini received credit for it. The agitated drapery and sense of movement are typical of Bernini's works. His sweeping, dramatic style epitomized the High Baroque, and he was responsible for some of the most important sculptures and monuments of seventeenth-century Rome. Bernini was the favorite artist of Pope Urban VIII and subsequent popes. He designed such Roman landmarks as the colonnade of Saint Peter's Basilica and the marble sculptural group of *Saint Teresa in Ecstasy* in Santa Maria della Vittoria.

Bernardo Strozzi
Italian, 1581–1644

An Act of Mercy: Giving Drink to the Thirsty, ca. 1618–1620

Oil on canvas
52¼ × 74⅝ in. (132.7 × 189.5 cm)
Museum purchase, 1950, SN634

Bernardo Strozzi primarily painted religious works, having spent twelve years in a Capuchin monastery. After Caravaggio, in 1607, devoted an entire canvas to the Seven Acts of Mercy, as described in the Gospel of Matthew, they became a popular subject among Italian artists in the seventeenth century. Rather than depicting all seven acts in one painting, Strozzi painted an insular group illustrating the charitable act of giving drink to the thirsty. In this work, the figure to the right grasps a chipped cup, revealing his dirty fingernails. The presence of unidealized details such as mottled flesh and dirty hands reflects the growing interest in naturalism among artists in Italy. Strozzi's palette, which includes acid greens and lively pinks, reveals his debt to the central and northern Italian Mannerists of the late sixteenth century. The bold brushstrokes and *impasto*, clearly visible in the costumes, betray his northern Italian roots.

The Apocryphal book of Judith tells the story of the Jewish woman who seduced and killed the Assyrian general Holofernes, preventing him from ravaging the city of Bethulia. Dressed in fine clothes and expensive jewels, Judith beguiled the unsuspecting Holofernes and beheaded him with the help of her maidservant, Abra, once she had enticed him into his tent and away from his guards. Judith's inscrutable expression has been interpreted as pride or, alternatively, shock. Francesco del Cairo depicts the heroine as a simple young girl in an elaborate costume and headdress. The influence of Caravaggio is visible in the chiaroscuro and in the representation of biblical figures as ordinary people dressed in dramatic costumes. A celebrated court painter in Turin, del Cairo frequently painted dark biblical and historical subjects that bordered on the macabre.

Francesco del Cairo
Italian, 1607–1665

Judith with the Head of Holofernes, ca. 1630–1635

Oil on canvas
46⅞ × 37⅛ in. (119.1 × 94.3 cm)
Museum purchase, 1966, SN798

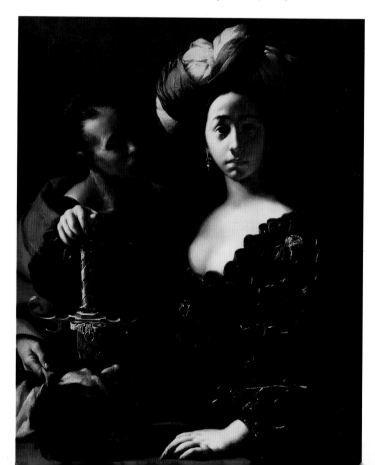

Guercino

(Giovanni Francesco Barbieri)
Italian, 1591–1666

The Annunciation, 1628–1629

Oil on canvas
76¼ × 108¾ in. (193.7 × 276.2 cm)
Bequest of John Ringling, 1936,
SN122

This immense painting was originally installed over a sanctuary arch in the Church of Santa Croce in Reggio Emilia, near Bologna. Each section contains a single monumental figure, approximately four times life-size. To the left, the Archangel Gabriel comes forward to present the Virgin Mary with a branch of lilies. The Annunciation—the moment at which Gabriel announces to Mary that she will bear the son of God—was often conceived as a work divided into two parts. Guercino's monumental religious paintings and ceiling frescoes, executed with striking illusionism, are some of the finest examples of the Baroque period. His Bolognese patron, Cardinal Alessandro Ludovisi, was elected Pope Gregory XV in 1621. Guercino followed him to Rome, where he came under the influence of the classicizing Annibale Carracci. This work, painted five years after his stay in Rome, is a synthesis of Baroque drama and Classical serenity.

Gallery 8 Baroque Art in Italy.

Mattia Preti

Italian, 1613–1699

Herodias with the Head of Saint John the Baptist, ca. 1635

Oil on canvas
47¼ × 67½ in. (120 × 171.5 cm)
Museum purchase, 1985, SN990

Mattia Preti presents a terrible scene told in the Gospels of Mark and Matthew in a chillingly calm fashion. Salome holds the decapitated head of John the Baptist, which she had requested of her stepfather King Herod. Her mother, Herodias, presents it to a group of onlookers, including the king. This work dates to the artist's training and early career in Rome, where he adopted the tenebrism and realistic depiction of figures made popular by Caravaggio in the seventeenth century. Later, Preti traveled throughout Italy and experimented with a variety of styles, including the classicism of Guercino and Nicolas Poussin. In 1641, Pope Urban VIII nominated Preti as a Knight of Malta, and the artist settled on the island permanently in 1661.

Pietro da Cortona

(Pietro Berrettini)
Italian, 1596–1669

Hagar and the Angel, ca. 1637–1638

Oil on canvas
45 × 58¹³⁄₁₆ in. (114.3 × 149.4 cm)
Bequest of John Ringling, 1936, SN132

Though Pietro da Cortona is known as one of the greatest practitioners of the dynamic High Baroque style, this scene from the book of Genesis is strikingly serene. When Abraham's wife Sarah could not become pregnant, she offered Abraham her Egyptian servant Hagar, who then bore a son, Ishmael. Later, Sarah gave birth to Isaac and requested that Abraham banish both Hagar and Ishmael into the wilderness. About to die of thirst, the bondswoman and her son were miraculously rescued by an angel, who directed them to a well. Pietro da Cortona has chosen to represent the climactic moment of the story, when the angel appears and directs the suffering outcasts to a nearby well, restoring them to health. However, despite the drama of the narrative, he depicts Hagar and Ishmael in idealized, classical poses.

Luca Forte

Italian, ca. 1615–before 1670

Still Life with Fruit, ca. 1640–1647

Oil on canvas
31 × 41¼ in. (78.7 × 104.8 cm)
Museum purchase, 1961, SN715

Often considered the founder of Neapolitan still life painting, Luca Forte introduced the realism of northern Italian art to the artistic community of Naples in the seventeenth century. In this impressive composition, the fruit is solid, three-dimensional, and almost sculptural. The luminosity of the painted objects instills a rich, luscious quality to the scene. The artist's penchant for wordplay can be seen by the insertion of the Latin dedication "Don Joseph Carrafas," the supposed patron of this painting. Giuseppe Carafas, the brother of the Duke of Maddalone, was killed during the Italian revolt against Spanish rule in Naples in 1647. One of the few signed paintings by Forte, this work is a fine example of his mature style. The tenebrist composition was an innovation, as the artist sought to incorporate the heightened chiaroscuro employed in Neapolitan portraits.

Massimo Stanzione

Italian, 1585–1658

Rest on the Flight into Egypt, ca. 1646–1649

Oil on canvas
78¾ × 68⅝ in. (200 × 174.3 cm)
Bequest of John Ringling, 1936, SN146

The triangular massing of the figures and the strong dividing diagonal composition of this work direct the eye of the viewer upward, providing a glimpse into the heavenly realm. The Christ Child, gazing at his mother, draws attention to her as she picks up a pear with her right hand. The *putti* descending through the upper registers guide the viewer's focus to the Virgin's face, further emphasizing the dramatic quality of Christ's vulnerability. A prominent painter of altarpieces and frescoes, Massimo Stanzione was a leading Neapolitan artist in the early seventeenth century and was the main rival of the Spanish émigré Jusepe de Ribera. He experimented with various styles throughout his career, from the heightened chiaroscuro of the Caravaggesque to the grandeur of the Baroque and the graceful forms and coloring of Guido Reni.

Carlo Dolci

Italian, 1616–1687

Saint John Writing the Book of Revelation, ca. 1647

Oil on copper
10³⁄₁₆ × 8⅛ in. (25.9 × 20.6 cm)
Bequest of John Ringling, 1936, SN137

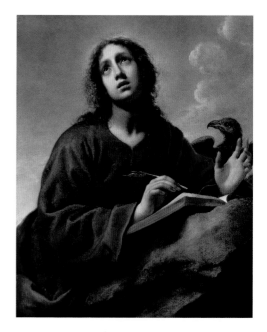

This small easel painting depicting Saint John the Evangelist on the island of Patmos illustrates the detailed softness characteristic of Carlo Dolci's style. The saint gazes upward, appealing for inspiration as he pens the book of Revelation. His ecstatic expression, dewy eyes, and open mouth are typical of Dolci's figures. The eagle at the right of the painting represents Saint John's visionary ability—it was believed to be the only creature that could gaze directly into the sun and therefore became an attribute of the saint. Dolci's images often combine vivid palettes with an almost Netherlandish attention to detail, and the combination of sweetness and melancholy creates an intense religious pathos. His skill as a portraitist informed his religious pictures, as his biblical figures frequently have the quality of psychological portraits, revealing the sitter's state of mind as well as describing his or her physical features.

Salvator Rosa

Italian, 1615–1673

An Allegory of Study, ca. 1649

Oil on canvas
54⅜ × 38 in.
(138.1 × 96.5 cm)
Bequest of John Ringling,
1936, SN152

Among the most celebrated Neapolitan painters of the seventeenth century, Salvator Rosa was also a prolific satirist, actor, poet, and musician. Since he produced numerous self-portraits in allegorical disguise, the present work was originally thought to be the artist himself. The face, however, does not bear a resemblance to Rosa's other self-portraits, in which he has long straight hair and angular features. Given the artist's notion of himself as a philosopher and author, the figure is likely allegorical. Contrary to common practice, Rosa did not usually execute preparatory drawings for paintings and instead painted directly onto the canvas from the live model. The subsequent loose handling of the paint and brush introduces a sense of immediacy and spontaneity, and is characteristic of the Neapolitan style.

Luca Giordano

Italian, 1634–1705

The Flight into Egypt, ca. 1696

Oil on canvas
60 × 86¼ in.
(152.4 × 219.1 cm)
Bequest of John
Ringling, 1936, SN157

The Neapolitan painter Luca Giordano executed this work in Madrid while in the employ of the Hapsburg King Charles II of Spain, who appointed him court painter in 1694. The tender expression of the Madonna's face and the softened, earthy palette suggest the influence of Bartolomé Esteban Murillo. According to the Gospel of Matthew, an angel urged the Holy Family to flee Bethlehem because King Herod was plotting a massacre with the aim of killing the Christ Child. Though artists in previous centuries had seen the biblical story as an opportunity to paint an extensive landscape view, Giordano limited the landscape to a distant mountain and a glimpse of foliage at the left of the canvas. The central action of the painting takes place almost entirely in the foreground, psychologically engaging the viewer.

83

El Greco

(Domenikos Theotokopoulos)
Greek, ca. 1541–1614

*The Crucifixion with Mary
and Saint John*, ca. 1603

Oil on canvas
42⅜ × 27¾ in. (107.6 × 70.5 cm)
Bequest of John Ringling, 1936, SN333

El Greco was born in Crete, where he trained as a painter. He relocated to Toledo, Spain, after rejecting the classical forms and proportions of Michelangelo and Raphael, then seen as artistic ideals in Italy. Known for his exaggerated proportions, particularly with regard to the figure, he created a new method of understanding the human form, visible here in the elongated limbs and face of Christ. The artist's disregard for natural forms and colors heightens the sense of the mystical and is reflective of the religious fervor of seventeenth-century Spain. A reduced version of a composition first executed by El Greco around 1580, this painting may be one of the small copies the artist made after his major works so that his son, Jorge Manuel, would have a stock of images from which to cull after his death.

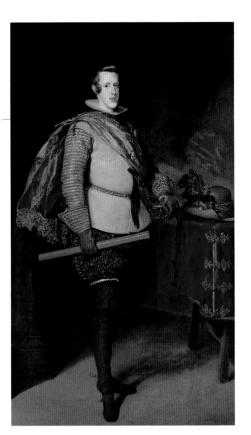

Diego Velázquez
(Diego Rodríguez de Silva y Velázquez)
Spanish, 1599–1660

Philip IV, King of Spain, ca. 1625

Oil on canvas
82⅜ × 47⅝ in. (209.2 × 121 cm)
Bequest of John Ringling, 1936, SN336

Diego Velázquez's brilliant portrait of Philip IV, the Hapsburg ruler, illustrates the Spanish preoccupation with courtly behavior, social standing, and class. Philip IV (1605–1665) ruled Spain and its dominions for more than forty years during the seventeenth century. Much of his reign was spent at war, and it was as a military leader that Velázquez most often portrayed the king. Indeed, this is probably the earliest of the artist's military portraits of Philip. Velázquez made several modifications to the composition, such as the outline of the monarch's cape and armor and the position of the table. These changes, called *pentimenti,* are visible to the naked eye and testify to the young painter's search for an appropriate image and pose for the powerful monarch.

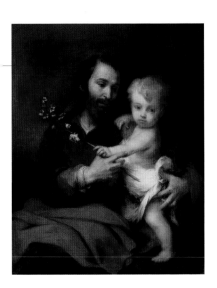

Bartolomé Esteban Murillo
Spanish, 1618–1682

Saint Joseph with the Standing Infant Christ, ca. 1670

Oil on canvas
42¾ × 33¾ in. (108.6 × 85.7 cm)
Bequest of John Ringling, 1936, SN349

Though usually depicted with the Virgin Mary, in seventeenth-century Spanish art the Christ Child was often shown with his father, Saint Joseph, who had become the focus of his own cult. Like Velázquez before him, Murillo was strongly influenced by the artistic traditions of his native city of Seville, where genre painting, depicting scenes of everyday life, was especially popular. He often imbued his paintings of the Holy Family with an informality and intimacy more commonly expressed in genre pictures, perhaps in an attempt to convey the tenderness between father, mother, and child. Despite its informal air, the painting retains an element of religious symbolism. The flowers in the child's hand allude to the legend of Joseph's staff, which miraculously burst into bloom as he proposed to the Virgin Mary—a divine signal that set Joseph apart from the rest of Mary's suitors.

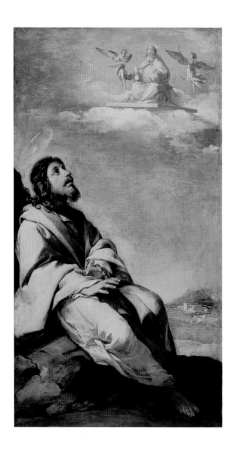

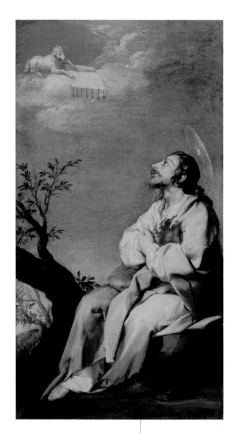

Alonso Cano

Spanish, 1601–1667

Saint John the Evangelist's Vision of God, 1638

Oil on canvas
28½ × 15¾ in. (72.4 × 40 cm)
Bequest of John Ringling, 1936, SN344

Saint John the Evangelist's Vision of the Lamb, 1638

Oil on canvas
28½ × 15¾ in. (72.4 × 40 cm)
Bequest of John Ringling, 1936, SN345

These pendant works show scenes of Saint John the
Evangelist's visions as recounted in the book of Revela-
tion. They were originally part of a large, multipaneled
altarpiece in the convent church of Saint Paul in Seville. Other
paintings from this now-dismantled altarpiece are currently in
the Musée du Louvre, Paris, and the Wallace Collection, London.
Cano introduces highly keyed, theatrical colors and bright light-
ing to accentuate the visionary nature of the subject matter. He
was a pupil of Francisco Pacheco in Seville, where he became
lifelong friends with fellow student Diego Velázquez. Cano was
also active as an architect and sculptor and was responsible for
the design of the façade of the cathedral in Granada.

Thomas Gainsborough

British, 1727–1788

Lieutenant General Philip Honywood, 1765

Oil on canvas
128¹⁵⁄₁₆ × 118¼ in. (327.5 × 300.4 cm)
Bequest of John Ringling, 1936, SN390

This portrait is believed to be Thomas Gainsborough's largest equestrian painting and the only one in which the rider is actually mounted. Gainsborough rose to fame largely as a painter of pastoral landscapes and society portraits, yet often combined the two genres as shown here. In this work, Lieutenant General Philip Honywood is shown on a handsome mount, passing through a clearing in the woods. The romantic landscape, set with overgrown trees and foliage, represents a section of the great park at Mark Hall on the Honywood estate. Although Gainsborough sought to emulate the formulas employed by earlier portraitists such as Titian and Anthony van Dyck, his individualized yet highly refined style helped to establish a subgenre within the portrait tradition known as "the Grand Manner."

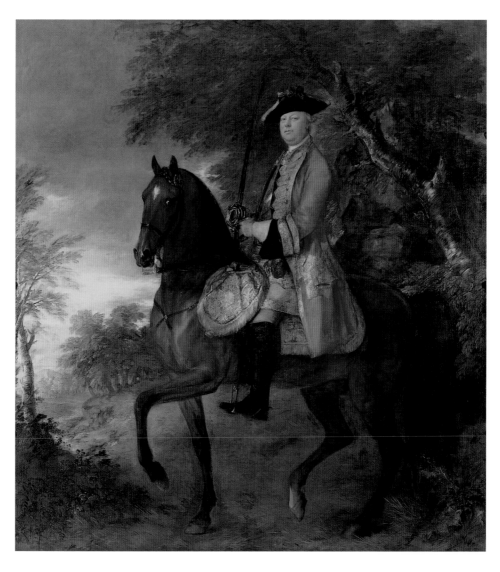

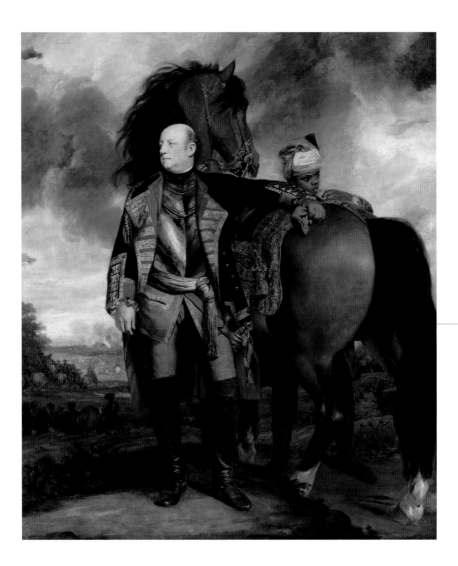

Sir Joshua Reynolds
British, 1723–1792

John Manners,
Marquis of Granby, 1766

Oil on canvas
97 × 82⁵⁄₁₆ in.
(246.4 × 209.1 cm)
Bequest of John Ringling, 1936, SN389

A founding member and first president of the Royal Academy of Arts in London, Sir Joshua Reynolds was one of the foremost artists in eighteenth-century England. Hallmarks of Reynolds's portraiture include the vivid color, dramatic lighting, and free handling of paint seen in this painting of John Manners, Marquis of Granby, a staunch partisan of the House of Hanover, the British royal family who reigned from 1714 to 1837. Specializing in portraits of distinguished British contemporaries, Reynolds here displays his reliance on the tenets of Neoclassicism in order to evoke his sitter's status. Granby's posture, for instance, is based on antique sculpture, identifying him as a man of dignity and civic virtue. In fact, Granby was a decorated war hero, having served in the Seven Years War (1756–1763), and was promoted to the rank of commander-in-chief the year this portrait was painted.

William Parry

British, active 1750–1768

George III Silver Half-Pint Mug, 1768

Silver
4¹⁄₁₆ × 2⅝ in. (10.3 × 6.7 cm)
Gift of Mr. and Mrs. Percy R. Everett,
1969, SN7386

Toward the close of the eighteenth century, in painting and decorative arts, the ornate style known as the Rococo was eclipsed by the smooth planes and minimally decorated surfaces of the Neoclassical style. In mid-century, a muted version of the Rococo remained popular and coexisted with Neoclassicism, particularly in the decorative arts. While the surface of this half-pint tankard is carved with elaborate floral motifs and scrollwork, the ornamentation is done in shallow repoussé, resulting in a smooth profile despite the ornate decoration. London remained the major center of activity for silversmiths; however, the southwestern city of Exeter was also home to a number of famed craftsmen, including William Parry.

Gallery 18 The European Grand Tour.

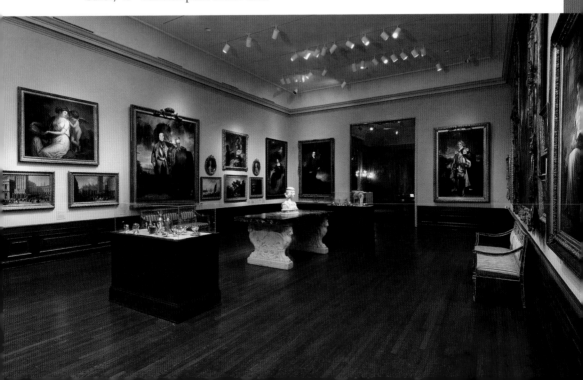

Benjamin West

American, 1738–1820

Agrippina and Her Children Mourning
over the Ashes of Germanicus, 1773

Oil on canvas
80 × 56½ in. (203.2 × 143.5 cm)
Bequest of John Ringling, 1936, SN403

An American-born painter of historical and mythological subjects, Benjamin West was a co-founder of the Royal Academy of Arts and succeeded Sir Joshua Reynolds as its president. Showing his acquaintance with the work of Gainsborough and Reynolds, West's paintings are often characterized by their Neoclassical underpinnings. In this work, which was exhibited at the Royal Academy in 1773, West turns to the classical story of Germanicus, the Roman general who was allegedly poisoned by his uncle, the Emperor Tiberius. Rather than portraying the dramatic death, West has focused on Germanicus' wife, Agrippina, and their two sons, one of whom became the notorious Emperor Caligula. Rich color, crisp lines, and invisible brushwork lend a realism to this work, which was vital to the development of history painting.

A specialist of candle- and moonlit scenes, Joseph Wright of Derby was fascinated by the effects of light. Although his most famous paintings depict dramatic scenes of scientific experiments performed at night, in this work Wright combines the evocative illumination of those images with the tradition of landscape painting. The result is a haunting nocturnal landscape in which the juxtaposition of the moon and the

Joseph Wright of Derby
British, 1734–1797

Moonlight Landscape, ca. 1785
Oil on canvas
25½ × 30½ in. (64.8 × 77.5 cm)
Museum purchase, 1972, SN906

solitary lamp on the bridge contrasts the natural light with that made by man. Though he has been linked to Romanticism, Wright's interest in philosophical and technological experimentation of the later eighteenth century securely locate him within the school of Enlightenment painters.

He was also highly influenced by the French landscape painters Claude Lorrain and Claude-Joseph Vernet.

Michael Plummer
British, active after 1791

George III Silver Teapot, 1795
Silver and wood
6⅞ × 10½ in. (17.5 × 26.7 cm)
Gift of Mr. and Mrs. Percy R. Everett, 1969, SN7389

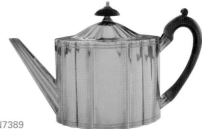

The Neoclassical movement of the late eighteenth century influenced the decorative arts as well as painting, sculpture, and architecture. This restrained, classical style rejected the heavy ornamentation of the Rococo for simpler, more discreet forms and palettes. Following suit, silver makers preserved the clean lines of an object's profile, introducing flat, mirror-like surfaces often void of heavy ornamentation or incisions. This George III teapot provides an excellent example of this unadorned style, which relied on the reflection of light off the surface for decoration rather than elaborate embossing or repoussé—two methods of creating raised designs on silver.

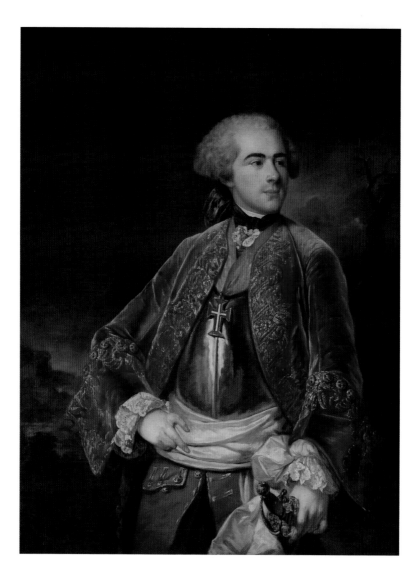

Carle van Loo

(Charles-André van Loo)
French, 1705–1765

Le Chevalier Louis Eusèbe de Montour, ca. 1750

Oil on canvas
47 × 36 in. (119.4 × 91.4 cm)
Gift of Miss Louise Marock, 1965, SN786

Called the greatest painter in Europe by the distinguished German writer Baron von Grimm, and compared to Raphael by Voltaire, Carle van Loo was the consummate eighteenth-century French artist. He was born into a family of painters, and later studied at the Académie, where he won the prestigious Prix de Rome. In 1734 he settled in Paris and immediately captured the attention of Louis XV, who later named him Principal Painter to the King. As one of the foremost artists working for the court in Paris and Versailles, van Loo received a variety of commissions, including hunting scenes, mythological paintings, and aristocratic portraits. Although little is known about the sitter, his elaborate and fashionable dress indicates he is a man of high standing. Characteristic of the artist's work is the energetic yet somewhat classicizing composition, which is evocative of the Rococo style.

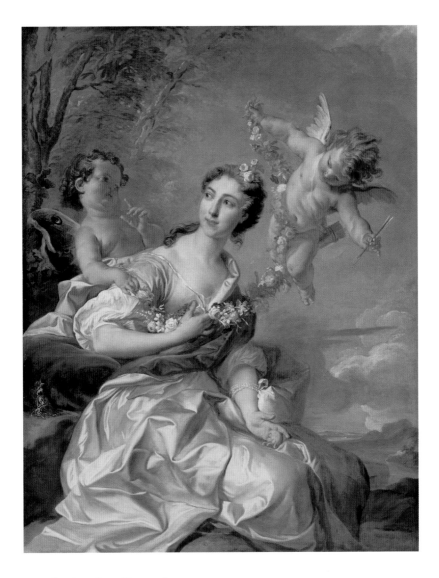

Noël-Nicolas Coypel

French, 1690–1734

Portrait of Madame de
Bourbon-Conti as Venus, 1731

Oil on canvas
54⅜ × 42 in. (138.1 × 106.7 cm)
Bequest of John Ringling, 1936, SN381

Noël-Nicolas Coypel was the son of the celebrated artist Noël Coypel, and had a brother and a nephew who also were painters, all of whom received prestigious royal commissions throughout their careers. While many famous women bore the name Bourbon-Conti, the sitter portrayed here is likely Louise-Diane d'Orleans, princesse de Conti, the daughter of Philippe II, Duke d'Orleans, who was Regent of France before Louis XV assumed the throne. Here she is depicted in the guise of Venus and shown with cupids and a garland of flowers. There is a cascading of forms from the top of Cupid's wing, down through the garland of flowers that the sitter holds, and extending to the billowing fabrics of her costume. Indicative of the flourishes of a silvery brush and Coypel's penchant for sumptuous drapery and clouds, the charming portrait is the epitome of Rococo elegance.

Claude-Joseph Vernet

French, 1714–1789

Les Blanchisseuses (*The Laundresses*), ca. 1750

Oil on canvas
31½ × 45 in. (80 × 114.3 cm)
Museum purchase, 1975, SN944

In his specialized genre of marine and landscape painting, Claude-Joseph Vernet had no true rival in France in the eighteenth century. His closest competitors as view painters in Italy were Canaletto and Bernardo Bellotto. He was most famous for his coastal and lake views; his violent storms and shipwrecks as well as tranquil harbor scenes were highly praised by critics at the Salon and avidly collected by the British and French. These paintings were often produced as pendant pairs or suites, showing contrasting weather conditions, the times of day, or the seasons. Although the scene depicted here is likely imaginary, it is rendered with such attention to detail and faithfulness to light that it is utterly convincing. Vernet's observational technique, which involved sketching in oil outdoors, exerted great influence on the development of naturalistic landscape painting in the nineteenth century.

Jean-Baptiste Greuze

French, 1725–1805

Meditation, ca. 1780

Oil on canvas
53 × 43⅜ in. (134.6 × 110.2 cm)
Bequest of John Ringling, 1936, SN382

Jean-Baptiste Greuze had hoped to be admitted to the Académie royale in Paris as a history painter, but the members, drawn to his more sentimental pictures such as this work, admitted him as a genre painter instead. Greuze fills a notional territory between Rococo and Neoclassical painting, and the Ringling picture illustrates his situation well. The woman, shown in the guise of a Roman vestal virgin, contemplates the choices before her: whether she will honor her vows of chastity or give in to the matters of the heart. The intact wreath of flowers signifies virginity, and her devotion and steadfastness are confirmed by the position of her arm on the altar, which separates the two doves and prevents them from mating. Greuze appeals to our emotions as the woman gazes out, but he also approaches the intellect in presenting the weighty choices that she must confront.

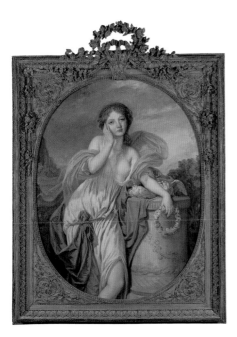

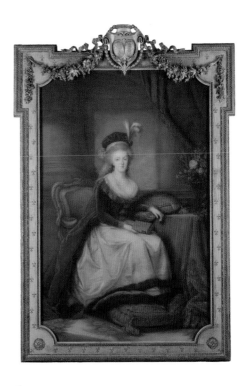

Élisabeth Vigée-Le Brun

French, 1755–1842

Marie Antoinette, Queen of France, ca. 1785

Pastel
87½ × 56½ in. (222.3 × 143.5 cm)
Bequest of John Ringling, 1936, SN383

Élisabeth Vigée-Le Brun is widely considered one of the most important woman artists of the eighteenth century. Born in Paris, where she also studied and became friends with Jean-Baptiste Greuze, Joseph Vernet, and other Neoclassical painters, she became a member of the Academy of Saint Luke and the Royal Academy. She later married the artist Jean-Baptiste-Pierre Le Brun. Her training as a portrait painter brought her to Versailles, where she was invited to paint Queen Marie Antoinette. The queen commissioned her to paint additional works, including portraits of her children and members of the royal household. This particular commission, like many of its type, had a political as well as an aesthetic agenda. In this instance, it was likely meant to diffuse criticism of the queen as a somewhat frivolous and inaccessible figure.

Covered Dish

French (Niderviller), eighteenth century
Faience (tin-enameled earthenware)
7½ × 11¾ × 10⅜ in. (19.1 × 29.8 × 26.4 cm)
Museum purchase, 1953, SN7248.a–b

Among the most famous of the eighteenth-
century French factories was at Niderviller, in
Lorraine, which produced faience and hard-paste
porcelain. Faience (tin-enameled earthenware)
became popular in France in the early eighteenth
century, and its motifs extend to designs found on fab-
rics, metalware, and woodworking. The decoration on this covered dish reflects the
growing interest in gardening and other rustic pastimes. The crabstock handles (in
the form of branches) with floral and foliate terminals in relief are a perfect foil for
the bouquets and sprigs decorating the piece. All of the flowers represented on the
dish were cultivated in France at the time.

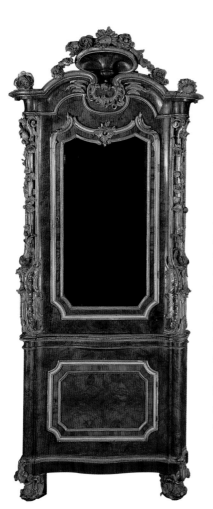

Johann Christian Hoppenhaupt

German, active 1742–d. 1778/86

Two-Part Corner Cabinet, ca. 1745

Carved and gilded walnut
104 × 41 in. (264.2 × 104.1 cm)
Museum purchase, 1951, SN1185 and SN1186

Johann Christian Hoppenhaupt was employed
by the royal family of Prussia in Berlin and at
King Frederick the Great's retreat in Potsdam,
Sans Souci, where he is best remembered for
his design of the music room. In this extrava-
gant cabinet, the simplicity of the lower portion
contrasts with the swelling form and decoration
of the upper case. The single paneled door fea-
tures an inset mirrored plate bordered by shaped
gilded moldings, and it is flanked by ribbed
gilded colonnettes decorated with ornate acan-
thus scrollwork. Hoppenhaupt seems to have
abandoned all pretense of architectural solidity—
the columns framing the mirror resemble trees
bursting into flower and leaf, and the entire piece
is framed by a broken pediment with aquatic and
vegetable motifs.

Johann Martin Saetzger
and workshop
German (Augsburg), d. 1785

Traveling Silver Set, ca. 1755–1757
Silver-gilt
Various dimensions
Museum purchase, 1950,
SN1539.1–1539.32

Since the Renaissance, the German city of Augsburg has been one of the chief centers in Western Europe for the production of silver. By the eighteenth century, traveling silver sets were made in large numbers for foreign customers. This set consists of utensils for eating and for dressing and is believed to have been designed for a Swedish gentleman. Several makers were involved with the production of the pieces. Their different artistic personalities can be discerned in the highly stylized birds, flowers, and scrolls that decorate the objects with a Rococo flair. The term "rococo" is a blending of the French word *rocaille*, meaning "shell," and the Italian *barocco* (Baroque), a combination that is well represented in the design of these exquisite objects.

Jan-Baptist Xavery
Flemish, 1697–1742

Portrait Bust of Anne, Princess of England, Wife of Stadholder Willem IV, 1733
Terra-cotta
31¼ × 21 × 11½ in. (79.4 × 53.3 × 29.2 cm)
Museum purchase, 1963, SN5020

The young sculptor Jan-Baptist Xavery settled in The Hague, the seat of royalty in the Netherlands, in 1725 and became court sculptor to Prince Willem IV in 1729. Trained initially by the Flemish sculptor Michiel van der Voort I, Xavery later traveled to Italy in search of inspiration. Studying there between 1719 and 1721, Xavery would have studied ancient Roman sculpture as well as works by Gian Lorenzo Bernini and other great masters. The sitter of this portrait bust, Anne, Princess of England (1709–1759), was the second daughter of George II of England, and she married Willem IV, Prince of Orange, in 1734. After being widowed in 1751, she became famous when she assumed the regency for her three-year-old son, Willem. This terra-cotta bust of the princess served as a model for a subsequent marble sculpture (Mauritshuis, The Hague).

Anton Raphael Mengs

German, 1728–1779

The Dream of Joseph, ca. 1773

Oil on wood panel
43¾ × 34 in. (111.1 × 86.4 cm)
Bequest of John Ringling, 1936, SN328

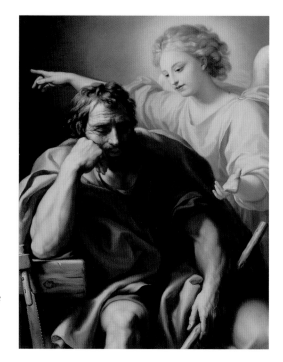

Anton Raphael Mengs began his artistic career in Dresden at the court of Frederick-Augustus II, Elector of Saxony. He spent most of his life in Rome, however, where he played an important role in the development of the Neoclassical movement, which espoused the cultural ideals of classical Greek and Roman civilizations. He shared a friendship with the German antiquarian and scholar Johann Joachim Winckelmann, whose writings first championed the principles of ancient Greek and Roman art as a standard of aesthetic beauty. The painting's subject is taken from the Gospel of Saint Matthew, in which an angel appears to Joseph in a dream and whispers the truth about Mary's conception of the Christ Child. The controlled, polished brushwork and the gracefully composed demeanor of the figures are typical of the Neoclassical style.

Covered Tureen and Underplate

German (Meissen), eighteenth century, ca. 1775
Hard-paste porcelain
11 × 20³⁄₁₆ × 11½ in. (27.9 × 51.3 × 29.2 cm)
Museum purchase, 1951, SN7239.a–c

In 1710, the Royal Saxon Pottery factory was founded at Meissen near Dresden, under the patronage of the Elector of Saxony, Friedrich August I (Augustus the Strong), and took as its mark the pair of crossed swords representing his might. This tureen and underplate have an interesting and unusual combination of Neoclassical ornamentation and Rococo-styled painting, highlighted with *chinoiseries* and rich gilding. The elegant design shows the influence of the early Meissen painter Johann Gregor Heroldt, who was inspired by French engravings, especially those of Antoine Watteau. The acanthus leaves and gilded ram's-head ornamentation linked by laurel leaves is a direct response to the style of Christian Wilhelm Ernst Dietrich, who was principal of the Meissen factory art school, which was founded in 1763.

Marco Ricci

Italian, 1676–1730

Landscape with Tobias and the Angel, ca. 1715

Oil on canvas
29¾ × 36½ in. (75.6 × 93.3 cm)
Bequest of John Ringling, 1936, SN179

Landscape with Boaz and Ruth, ca. 1715

Oil on canvas
29¾ × 37 in. (75.6 × 94 cm)
Bequest of John Ringling, 1936, SN180

The cosmopolitan artistic community of early eighteenth-century Venice included Marco Ricci, a landscape painter who often collaborated with his uncle, Sebastiano Ricci. Like other Venetian artists such as Francesco Zuccarelli and Canaletto, Marco traveled to London early in his career, observing the naturalism of Dutch landscape painting en route. Though popular in England (King George III owned more than forty of his paintings), Marco Ricci painted with an unmistakably Venetian style. A combination of *impasto* (thick layers of paint built up on the canvas) and the soft, Venetian light resulted in wonderful atmospheric effects in his landscapes. The texture of the paint is clearly visible, and the staccato brushstrokes of thick oil paint, called *macchie*, or marks, had been a trademark of Venetian painting since the sixteenth century.

Luca Carlevaris

Italian, 1663–1730

Piazza San Marco Towards the Basilica of San Marco, Venice, ca. 1725

Oil on canvas
24½ × 38½ in. (62.2 × 97.8 cm)
Museum purchase, 1953, SN669

Piazza San Marco Towards the Piazzetta, Venice, ca. 1725

Oil on canvas
23¼ × 39½ in. (59.1 × 100.3 cm)
Museum purchase, 1953, SN670

Luca Carlevaris was one of the first Italian artists to produce *vedute* in the manner of the seventeenth-century Dutch painters. Here, the artist offers two different views of the Piazza San Marco in Venice. In one canvas, the façade of the Basilica of San Marco and part of the Palazzo Ducale at the right are seen behind the bell tower. Carlevaris introduced fresh and unprecedented atmospheric effects, as evidenced in the misty, shrouded vignette of the stage at lower left. The rose-colored sunlight filters through the clouds at the right and casts a pinkish Venetian glow on the façade of the Basilica and Campanile. In the square, visitors pass or pause to enjoy the comedians on stages erected for their performances. The pendant view, seen from the steps of the Basilica, shows the Loggetto, or small loggia, at the base of the Campanile, designed by Jacopo Sansovino in 1542.

Canaletto

(Giovanni Antonio Canal)
Italian, 1697–1768

*Piazza San Marco, Seen from
Campo San Basso, Venice,* ca. 1750

Oil on canvas
16⅛ × 12¼ in. (40.9 × 31.1 cm)
Bequest of John Ringling,
1936, SN186

*The Riva degli Schiavoni
Towards the East, Venice,* ca. 1750

Oil on canvas
14½ × 11 in. (37 × 28 cm)
Bequest of John Ringling,
1936, SN187

Popular for his *vedute*, or city views,
Canaletto bathed vistas of his native
city in various shades of light to
mimic the dreamy Venetian atmo-
sphere. The artist gives us sharp
perspective views, rather than
detailed portraits of the façades of
important buildings. Both works
offer illustrations of popular desti-
nations for Venetians and tourists
alike—the Piazza San Marco and
the adjacent Riva degli Schiavoni,
a public promenade hugging the
Canale di San Marco. The exagger-
ated angles not only are composi-
tionally innovative but also ensure
that the works are legible from a
distance and on the crowded wall of
paintings. Although the two scenes
give the impression of having been
painted on the spot in Venice, these
companion pictures were likely
painted while Canaletto was living
in London between 1746 and 1755.

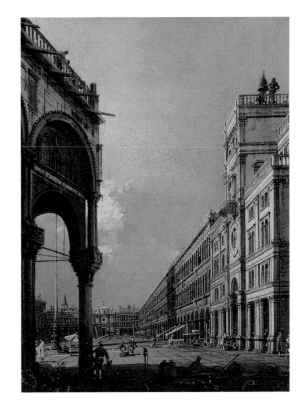

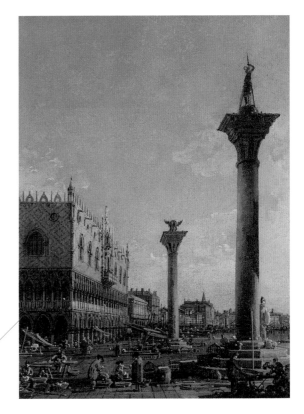

As an architect and stage designer, Pannini acquired advanced skills in perspective, as evidenced in his paintings of fantastic architecture, known as *capricci*. Through his work and teaching as an instructor at the French Academy in Rome, Pannini dominated the Grand Tour market with his *capricci* and *vedute*, or city views, which were popular among tourists. *Hermes Appears to Calypso* depicts a scene from Book V of Homer's *Odyssey*, in which Hermes rescues the hero Odysseus from the island of Ogygia, where he stayed for seven years with the nymph Calypso. Homer's lack of detail in describing the scene gave Pannini the liberty to create fanciful architectural ruins that dwarf the mythological figures engaged in the narrative. The pendant to this work, *Circe Entertaining Odysseus at a Banquet*, shows a scene from Book X of the same epic in which Circe and Odysseus are seated under a portico while Hermes drops to Odysseus the magic flower that protects him from her spell.

Giovanni Paolo Pannini

Italian, ca. 1692–1765

Hermes Appears to Calypso, ca. 1718–1719

Oil on canvas
50⅞ × 64⅜ in. (129.2 × 163.5 cm)
Bequest of John Ringling, 1936, SN171

Circe Entertaining Odysseus at a Banquet, ca. 1718–1719

Oil on canvas
51 × 63⅝ in. (129.5 × 161.6 cm)
Bequest of John Ringling, 1936, SN172

Sebastiano Conca

Italian, 1680–1764

The Vision of Aeneas in the Elysian Fields, ca. 1735–1740

Oil on canvas
48⅝ × 68½ in. (123.5 × 174 cm)
Bequest of John Ringling, 1936, SN168

This work depicts a passage from Virgil's *Aeneid*, the epic story of the Trojan warrior Aeneas, whose descendants would found Rome. The helmeted hero descends to Elysium, the part of the underworld reserved for heroes whose souls will be reborn. Surrounded by future Roman leaders (including Emperor Augustus on horseback), Anchises, Aeneas' deceased father, tells his son of the grandeur Rome will enjoy. Venus, Aeneas' mother, and Mercury hover above the central figures in a chariot. Sebastiano Conca began his career in Naples as a student of Francesco Solimena before relocating to Rome around 1706, when he met his patron, Cardinal Pietro Ottoboni. While in Rome, Conca also enjoyed the patronage of a number of English tourists. Conca's florid palette is a departure from the velvety darkness prevalent in Neapolitan painting of the previous century, illustrating the transition from the Baroque to the Rococo.

Francesco Guardi

Italian, 1712–1793

Abundance, ca. 1745–1750

Oil on panel
62½ × 30½ in. (158.8 × 77.5 cm)
Bequest of John Ringling, 1936, SN190

Hope, ca. 1745–1750

Oil on panel
63½ × 30¾ in. (161.3 × 78.1 cm)
Bequest of John Ringling, 1936, SN189

Before becoming a popular *vedutiste*, or view painter, in Venice, Francesco Guardi collaborated with his brother Antonio on a number of projects, including the decorative program for the organ in the Venetian church of San Raffaele Arcangelo. These panels, representing the allegorical figures of Hope and Abundance, may have covered the organ pipes. The figures are loosely based on descriptions of their respective virtues in Cesare Ripa's *Iconologia*, a late sixteenth-century handbook that defined and solidified pictorial representations of abstract concepts and that was seen as an authoritative text for the correct illustration of allegories. The anchor that Hope grasps symbolizes strength and steadfastness, while the plentiful wheat shafts in the arms of her counterpart represent abundance. The loose, rapid brushstrokes and rich texture of the paint—especially visible in the folds of the figures' drapery—are hallmarks of Francesco Guardi's Italian Rococo style.

Michelangelo Pergolesi

Italian, active 1770–1801

Settee from a Suite of
Carved Furniture, ca. 1770

Carved, painted, and lacquered wood
Settee: 38 × 63¼ × 19¼ in.
(96.5 × 160.7 × 48.9 cm)
Museum purchase, 1949, SN1533

This settee is part of a large suite of furniture designed by Michelangelo Pergolesi and purchased by the Ringling Museum's first director, A. Everett "Chick" Austin, Jr. It has a shaped pierced backrest composed of zoomorphic bird heads delineating three separate splats, separated by female busts sprouting from floral motifs and shaded by parasols. The slightly concaved legs are carved with acanthus leaves and rosettes, terminating in delicately arched toes. Pergolesi was an architect and a specialist in ornamental designs, and best known for his collaboration with the English architect Robert Adam in the 1770s. Pergolesi's engravings of plaster moldings, pillars, paneling, and scrollwork were widely used by architects, and his knowledge of decorative architectural elements informed his own designs for furniture.

Gallery 16 Eighteenth-Century Art in Italy.

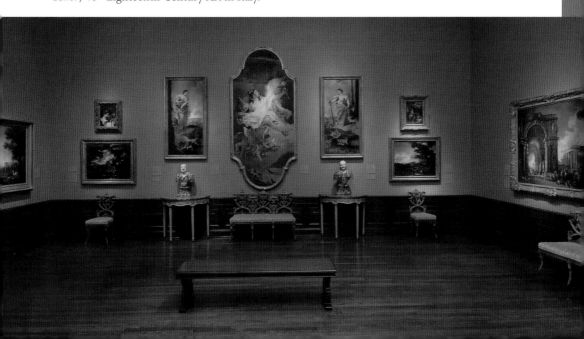

Giovanni Battista Tiepolo

Italian, 1696–1770

An Allegory Representing the Glory and Magnanimity of Princes, ca. 1760

Fresco (later transferred to canvas)
148 × 75 in. (375.9 × 190.5 cm)
Museum purchase, 1951, SN652

These imposing life-size figures were likely part of a large fresco decoration for a Venetian villa, and the decorative scheme appears to have been a series of imaginary sculptures integrated into the architecture of the space. Done in the *grisaille* technique, a monochromatic approach that was often used to simulate stone or metal, the golden figures are meant to mimic bronze statues, with a marble obelisk as the only backdrop. The subject of this fresco is likely the Glory and Magnanimity of Princes as defined in the *Iconologia*, a late sixteenth-century handbook of allegorical figures and their meanings by Italian author Cesare Ripa. Following the text, Tiepolo depicts the Glory of Princes as a beautiful woman embracing an obelisk; the grand height of the architectural structure symbolizes the great stature of benevolent princes.

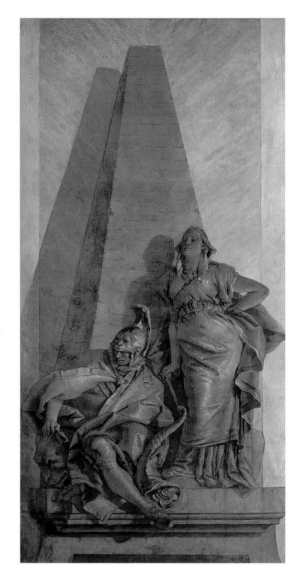

Chair from the Villa of the Prince of Palagonia

Italian, Bagheria, Sicily, ca. 1800
Carved and gilded wood, glass
38¼ × 22 in. (97.2 × 55.9 cm)
Gift of A. Everett Austin, Jr., 1955, SN1802

This chair is from a suite of furniture made for the Prince of Palagonia, Francesco Ferdinando Gravina II, a famous alchemist and eccentric. His home in Sicily is known for its extravagantly decorated rooms and its strange gardens with sculptures of dwarves and monsters. The geometric decoration of the furniture is relatively reserved, but the faux-painted glass resembling lapis lazuli would have been especially striking when the set was seen in its entirety. The Ringling Museum has four pieces from this suite, including two settees and two side chairs. The remaining pieces are in The Metropolitan Museum of Art, New York, and The Art Institute of Chicago.

Angelica Kauffman

Swiss, 1741–1807

Sappho Inspired by Love, 1775

Oil on canvas
52 × 57⅛ in. (132.1 × 145.1 cm)
Bequest of John Ringling, 1936, SN329

Angelica Kauffman became one of the most famous women painters of the eighteenth century. A student of Sir Joshua Reynolds, she was also a founding member of the Royal Academy of Arts in London and one of the leading proponents of the Neoclassical style. In this work, Sappho, the Greek lyric poet, writes the beginning of the last verse from her famed *Hymn to Aphrodite*: "Come then now, dear goddess, and release me from my anguish."

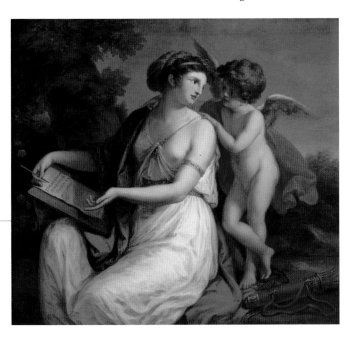

In theme and execution, the painting epitomizes the tenets of Neoclassicism, in which subjects and motifs were based on those of classical antiquity. As a symbol of women's achievement in the arts, the subject may also have represented Kauffman's own struggles as a painter. It has been suggested that Kauffman invested some of her own features in Sappho's face, further testimony to her identification with the poet.

Alfred Stevens

Belgian, 1823–1906

A Portrait Group of Parisian Celebrities, 1889

Oil on canvas
92¾ × 96¾ in. (235.6 × 245.7 cm)
Bequest of John Ringling, 1936, SN439

In 1889, an International Exhibition was held in Paris to commemorate the centenary of the French Revolution. To celebrate this occasion, which saw the completion of the Eiffel Tower, Alfred Stevens created the monumental painting entitled *Le Panorama du Siècle*. At 120 meters long and 20 meters high, it contained 641 identifiable portraits of famous Parisians who lived in the city between 1789 and 1889. The enormous work was installed in a rotunda created for it in the Tuileries Gardens in Paris. After the close of the exhibition, the work was divided into sections and dispersed. *A Portrait Group of Parisian Celebrities* is one of these fragments, portraying the literary and performing arts celebrities of the century, including the dramatist Henry-François Becque and the actress Sarah Bernhardt. Influenced by James McNeill Whistler and the Aesthetic Movement, Stevens's canvas is a study and celebration of Parisian society at the fin-de-siècle.

Sir Edward Burne-Jones

(Edward Coley Burne-Jones)
British, 1833–1898

The Sirens (Les Femmes Chasseresses), ca. 1891

Oil on canvas
84 × 120⁷⁄₁₆ in. (213.4 × 305.9 cm)
Bequest of John Ringling, 1936, SN422

Sir Edward Burne-Jones's painting depicts a scene inspired by Homer's *Odyssey*, where the Sirens, female inhabitants of an island, enchanted men with their song and lured them to their deaths. In this passage, the ship has arrived at the Sirens' lair, and the women flank the shore to greet their victims. In the foreground are the discarded helmets of others who have already met their fate. Burne-Jones conceived of the idea for this work twenty years before he began painting it, and it remained unfinished in his studio at his death. The artist was a prolific painter and designer as well as a leader of the Aesthetic Movement in fin-de-siècle England. He was associated with the circle of William Morris and Dante Gabriel Rossetti, and with them formed a second Pre-Raphaelite Brotherhood, a medieval-like guild of artists and craftsmen. The group's production included paintings, tapestries, stained glass, furniture, and book illustrations.

Rosa Bonheur
French, 1822–1899

Labourages Nivernais (Plowing in Nivernais), 1850
Oil on canvas
52½ × 102 in. (133.4 × 259.1 cm)
Bequest of John Ringling, 1936, SN433

Rosa Bonheur was the most famous woman artist of her day and ranked as one of the leading animal painters in the nineteenth century. In an age in which women were seldom allowed into artists' studios except as models, Bonheur received artistic training from her father, a landscape painter. The Ringling Museum painting is a version (with minor variations) of the canvas Bonheur sent to the Salon of 1849, where it won a gold medal. Bonheur executed the work after she had spent a productive winter working from nature in the Nièvre region of central France. Inspired by the chapter from George Sand's rustic novel *La Mare au Diable* (1846), the painting depicts oxen in a noble, heroic manner amid a fertile landscape that extols the virtues of country life.

Auguste Rodin
(François-Auguste-René Rodin)
French, 1840–1917

Titan IV, ca. 1875
Bronze
11½ × 6 in. (29.2 × 15.2 cm)
Museum purchase, 1975, SN5524

Before making a name for himself with such works as *The Thinker*, Auguste Rodin was an assistant in the workshop of Albert-Ernest Carrier-Belleuse during the 1860s. This small sculpture is a study for a Belleuse work, *Vase of the Titans*, that featured four of the famed warriors of Greek mythology supporting a wide-mouthed urn encircled with a laurel wreath. Rodin made these four figures following a careful study of Michelangelo's work during a trip to Italy in 1875, and *Titan IV* reveals the influence of the Renaissance master's unfinished *Dying Slave* now in the Musée du Louvre, Paris. Having been rejected from the École des Beaux-Arts, Rodin gained renown for his figures' expressive modeling and dynamic torsion, which conveyed a sense of vitality and passion.

Eugène Boudin

French, 1824–1898

A View of Dunkirk, 1880

Oil on canvas
16⅛ × 31⅞ in. (41 × 81 cm)
Bequest of John Ringling,
1936, SN436

Eugène Boudin participated in only the first Impressionist group exhibition in 1874, but he continued to have an influence on several of the group's members. Of his attempts to capture an immediate impression of a scene by working outdoors (*en plein air*) rather than in his studio, Boudin wrote in his journal: "Everything that is painted directly and on the spot always has a strength, a power, a vivacity of touch that cannot be recovered in the studio...three strokes of the brush in front of nature are worth more than two days' work at the easel." This view of Dunkirk, a maritime city on the northern coast of France, displays the quick brushwork, highly keyed fractured color, and vivid sense of visual immediacy that characterized Impressionism.

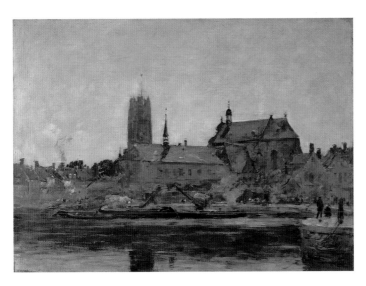

Gustave Doré

French, 1832–1883

The Acrobats, ca. 1880–1883

Bronze
50¾ × 9¾ in. (128.9 × 24.8 cm)
Bequest of John Ringling, 1936, SN5338

Although Gustave Doré was well known as
an illustrator for such books as *The Divine
Comedy* and *Faust*, he was equally success-
ful as a painter of religious subjects and
landscapes. However, it was only late in life
that he turned to sculpture, producing com-
missions for large monuments as well as
smaller bronzes. *The Acrobats* demonstrates
Doré's interest in anatomy, but it also has an
allegorical meaning. The figures struggle to
attain balance and stability, but the strength
of only one man supports them—a testament
to human ambition, and perhaps folly. As
a young artist, Doré had been so fascinated
with acrobats that he had a trapeze installed
in his studio.

Édouard Vuillard

French, 1868–1940

Le Dejeuner de Francine, ca. 1890–1910

Pastel on academy board
24¾ × 33 ¹³⁄₁₆ in. (62.9 × 85.9 cm)
Gift of Mr. and Mrs. Norman L. Jeffer,
in memory of their son Harris, 1967, SN683

Édouard Vuillard, a follower of the Impres-
sionists, specialized in domestic scenes and
interiors. As a student in Paris, Vuillard was
influenced by Synthetism, a movement that
encouraged artists to use simple lines and
forms to give the merest outline of a figure
or object, allowing the viewer to supply the
remaining visual information. This approach
is evident in the barely delineated hand and
face of the central figure, Francine. Vuillard
turns the viewer into a voyeur by showing
things at odd angles and by his "unfinished"
technique, both of which force a more active
participation in the act of looking. The pic-
torial interest of this work lies in the artist's
ability to recreate the experience of see-
ing, and in presenting an intimate scene
of domestic life.

Karl Bitter

American, 1867–1915

*Fireplace, Door Surround, and Cornice
from the Huntington Mansion*, ca. 1889–1894

Marble
Bequest of John Ringling, 1936

This interior decorative ensemble was originally
part of the Fifth Avenue Italian-style palazzo of the
transportation millionaire Collis P. Huntington
in New York City, which was designed by George
Post in 1889. The marble fittings were made by
Karl Bitter, a student of Augustus Saint-Gaudens
and one of the most gifted sculptors of the Ameri-
can Gilded Age. The fireplace in particular dem-
onstrates Bitter's detailed naturalistic carving
technique and an overall harmony of design.
After Huntington's home was torn down in 1926,
Ringling purchased the fittings and had them
installed in the Museum's auditorium (now a
gallery space). In addition to the furnishings
from Huntington's house, Ringling also acquired
fragments and rooms from other homes of Amer-
ica's most socially prominent families, including
the Vanderbilts and the Astors.

Gallery 21 Art in Europe and North America, 1850–1940.

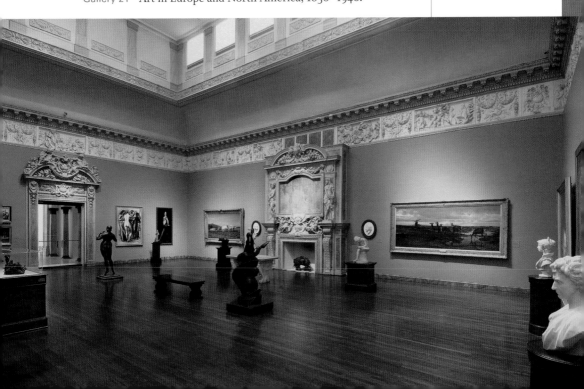

Richard Morris Hunt

American, 1827–1895

Jules Allard et Fils

French, active 1878–1907

Cream Salon of Mrs. Caroline Astor,
ca. 1893–1895

Bequest of John Ringling, 1936

This nineteenth-century historic interior comes from the Astor mansion, originally situated at 840 Fifth Avenue in New York City. The home was built between 1893 and 1895 by the Gilded Age architect Richard Morris Hunt for Mrs. William Backhouse Astor (1830–1908) and her son, Colonel John Jacob Astor IV, following the death of her husband in 1892. Hunt designed the exterior of the mansion in the French Renaissance style, but its interiors were decorated in a wide variety of historical vocabularies by the Parisian interior design firm Jules Allard et Fils. The Cream Salon of Mrs. Caroline Astor was considered the epitome of feminine taste. Decorated in the French Rococo Louis XV style, its subdued palette and gold leaf molding and tracery spoke to the refinement of its proprietor. John Ringling purchased this room, along with the Library of Mr. John Jacob Astor IV, in 1926 at the sale of the residence prior to its demolition.

Gallery 19 The Astor mansion Cream Salon.

Richard Morris Hunt
American, 1827–1895

Jules Allard et Fils
French, active 1878–1907

Library of Mr. John Jacob Astor IV,
ca. 1893–1895
Bequest of John Ringling, 1936

While the Cream Salon was part of Mrs. Caroline Astor's portion of the Astor mansion, this room existed in the other side of the double residence, occupied by her son, Colonel John Jacob Astor IV (1864–1912), and his wife. John Jacob converted what had originally been designed as a dining room into a library after his mother's death in 1908. In contrast to the Cream Salon, the library retained the grandeur and masculinity of the earlier Louis XIV period, characterized by classicizing details such as the Ionic pilasters and capitals, and an elaborate egg-and-dart motif above the doorway. John Jacob would enjoy his beautiful home for only a few years. He died with the sinking of the *Titanic* in 1912. Fourteen years later, his son Vincent auctioned off the contents of the mansion, and these rooms became a part of the Ringling legacy.

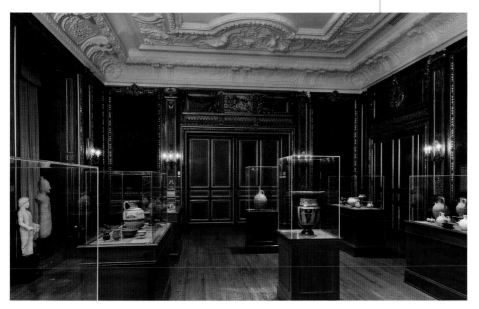

Gallery 20 The Astor mansion Library.

Robert Henri

(Robert Henry Cozad)
American, 1865–1929

Salome, 1909

Oil on canvas
77½ × 37 in. (196.9 × 94 cm)
Museum purchase, 1974, SN937

Robert Henri was the leader of the Ashcan School, the group of former Philadelphia newspaper illustrators who were the first American artists, including George Luks and William Glackens, to focus on the urban scene. This is the second of two canvases Henri painted in 1909 depicting the soprano Mademoiselle Voclezca in the title role of Richard Strauss's opera *Salome*. The New Testament figure Salome was the stepdaughter of King Herod; she danced before the king and, at the behest of her stepmother, Herodias, she requested the death of John the Baptist. The gruesome story of his beheading, however, is not captured in Henri's painting. Instead, the artist has chosen to focus on Salome's dance and conveys its seductive power with an expressive brushstroke laden with paint.

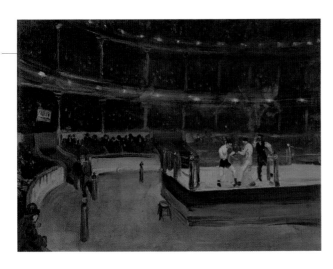

George Luks

American, 1867–1933

Madison Square Garden Prize Fight, ca. 1910–1920

Oil on canvas
24 × 31⅞ in. (61 × 81 cm)
Gift of Daniel and Sally Goldreyer, 2003, SN11086

George Luks began his artistic career as a newspaper cartoonist, an experience that opened his eyes to the beauty of everyday events, such as a prize fight. An ex-pugilist himself, Luks was a member of The Eight, a group of painters who exhibited their works together in New York in 1908 as a denouncement of the conservative attitudes of the National Academy. The Eight largely consisted of members of the Ashcan School, including Robert Henri, William Glackens, John Sloan, and Maurice Prendergast, whose depictions of the lower and middle classes ran contrary to the concept of decorum and propriety appropriated by the Academy. Embracing commonplace subjects and employing bold colors, Luks captured the grit and excitement of American urbanism.

Marsden Hartley

American, 1877–1943

Shell, 1929

Oil on composition board
18 × 15 in. (45.7 × 38.1 cm)
Gift of Mr. and Mrs. William L. Moise, 1965, SN794

Marsden Hartley's *Shell* derives its pictorial language from Cubism, while not strictly adhering to that movement's principles. Rather than showing its many facets, the lines surrounding the shell transform it into a magical or talismanic object. Throughout his career, Hartley had a deep connection to the sea, which he viewed as the giver and taker of life. Until the outbreak of World War I, Hartley lived in Europe, where he was greatly influenced by the work of Henri Matisse and Pablo Picasso. Returning to America in 1916, he traveled along the New England coast, painting abstract themes based on marine motifs. By 1929, however, he had returned to Europe and was working in the south of France, when this painting was produced.

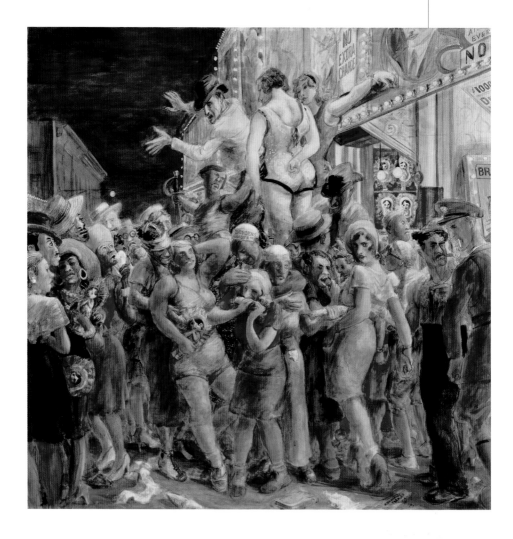

Reginald Marsh

American, 1898–1954

Wonderland Circus, Sideshow, Coney Island, 1930

Tempera on canvas laid down on masonite
48¾ × 48 in. (123.8 × 121.9 cm)
Museum purchase, 1976, SN951

Reginald Marsh was heir to the Ashcan School, emerging as a
mature artist only in the 1930s, after a decade of study while work-
ing as an illustrator for the *New York Daily News* and *The New Yorker.*
Like the other artists of the group, he found the teeming city of
New York an endless source of coarse yet poignant subjects, from
the squalor of the Bowery to the strip joints of Times Square. He
was at his best, however, in depicting Coney Island, where masses
of working-class New Yorkers congregated to seek enjoyment and
escape the summer heat. *Wonderland Circus,* one of Marsh's first
major paintings, features a barker drawing attention to two beauti-
ful women who form the apex of a pyramid composition.

Edward Hopper

American, 1882–1967

Jenness House Looking North, 1934

Watercolor on paper
19 × 27½ in. (48.3 × 69.9 cm)
Museum purchase, 1976, SN949

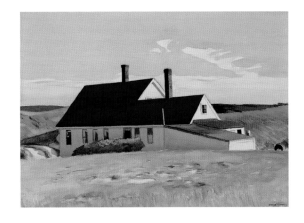

Edward Hopper painted four versions of the Jenness House between 1932 and 1934. The Hoppers' closest neighbors on the Cape were the Jenness family, who let the Hoppers stay in their home in the spring of 1934. In exchange, the artist offered to paint a watercolor of the house. As is evident here, Hopper had a strong interest in the clear articulation of architectural forms. He was fascinated by the effects of sunlight on buildings and painted numerous houses from different points of view, highlighted by patterns of light and shade. In the Ringling painting, the back side of the house is shaded while the front is bathed in bright sunlight that draws attention to the modulation of colors from reddish-orange to deep red on the roof and from bright white to gray on the exterior walls.

Thomas Hart Benton

American, 1889–1975

Interior of a Farmhouse, 1936

Tempera on board
18 × 30 in. (45.7 × 76.2 cm)
Museum purchase, 1976, SN950

This painting is a sketch for a large mural entitled *The Social History of the State of Missouri* that was commissioned for the State Capitol at Jefferson City in 1936. It was one of several large-scale works Benton produced for the Works Progress Administration (W.P.A.) during the Great Depression. The different thematic sections of this anti-capitalist mural are divided by gray architectural frames, also visible in the sketch. Considered to be one of Benton's masterpieces as a muralist, it celebrates his dedication and responsibility as an artist to the social and political issues of the day. Benton studied under abstract art pioneer Stanton Macdonald-Wright in Paris in 1912 but later rejected modernism. His pupil Jackson Pollock became one of the foremost practitioners of Abstract Expressionism in the next generation of American painters.

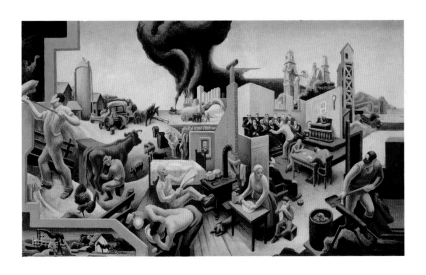

Gaston Lachaise

French, 1882–1935

Elevation (Standing Woman), 1927

Bronze
70 × 28 × 17 in. (177.8 × 71.12 × 43.18 cm)
Museum purchase, 1964, SN5464

Active during the rise of Cubism, Gaston Lachaise bridged the gap
between traditional sculptural techniques and the modern movement
toward abstract art. Inspired by his wife and muse, Isabel Dutaud
Nagle, Lachaise extolled the beauty of the female form throughout
his oeuvre. While working as an assistant to René Lalique, he was
introduced to the elegant forms of Art Nouveau as well as Indian
temple sculpture, two sources that informed his work throughout
his career. *Standing Woman*, alternatively named *Elevation*, derives
its pose from Hindu goddesses adorning temple architecture. Her
high center of gravity and graceful, slender legs and feet belie
the tremendous weight of the material and give the impres-
sion of upward movement.

Yves Tanguy

French, 1900–1955

The New Nomads (Les Nouveaux Nomades), 1935

Oil on canvas
31¾ × 27⁷⁄₁₆ in. (80.6 × 69.7 cm)
Gift of the Estate of Kay Sage Tanguy, 1964, SN782

The New Nomads is a characteristic
landscape by this Surrealist artist.
Though the title suggests the pres-
ence of human figures, the canvas
is given over to an expansive sky
barely distinguished from the land-
scape beneath, while the ground is
dotted with angular fragments of
rock. The faintly visible outline of
a human form against the sky may
indicate the imprint of a human
presence that has, like a nomad,
recently departed. However, this
work is better defined as a "mind-
scape," as it depicts the world of the
imagination rather than recogniz-
able scenery. Yves Tanguy neverthe-
less uses typical landscape formulas
such as perspective, light, and
shadow to create illusionistic depth.
Recognized as a champion of pure
Surrealism, Tanguy was the only
leading artist of this movement to
be self-taught.

Male Dwarf

Italian, ca. 1900
Limestone
43¼ × 15 × 10 in. (109.22 × 38.1 × 25.4 cm)
Bequest of John Ringling, 1936, SN5183

The sixteen sculptures that make up the Dwarf Garden on
the grounds of the Ringling Estate were purchased by John
Ringling on a trip to Italy in the 1920s. They closely resemble a
group of eighteenth-century statues displayed in the gardens of
the Villa Valmarana, also known as the House of the Dwarfs, in
Vicenza. These figures represent different theater characters,
many from the *Commedia dell'Arte*. In the Ringling group, the
male dwarf stands with his foot elevated on a step holding both
hands up to his head in a seemingly mocking gesture. Con-
ceived as a transitional space between the Museum of Art and
the Asolo Theater, the whimsical Dwarf Garden is reminiscent
of the romantic European gardens of the eighteenth century.

Chiurazzi Foundry

Italian (Naples), 1840–2000

The River Nile, ca. 1920

Bronze
62½ × 123 × 61 in. (158.8 × 312.4 × 154.9 cm)
Bequest of John Ringling, 1936, SN5453

John Ringling originally intended to build a
School of Art with a sculpture court adjoin-
ing the Museum of Art (on the site of the
new Searing Wing), which would show-
case bronze copies of famous Classical and
Renaissance sculptures produced by the
Chiurazzi Foundry in Naples. Today, the
collection of more than sixty bronze and stone casts is displayed in the Museum's outdoor
courtyard and throughout the grounds of the estate. *The River Nile* is a cast of a Roman Impe-
rial sculpture from the sanctuary of Isis and Serapis in Rome (Vatican Museums) inspired by
the art of Hellenistic Alexandria in Egypt. The Nile takes the form of a mature bearded man
reclining who is surrounded by sixteen children representing the sixteen cubits to which
the Nile rises in flood. Symbols of Egypt such as a cornucopia
filled with fruit to represent the fertility of the land, the
sphinx, and the crocodile are incorporated into the work.

Albrecht Dürer

German, 1471–1528

Christ on the Mount of Olives, ca. 1497

Woodcut on off-white laid paper
15¼ × 11 in. (38.7 × 28 cm)
Museum purchase, 1978, SN8884

In 1497, Albrecht Dürer began to design a series of twelve woodcut prints known as The Great Passion. The first seven were executed from 1497 to 1500 and the last five were not finished until 1510. The Great Passion was published in 1511 with a frontispiece and poem by the Benedictine theologian Benedictus Chelidonius. Having worked in the workshop of the famed Nuremburg woodcut designer Michael Wolgemut, Dürer grew adept at harnessing the innate potentiality of line to convey light, depth, and emotion. In the Ringling print, his mastery of the woodcut technique is evident as he fills the composition with crisply hatched lines, punctuated by incised pockets of rich black ink. This vigorous linearity becomes frenetic at times, echoing the inner turmoil of Christ, who prays one last time before the Roman soldiers, led by Judas, arrive to arrest him.

Giulio Romano

(Giulio Pippi)
Italian, 1499–1546

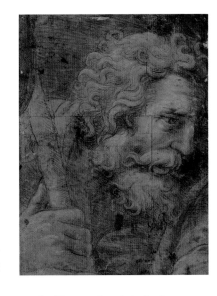

Head of Saint Joseph, Study for *The Nativity with Saints Longinus and John,* ca. 1532–1534

Black chalk heightened with white chalk
over brush and brown wash on four
joined sheets of tan laid paper
15⅞ × 12¹³⁄₁₆ in. (40.3 × 32.5 cm)
Museum purchase, 1960, SN712

Although better known for his monumental
fresco programs and architectural projects,
Giulio Romano was also a highly skilled drafts-
man. A student of Raphael, Romano combined
the High Renaissance principles of his teacher
with his own Mannerist style, as is evident here. Typical of Romano's style is the free
handling of line seen in Joseph's wild serpentine hair and beard. Paired with the emo-
tional force of Joseph's demeanor, Romano's candid insight into human expression cre-
ates a dynamic homage to paternal devotion. This head of Saint Joseph is among the
few remaining works from his Mantuan career not connected with his extant fresco
cycles. It is a cartoon fragment for *The Nativity with Saints Longinus and John* (Musée
du Louvre, Paris), originally in the Boschetti Chapel of Sant'Andrea in Mantua.

Bernardino Campi

Italian, 1522–1591

The Holy Family with Saint Lucy, ca. 1555

Pen and brown ink with brush and
brown wash heightened with white
gouache on tan laid paper
14¹¹⁄₁₆ × 9¹³⁄₁₆ in. (37.3 × 24.9 cm)
Museum purchase, 1961, SN720

This drawing is a study for Campi's painting
Holy Family with Saint Lucy, also in the Ring-
ling Museum collection. Trained in Cremona,
the heart of the Lombardy region, Bernardino
Campi was a painter whose fame was achieved
largely through his altarpieces. In this work,
he depicts the Holy Family in the company of
the fourth-century saint who was martyred
by having her eyes gouged out for her refusal
to marry a non-Christian. Although her sight
was miraculously restored, Saint Lucy is often shown with the symbols of her torture.
Here she holds a plate with her eyes and a needle upon it. The graceful poses and
elongated proportions of the figures show the influence of the central Italian Manner-
ist painter Parmigianino, and the garden setting derives from the Emilian tradition.

Jacopo Palma il Giovane

Italian, ca. 1548–1628

Studies for a Resurrected Christ, ca. 1611

Pen and brown ink on cream laid paper
11⅝ × 8¼ in. (29.5 × 20.9 cm)
Museum purchase, 1977, SN960

This drawing is by the Venetian artist
Jacopo Palma, who was known as *il giovane*
or "the younger," to distinguish him from
his great uncle, also named Jacopo. Palma,
who worked closely with the sixteenth-
century Venetian masters—Titian, Veronese,
Tintoretto—was highly aware of the waning
interest in their pictorial traditions. As such,
his mature work is a complex synthesis of
Titian's tenebrism, Tintoretto's broken brush-
work, and his own naturalism. This sheet
of studies, executed in pen and brown ink,
seems to be primarily focused on motion.
The twisting torso and bent legs are worked
out from a variety of angles, and have a spon-
taneous feel. The studies scale the page in a
sinuous motion that mimics the very subject
matter, suggesting that Palma's studies were
in fact carefully conceived and premeditated.

Elisabetta Sirani

Italian, 1638–1665

Venus and Anchises, ca. 1655

Brush and brown wash over
black chalk with traces of
white chalk on blue laid paper
13¼ × 11 in. (33.7 × 27.9 cm)
Museum purchase, 1971, SN309

Elisabetta Sirani, daughter of Giovanni
Andrea Sirani (Guido Reni's principal
assistant), became a professional painter
at the age of seventeen. Although the
details of her training are unclear, it is
most probable that she received instruction
from her father. While her father's work is
generally regarded as a reflection of Reni's
later style, Elisabetta not only mastered
certain aspects of Reni's technique, but she
also surpassed them. In this drawing, she
displays her lively brush and wash tech-
nique and virtuosic understanding of tonal
range. The subject of the drawing is the
love affair between the goddess Venus and
the shepherd Anchises. Pictured here is
the union that led to the conception of
their son Aeneas, who became the famed
Trojan warrior of the *Iliad*.

Jan van de Velde II

Dutch, 1593–1641

Tobias and the Angel, ca. 1635

Etching on cream laid paper
6⅝ × 8⅛ in. (16.7 × 20.5 cm)
Museum purchase, 1973,
SN8766

A master draftsman and printmaker, Jan van de Velde II was the nephew of Esias van de Velde. Spending the majority of his career in Haarlem, van de Velde was known for his images marked by small controlled cuts and sharply outlined forms. The subject of Tobias and the Angel is taken from the book of Tobit in the Apocrypha. Depicted here is the central episode in which Tobias, son of the blind merchant Tobit, is sent by his father to collect a debt. Accompanied by a boy (the Archangel Raphael in disguise), Tobias embarks on the journey and catches a fish—the heart, liver, and gall of which will later cure his father's blindness. Most notable perhaps is the similar appearance of the two figures. It has been suggested that this was a device used to propagate the belief that God assigns each human a guardian angel. The lush river scene is reminiscent of a Dutch landscape while the background hills suggest the influence of the Italianate style.

Peter Paul Rubens

Flemish, 1577–1640

Saint Catherine of Alexandria, ca. 1620

Etching on cream laid paper
11⅝ × 7⅞ in. (29.5 × 20 cm)
Museum purchase, 1971, SN8611

In 1620, Peter Paul Rubens was commissioned to paint thirty-nine ceiling canvases and three altar paintings to decorate the new Jesuit church in Antwerp. The subject of this etching is taken from one of the ceiling paintings for the church, which was executed with the assistance of Anthony van Dyck. It was destroyed by fire in 1718. Depicted here is Saint Catherine of Alexandria, a third-century saint who was martyred by being pulled apart by spiked wheels and then decapitated for her refusal to worship pagan gods. Pictured with the tools of her martyrdom, Saint Catherine appears triumphant, a glorious symbol of Catholic victory over pagan heresy, which was a favorite theme of the artist's. Generally considered to be the only print executed by Rubens himself, this etching displays the artist's ability to evoke vibrancy and movement on paper as well as on canvas.

Jean Gaspard Gevaerts

Flemish, 1593–1666

Theodoor van Thulden

Flemish, 1606–1669

Peter Paul Rubens

Flemish, 1577–1640

"Medallion Portrait of Philip IV, Sun and Moon Drawn in Chariots, Triumphal Arch Decorated with Figures of Peace and Victory," in *Pompa introitus honori Ferdinandi Austriaci Hispaniarum Infantis* (Antwerp: Meursius, 1641)

[12], 202 pp. Folio. 40 engraved plates
19½ × 13¼ in. (49.5 × 33.7 cm)
Museum purchase, 1954, Library No. 4205

Pompa introitus honori... is the quintessential book of the seventeenth century. Its magnificent engravings by Theodoor van Thulden, after designs by Peter Paul Rubens, are flamboyant commemorations of fantastical scenes. Renaissance Festival books such as this were produced as official accounts of important civic, religious, or royal events. Written by Jean Gaspard Gevaerts, *Pompa* marks the triumphal entry of the new regent Archduke Ferdinand (the younger brother of Philip IV) into Antwerp in 1634. Temporary festival arches, porticoes, chariots, and theatrical creations by Rubens were erected throughout the city and permanently captured in this elaborate volume, which was limited to only one thousand copies.

Jan Fyt
Flemish, 1611–1661

Study of a Hound, ca. 1648

Black chalk on blue laid paper
laid down on tan laid paper
7⁵⁄₁₆ × 13¼ in. (18.4 × 33.6 cm)
Museum purchase, 1974, SN943

Scenes of the hunt are the most common representations in Jan Fyt's oeuvre. One of the most prosperous artists in Antwerp and a student of Frans Snyders, Fyt was known for his elaborate compositions in which hunting dogs ravage stags, boar, and bear. Like most artists, Fyt executed preparatory studies and sketches for his paintings. This drawing is a study for the painting in the Ringling Museum collection, *Atalanta and Meleager Hunt the Calydonian Boar.* Depicted here is a dog with fierce eyes and curled lips. The contours of the dog are reinforced through a combination of hatching and stumping, which both endows the animal with a greater sense of volume and movement and confirms the artist's command of the black chalk medium.

Marco Ricci
Italian, 1676–1730

Roman Architectural Ruins with Large Archway, ca. 1708–1710

Gouache over traces of black
pen on goatskin
12¼ × 8½ in. (31.1 × 21.6 cm)
Museum purchase, 1979, SN974

This gouache by Marco Ricci belongs to the *capriccio* genre. Such whimsical pictures were largely a product of the artist's imagination. Ricci was known as a painter, printmaker, and stage designer, and spent considerable time traveling throughout Europe, where such Italian architectural fantasies were in large demand. He may have drawn this architectural *capriccio* for one of his foreign patrons. Subtle tonal variations give form and density to the buildings, all but erasing the need for outlining, while the vibrant color of the gouache gives the surface a smooth, almost glossy texture. Even the smallest details, such as the fluted columns and classical frieze, are delineated by color rather than line.

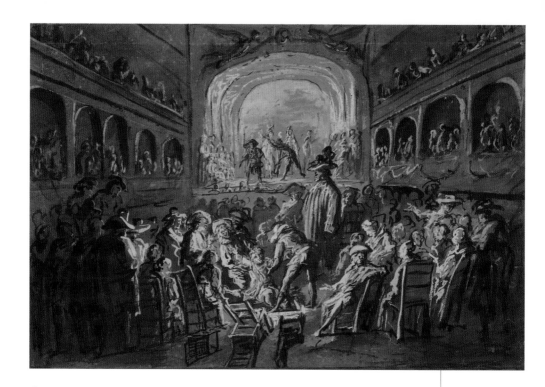

Jean-Baptiste Oudry

French, 1686–1755

La Scène du Grand Baguenaudier (Interior of a Theater with Spectators), ca. 1718–1725

Pen and black ink with brush and black wash,
heightened with white gouache on blue laid paper
12⅝ × 18¼ in. (32.1 × 46.3 cm)
Museum purchase, 1952, SN662

Principally a still life and animal painter, here Jean-Baptiste Oudry renders a scene from the seventeenth-century French author Paul Scarron's burlesque comedy *Roman comique* (1651–1657). The subject shows the dramatic aftermath of a comical confrontation in which Ragotin, one of the main characters, has fallen during the middle of a theatrical performance, causing the action onstage to cease and all focus to be turned to him. Executed almost entirely in wash with very little delineation of the pen, this free drawing serves as an intermediary stage between the painting it copies (Musée du Mans) and the more highly finished chalk drawings used for a later engraving. The sketchy and summary quality of the Ringling sheet indicates the speed with which it was completed. The combination of black wash with white gouache highlights likewise heightens the lighting effects to reflect the dynamism of the lively scene.

128

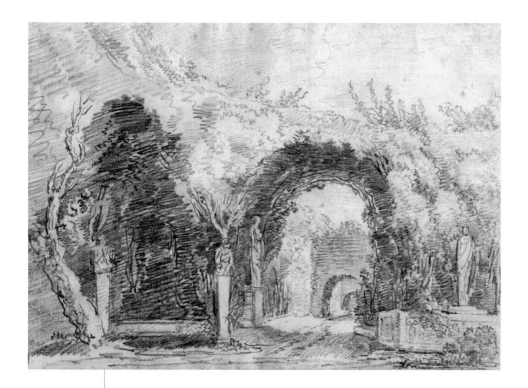

Jean-Honoré Fragonard

French, 1732–1806

The Vaulted Garden, ca. 1772–1774

Black chalk on off-white laid paper
8⅛ × 11⁵⁄₁₆ in. (20.6 × 28.7 cm)
Museum purchase, 1959, SN710

By the 1770s, Jean-Honoré Fragonard had become one of the most celebrated French artists of the eighteenth century. Painter, printmaker, and draftsman, he imbued all his works with the elegance of the Rococo style that was so fashionable with collectors and artists. Fragonard spent the greater portion of his early career in Rome, and many of his paintings and drawings reveal a distinctly Italianate feel. In this work, which is reminiscent of his Tivoli drawings of the mid-1760s (the artist stayed at the Villa d'Este in Tivoli in the summer of 1760), Fragonard approaches the scene with a fresh and casual air. The juxtaposition of thick dark lines with lighter thinner markings suggests a sunlit atmosphere and gives the drawing a feel of spontaneity. Neither a documentary view nor a preparatory study, this work was most likely an autonomous execution for a private collector who enjoyed the fantasy of this luxurious gardenscape.

Angelica Kauffman

Swiss, 1741–1807

Juno Borrowing the Cestus of Venus,
1776–1777

Pen and black ink with brush
and gray wash over traces of
graphite on cream laid paper
6⅝ × 6⅝ in. (16.8 × 16.8 cm)
Museum purchase, 1971, SN899

In this work illustrating a passage from
Homer's *Iliad*, Angelica Kauffman,
one of the great Neoclassical painters,
demonstrates her skill with drawing.
Delicate and graceful, the Ringling composition reveals the versatility of the ink medium
and its ability to suggest mood through varied tonalities. The gray of the cloud is modulated
through the dilution by water, a technique similar to watercolor, softening and soothing the
composition's atmosphere. The outlines of the drapery folds that cling to the Roman god-
desses are achieved through a controlled pen, serving to better capture the body contours
and deepen the pictorial plane. In theme and figural execution, the drawing is character-
istically Neoclassical; however, the loose brushwork and sentimentality locate this work
within the Rococo style.

Benjamin West

American, 1738–1820

Study of a Child, 1785

Black, red, and white chalk on dark
blue laid paper laid down on tan card
11⅝ × 9¼ in. (29.5 × 23.5 cm)
Gift of R. H. Roussey in memory of
Dr. William H. Wilson, 1983, MF83.7

American by birth, Benjamin West
spent the great majority of his life
abroad. Studying in Rome and London,
West became one of the first American
artists to reject the portraiture genre
popular in the Colonies and focus
instead on history painting, for which
he achieved international fame. This
drawing may have been intended as a
nativity study, as indicated by the long elegant hand resting over the child's body and the
small ensemble sketch at the lower left. The baby's face and form are conveyed through
soft, sketchy contours, and the gentle hatching and stumping give weight to his chunky
frame. West also demonstrates his virtuosic understanding of color and light through the
trois crayons (three chalks) technique.

Luigi Palma di Cesnola
Italian, 1832–1904

Cyprus: Its Ancient Cities, Tombs, and Temples.
A Narrative of Researches and Excavations
During Ten Years' Residence in That Island
(New York: Harper & Brothers, 1878)

> 59 plates, 2 maps, illustrations
> 9⅜ × 6½ in. (24 × 16.5 cm)
> Museum Library Purchase, 1963, Library No. 4534

The Ringling Museum's collection of Cypriot antiqui-
ties bears the name of Luigi Palma di Cesnola: explorer,
archaeologist, and military hero. Cesnola was born in 1832
in Rivarolo, Italy, and emigrated to New York at the start of
the Civil War in 1861. He was made a brigadier general and
awarded the post of American consul to Cyprus in 1865.
In 1879 he became the first director of the Metropolitan Museum of Art in New York
and stayed in that position until his death in 1904. Antiquities gathered in Cyprus by
Cesnola formed the basis of the Metropolitan's early collections. Yet in 1885, Cesnola
authorized the sale of part of the collection at the Metropolitan, and in 1928 another
portion was dispersed at auction, where John Ringling purchased much of it.

Henri Matisse
French, 1869–1954

"Frontispiece and Title-page:
Portrait of Charles d'Orléans,"
Poèmes de Charles d'Orléans
(Paris: Tériade Éditeur, 1950)

> 101 color lithographs,
> no. 767/1200, signed in
> pencil by Henri Matisse
> 6½ × 10.6 in. (41.9 × 26.9 cm)

The shapes of the letters of poetry coalesce with bright colors in Matisse's book illustra-
tions, an important part of his oeuvre, especially in the later years of his life. In *Poèmes*,
which he began around 1943, he used simple classroom crayons to create joyous and lyri-
cal passages. The pages were later produced in perfect facsimiles on velin d'Arches by the
Mourlot Frères workshops. Matisse's books were often inspired by French poetry, written
either by his contemporaries or, in this instance, by the fifteenth-century French poet
Charles d'Orléans (1394–1465). Variations on the simplified fleur-de-lis and tapestry
patterns of the poet's times provide visual connectivity throughout the book.

Adolph Gottlieb

American, 1903–1974

Sacred Rites, 1946

Gouache on paper
30 × 22 in. (76.2 × 55.9 cm)
Gift of Benjamin Baldwin,
1977, SN963

One of the most worldly and learned artists of the New York School, Adolph Gottlieb spent his formative years in New York, where he was born, studying and working with many of the leaders of American modernism. Together with Mark Rothko, he is credited with providing the theoretical language for the Abstract Expressionist movement. The Ringling drawing is part of the artist's primitive Pictograph series from the 1940s, and was included in the Gottlieb retrospective held at the Guggenheim Museum in 1968. In many of these "constructions" or pictographs, Gottlieb created an uneven grid and filled it with objects and images, some referencing still-life and landscape motifs, and others responding to a totemic or architectural vocabulary. In its dynamic composition, *Sacred Rites* hovers between the deliberate geometry of a Cubist work and the concurrence of random, unconscious forms associated with Surrealism. This confrontation or convergence of both conscious and unwilled actions in the act of painting betrays something of the dilemma Gottlieb faced in responding to the two prevailing art movements of the day.

Ellsworth Kelly

American, 1923–

Blue Flower, 1969

Pencil on paper
29½ × 22 in. (74.9 × 55.9 cm)
Museum purchase with matching funds provided by Mrs. William Cox, Mr. and Mrs. A. Werk Cook, and the National Endowment for the Arts, 1977, MF77.8

A painter, sculptor, and printmaker, Ellsworth Kelly influenced movements such as Minimalism, Color Field painting, and Post-Painterly Abstraction, though he was never fully a part of any of these movements.

In the early 1950s, he began focusing largely on abstraction, but he continued to create line drawings from nature and human subjects. One of many plant drawings executed in the 1960s, *Blue Flower* consists of a flattened image, representing with absolute clarity a living object by the use of line alone. This approach reduces the flower to its essentials while creating an abstraction that departs from the three-dimensional subject it represents. In a sense, Kelly was more interested in plant forms as shapes than in reproducing nature. These drawings played a key role in his formulation of the artistic concept that guided him in all of his work: a concern for using nature as a point of departure from which to create abstract forms.

Jasper Johns

American, 1930–

Ale Cans V, 1975

India ink on folded paper
18 × 22 ¼ in. (45.7 × 56.5 cm)
Museum purchase with matching funds
provided by Mrs. William Cox, Mr. and
Mrs. A. Werk Cook, and the National
Endowment for the Arts, 1977, MF77.7

Jasper Johns remains one of the icons of the American Pop art movement, and his progressive body of work encompasses paintings, sculpture, prints, and drawings, all of which are explored deeply in his art making. *Ale Cans V*, depicting two cans of Ballantine Ale, takes its representation from *Painted Bronze (Ale Cans)* of 1960, and relates to one of Johns's most popular prints series dating to 1964. The sculpture was also chosen as the cover image for Leo Steinberg's seminal work on the artist. Johns returned to the Ballantine Ale cans over a decade later with a series of six drawings, moving from object to image in Pop art fashion. The first four ink drawings, numbered *I* to *IV*, were made on plastic and feature the familiar cans of ale from slightly different perspectives. The last two drawings, including the Ringling work, were made on paper, showing the same two cans; however, they are mirror images, produced by folding the paper at the center and blotting.

Christo

(Christo Javacheff)
American (born in Bulgaria), 1935–

*Running Fence, Project for Sonoma
and Marin Counties, California*, 1976

Pastel, charcoal, pencil, and crayon on paper
28 × 22 in. (71.1 × 55.9 cm)
Museum purchase with matching funds provided by
Mrs. William Cox, Mr. and Mrs. A. Werk Cook, and the
National Endowment for the Arts, 1977, MF77.10

When Christo Javacheff moved to Paris in 1958 to study painting, the Parisian art scene was engrossed in a movement known as *le nouveau réalisme* (New Realism). Dominated by artists such as Yves Klein and Jean Tinguely, the movement sought to question the boundaries of materiality and celebrate the object status of artistic production. It was there that Christo developed the form of expression for which he is now famous. *Empaquetage* (packaging) consists of wrapping objects in materials that both conceal and reveal the shapes of forms using large expanses of fabric and plastic materials. *Running Fence* was a work of art completed in September 1976 in which Christo and Jeanne-Claude constructed a 24½-mile-long, 18-foot-high fabric-and-steel fence that traversed Sonoma and Marin Counties in northern California. Crossing fourteen roads and the town of Valley Ford, this fence threaded the landscape like a "ribbon of light." All expenses for the project were funded by Christo and Jeanne-Claude through the sale of preparatory drawings and collages, scale models, and lithographs.

Eugène Atget

(Jean-Eugène-Auguste Atget)
French, 1857–1927

Bibliotheque Nationale #183, 1902

Silver chloride print, gold-toned
7 × 8⅜ in. (17.8 × 21.3 cm)
Gift of Warren J. and Margot Coville, 1997, MF97.1.17

Eugène Atget began his career as an actor. However, after
one year of studying at the Conservatoire d'Art Dramatique
in Paris he was called to the military. Upon his return in
the late 1880s he pursued an interest in painting but later
turned to photography, an artistic medium that was experi-
encing significant popularity by that time. Atget found great
success specializing in views of Paris, including images of
old houses, churches, streets, doors, and libraries. The
Bibliotheque Nationale #183 belongs to this body of work.
Taking a straightforward approach, Atget captures the softly
modulated shadows and architectural details. Although he
often claimed that his aim was to document, not create art,
the careful cropping and palpable atmospheric effects of this
photograph transform a building façade into visual poetry.

Berenice Abbott

American, 1898–1991

Court of the First Model Tenement in New York City, March 16, 1936

Gelatin silver print
18¹⁵⁄₁₆ × 15⅜ in. (48.1 × 39.1 cm)
Gift of Warren J. and Margot Coville, 2003, SN11112.1

A native of Ohio, Berenice Abbott never had formal photography training, but her interest in art prompted her to move to New York City. Through her connections in the art world, she relocated to Paris in 1921, where she experimented with sculpture and poetry. In 1923, photographer Man Ray hired her as his darkroom assistant, and she quickly mastered various photographic processes. Through Man Ray she met Eugène Atget, the famed photographer of Parisian street life. This meeting shaped much of what Abbott would consider worthy subject matter in her career as a photographer. Upon returning to New York City in 1929, she began to photograph all aspects of the city, from glamour to squalor, such as this candid view of a New York tenement.

135

Edward Weston

American, 1886–1958

Surf on Black Beach, 1938

Gelatin silver print
7 × 9½ in. (17.8 × 24.2 cm)
Museum purchase, 1969,
SN8456

Edward Weston was raised in
the suburbs of Chicago and
by the age of seventeen had
already exhibited his work at
the Art Institute of Chicago,
in 1903. In 1906 he relocated
to California, and he remained on the West Coast for the rest of his life. Weston visited
the New York studio of Alfred Stieglitz in 1923, which prompted him to reject the con-
cept of manipulating images into art pieces or "pictorial photography," of which Stieglitz
was a leading exponent. Weston instead embraced the concept of naturalistic photog-
raphy, which espoused the beauty of unadorned, truthful images. In this beach scene,
the reflection of light gives the sand an almost metallic black finish, and the modulating
waves and marks in the sand create a punctured pattern in the black surface.

Henri Cartier-Bresson

French, 1908–2004

Allée du Prado, Marseille, 1932

Gelatin silver print
14¼ × 9½ in. (36.19 × 24.13 cm)
Gift of Jay and Laura Crouse,
1987, MF87.30

Having begun his artistic career as a painter in France, working with André Lhote in 1927–1928, Henri Cartier-Bresson turned to photography in the 1930s. Beginning in 1932 he worked with a Leica, a small portable camera with a short exposure time that permitted photographers to snap candid unstaged shots. Cartier-Bresson's concept of the "decisive moment" became the bedrock of modern photojournalism and informed his own photographs of everyday subjects as well as of historical figures.

Here, a man stands alone on a tree-lined boulevard, which provides a simple backdrop for this scene of everyday life in Marseille. Despite technological developments, such as color photography, Cartier-Bresson preferred to create black-and-white prints throughout his career. He was one of the founders of Magnum Photos, Inc., a collective association of photographers who retained the rights to their own negatives.

Ansel Easton Adams

American, 1902–1984

The Grand Tetons and the Snake River, 1942

Gelatin silver print
28 × 22 in. (71.1 × 55.9 cm)
Gift of Alvin J. Gilbert,
1976, SN8866

One of the most famous American photographers, Ansel Adams began working with the medium as a teenager during a family vacation to Yosemite National Park. From 1920 to 1927 he was an officer of the Sierra Club, and his weekly expeditions through the valley would continue to impact his work throughout his career. An encounter with photographer Paul Strand in 1930 inspired Adams to devote his career to producing photographs that not only described American geographic features but also evoked the profound emotions the landscape inspired. With other photographers, including Edward Weston, he founded Group f/64 and later created the influential photography magazine *Aperture*. Though Yosemite was his most photographed subject, this image of the Grand Tetons and the Snake River in Wyoming is in keeping with his interest in capturing the beauty and grandeur of the American West.

Diane Arbus

American, 1923–1971

*Woman with Her
Baby Monkey, N.J.*, 1971

Gelatin silver print
25 × 21 1/16 × 1 1/8 in.
(63.5 × 53.5 × 2.9 cm)
Museum purchase,
1992, SN11019

Diane Arbus's body of work focuses on the unusual. Working almost exclusively in black-and-white, she haunted the fringes of society for glimpses of the truth about the human condition. Her photographs of mostly anonymous New Yorkers form the core of what she termed her "contemporary anthropology." Using a Rolleiflex medium format camera, Arbus routinely violated the idea of an appropriate distance between subject and photographer, purposefully exploiting the voyeuristic tendencies of the medium. After separating from her husband, Allen Arbus, she studied under photographer Richard Avedon, and by 1960 was considered a serious photojournalist. *Woman with Her Baby Monkey, N.J.* plays on the viewer's expectations, replacing a child with a monkey in the woman's arms and creating a jarring effect.

Cindy Sherman

American, 1954–

Untitled, from the portfolio
The Indomitable Spirit, 1979–1989

Chromogenic development
print (Ektacolor)
18 1/2 × 23 11/16 in. (47 × 60.2 cm)
Museum purchase with funds from
The Ringling Museum of Art Investment
Trust Fund, 1990, SN8988.4

Cindy Sherman studied film and photography at Buffalo State College, and her decision to pursue photography was born of a belief that it was the most appropriate medium to express American media-dominated culture. After moving to New York City, she quickly became known for her black-and-white stills, in which she portrayed herself as parodies of female stereotypes, particularly as the vulnerable voluptuous blonde. In the Ringling photograph, Sherman builds on this role. The viewpoint of the camera, somewhat obscured by leaves in the foreground, gives the entire photograph a voyeuristic lens, suggesting that her privacy has just been betrayed by our uninvited gaze.

138

Thomas Struth

German, 1954–

National Gallery 1, London, 1989

Cibachrome print
71 × 77¼ in. (180.3 × 196.2 cm)
Museum purchase,
1990, SN11009

Thomas Struth, a German photographer who trained in Düsseldorf and worked with Gerhard Richter from 1973 to 1980, is best known for his series Museum Photographs. These unstaged, unaltered monumental pictures feature people visiting major museums, churches, and other cultural destinations. Struth endeavors to examine the visitor's relationship with works of art—in this case, literally, as the visitors appear to be an extension of the painted space. Stepping in to take a closer look, one spectator in *National Gallery 1* mimics the posture of a figure in the Renaissance painting hanging on the wall, while the stance of another visitor echoes the pose of Christ. This large-scale photograph is a tour de force not only in its composition and subject matter, but also in its technical quality.

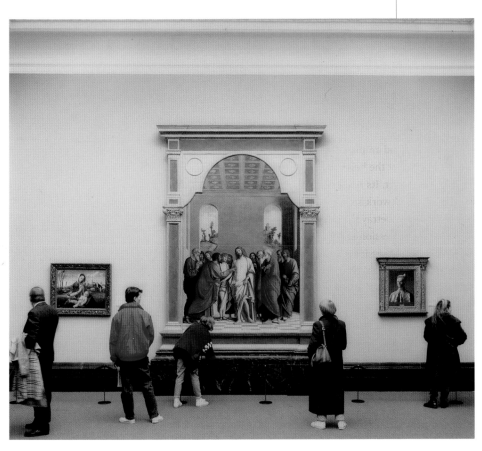

Alexander Calder

American, 1898–1976

Black Cascade: 12 Verticals, 1959

Painted black metal and wire
42 × 36 × 36 in. (106.7 × 91.4 × 91.4 cm)
Gift of Friends of Art of the Ringling
Museum, 1965, SN5483

Alexander Calder was born in Philadel-
phia and earned a degree in mechanical
engineering before pursuing a career as
an artist in 1923, when he enrolled in
the Art Students League in New York.
Early in his work, he experimented with
wire as a sculptural medium, creating figures that he would hang from his own sus-
pension designs, the most famous work being *Circus* of 1927. From this project was
born his fascination with mobiles, designs that allow sculpture to move. Calder cre-
ated mobiles of abstract compositions, which he suspended either from the ceiling
or from an armature, allowing forms to move freely in space. The Ringling mobile,
composed of geometric forms shaped from black metal, creates unpredictable pat-
terns of movement, challenging the notion of sculpture as a static art form.

Syd Solomon

American, 1917–2004

Silent World, 1961

Liquitex on gesso panel
58¼ × 48¼ in. (148 × 122.6 cm)
Museum purchase, 1962, SN742

This colorful and animated painting
was produced at the height of Syd
Solomon's career. Its rich palette
and thick brushwork are indicative
of his style and betray the influence
of German Expressionist painters and
the Abstract Expressionists working
in New York City. Following World War
II, Solomon began spending half of the
year in Sarasota and he was taken by
the natural beauty of the landscape.
In this work, Solomon demonstrates
the full potential of the medium of
acrylic paint. One of the first paint-
ers in America to use acrylic rather than oil, he was forced to paint quickly since
the work dried almost immediately. In turn, he has allowed the viewer to follow his
hand and witness his instinctive and decisive brush.

Philip Guston

American, 1913–1980

Wall Fragment, 1971

Oil on paper
19¾ × 27¾ in.
(50.2 × 70.5 cm)
Gift of Musa Guston,
1992, MF92.8

Born in Montréal, Philip Guston moved to Los Angeles in 1919. He studied briefly at the Otis Art Institute alongside Jackson Pollock before moving to New York in 1935. Initially working in the Abstract Expressionist style espoused by the New York School, Guston later turned to figural painting, rendering recognizable subjects in an almost childlike fashion. *Wall Fragment* features a central brick wall encased in a curved outline, separating it from other forms inhabiting the gray background. During the 1970s, the artist experimented with cartoon-like shapes and outlines, and his characteristically gray palette defined his work throughout his career. These paintings are often composed of recurrent motifs, creating a visual language with Surrealist overtones.

Frank Stella

American, 1936–

Jablonow I, 1971

Mixed media
on shaped canvas
96 × 116 × 3⅝ in.
(243.8 × 294.6 × 9.2 cm)
Museum purchase,
1974, SN941

Although Frank Stella was influenced by the Abstract Expressionist movement, he took painting in a new direction by creating bold geometric compositions using precise forms and lines. Later his work evolved into shaped canvases, in which lines and fields of color cover the canvas extending to the edges of the painting. Initially taking the form of large, basic geometric shapes such as a rectangle with overlapping triangle, these works became progressively more complex. In *Jablonow I*, there is a dynamic asymmetry of forceful diagonal lines going in different directions, and the irregular edges challenge the conventions of painting. Stella's inspiration for this painting came from photographs of the ruins of a Polish synagogue in the village of Jablonow, which was destroyed in World War II.

Robert Rauschenberg

American, 1925–

Preview (from the Hoarfrost series, 5/32), 1974

Transfer and paper bag collage on silk chiffon and silk taffeta
69 × 80½ in. (175.3 × 204.5 cm)
Gift of Mr. and Mrs. Robert M. Zell, 1982, MF82.10

Robert Rauschenberg's Hoarfrost series consists of large unstretched pieces of fabric with newsprint and photographs printed onto them. Paper and cardboard are incorporated into the composition, creating a collage effect, and the sheer, semitransparent fabric, with its upper edge pinned to the wall, is allowed to move freely. Rauschenberg used the same technique throughout the Hoarfrost series to produce more than 150 individual works. The Ringling collage represents a male figure, which appears to be an Archaic Greek *kouros*, placed between two cars. The contrast of the images creates a startling juxtaposition of the ancient and modern.

John Chamberlain

American, 1927–

Added Pleasure, 1975–1982

Painted and chromium-plated steel
111 × 53 × 36 in. (281.9 × 134.6 × 91.4 cm)
Museum purchase, 1983, SN5533

John Chamberlain embraced the spontaneity and intuition used by the Abstract Expressionists, introducing these concepts in his sculpture. This compact work consists of pieces of painted sheet metal from old cars that Chamberlain bent and twisted and then randomly fit together to create a highly volumetric work. The various shapes and sizes of metal create a modulated surface texture, completely redefining what it means to make a sculpture when compared to traditional techniques such as bronze casting. Chamberlain departed from the current trend in sculpture that focused on the simplification of volume and the dissolution of form into planar constructs by creating dynamic three-dimensional objects.

Philip Pearlstein

American, 1924–

Female Model on Ladder, 1976

Oil on canvas
72 × 96 in. (182.9 × 243.8 cm)
Museum purchase, 1981, SN979

In Pittsburgh, Philip Pearlstein worked almost exclusively as an abstract landscape painter in the 1940s and 1950s. Upon winning a Fulbright Fellowship award to paint in Rome from 1958 to 1959, he adopted a different style that was dependent on precise drawing and brushwork. Abandoning abstraction and the landscape, he created strictly figural works, painting directly from the nude model and often choosing close viewpoints that dissolved the appropriate distance between artist and model. Viewing the human body as a landscape in its own right, Pearlstein developed an additive method of painting, whereby he developed one portion of the canvas at a time. Eschewing the primacy of narrative, he explained: "I only care about the visual aspect of paintings. I don't want the burden of literature thrust upon me when I only want to use my eyes."

143

Louise Nevelson

American, 1899–1988

City-Sunscape, 1979

Polyester resin cast
12¾ × 9⅛ in. (32.4 × 23.2 cm)
Gift of Paulette and Kurt Olden, 1987, MF87.17

Having studied at the Art Students League in New York, and also under the artist Hans Hofmann, Louise Nevelson produced work that is informed by a variety of techniques and styles, including Cubism and Constructivism. This eclecticism of styles is particularly visible in the Ringling piece. Here a monochrome relief creates a visual puzzle. Although it appears to include fragments of wood, found objects, and pieces of architectural ornamentation, it is a resin cast. By painting the sculpture black, Nevelson obscures the identity of the actual work, forcing the viewer to investigate this intriguing piece more closely. Combining the formal aesthetic of Cubism with industrial materials, Nevelson became one of the most important American sculptors of the twentieth century.

Jackie Ferrara

American, 1929–

Semaphore, 1984

Stained pine
86 × 22½ in. (218.4 × 57.2 cm)
Museum purchase, 1991, SN7431

While Jackie Ferrara uses the simple geometry of minimalist sculpture, she departed from that movement's interest in inert form and industrially fabricated materials. *Semaphore* is constructed of flat pieces of wood stacked up with the order, precision, and geometry of architecture, gradually becoming narrower toward the top. Other similar works resemble towers or pyramids, although there is no specific reference to any one structure or monument. Instead, Ferrara creates timeless, universal forms. In addition to these towering compositions, she has built complex structures spread out horizontally, consisting of multiple bases supporting forms on different levels.

David Hockney

British, 1937–

Christopher Isherwood Talking to Bob Holman,
Santa Monica, 14 March 1983

Collage of 98 color photographs
on rag paper laminated to rag board
laminated to stretcher of wood
and Upsom board
44 × 65⅛ in. (111.8 × 165.4 cm)
Museum purchase, 1986, SN8970

In his early career, David Hockney rejected pho-
tography because it produced images of static
moments in time. In the 1980s, however, he began
to explore the possibilities of photography, but
not in the conventional sense of single images or
works. Instead, he took multiple shots of his sub-
jects from different points of view to convey the
movements and changing expressions of people,
assembling and overlapping them into one com-
position. Here the subject is a conversation among
three friends in which several images of each per-
son document activity and the passage of time.
The photo-collage is a study of visual perception
from the perspective of a person entering a room
and seeing it not as a unified whole, but as a
series of glances from one side to the other.

Barbara Kruger

American, 1945–

Untitled (Who Will Write the History of Tears?), 1991

Photographic silkscreen on vinyl
60 × 148 in. (152.4 × 375.9 cm)
Foundation purchase with funds provided
by the National Endowment for the Arts,
the John E. Galvin Charitable Trust,
and the Modern Art Council, 1991, MF91.1

Barbara Kruger studied photography with Diane Arbus and later worked for Condé Nast Publications. Her work is characterized by a visual language long used in newspapers and advertising. Through the use of graphic motifs and one-liners, Kruger grabs and focuses the viewer's attention in a reassuringly familiar format while simultaneously subverting any connection with its content. In this photo-based work, the image of a baby and the words "Who will write the history of tears?" raise the uneasy question of our relationship with children—our own and those around the world. Throughout her work, Kruger often poses difficult questions that require complex meditations on our relationship with the media as well as with our families.

Jorge Marin

Mexican, 1963–

La Gloria, 2007

Bronze
180 in. (457.2 cm)
Museum purchase, 2007, with gifts from
the Robert L. Stuffings Charitable Trust,
The Gloria and Louis Flanzer Philanthropic
Trust, and the Ringling Museum of Art
Endowment, 2007, SN11157

In 2006, Jorge Marin was commissioned to create this sculpture for the entrance to the Ulla R. and Arthur F. Searing Wing at the Ringling Museum of Art. Marin's subjects include nude archers and acrobats, centaurs, and angels, and are borrowed from mythology, religion, and theater. *La Gloria* recalls the *Nike of Samothrace*, a famous Hellenistic sculpture (Musée du Louvre, Paris), as she lands balanced on one foot. Although he makes reference to the classical, Marin reworks this ancient model to create a universal figure for all humankind. The opening in the chest represents humanity's desire to share passion and love with the world.

Cà d'Zan

In the Venetian dialect, *Cà d'Zan* means "house of John." Situated on the edge of Sarasota Bay, the eighty-foot-tall, two-hundred-foot-wide structure stands majestically, its belvedere tower offering a bird's-eye view of the barrier islands that protect the bay. In 1923 John Ringling commissioned New York architect Dwight James Baum to begin drawings for a winter residence. Baum worked closely with Mable Ringling, assembling details from images and sketches collected from her numerous trips to Venice. The house incorporates direct quotes from the Venetian Gothic architecture of *palazzi* along the Grand Canal, including the Cà d'Oro, the Palazzo Ducale, the Palazzo Contarini-Fasan, and the Palazzo Franchetti. The architect also hired O. W. Ketcham to create the terra-cotta features for the decorative embellishments, making copies from the magnificent *palazzi* as well as including modern touches such as the signs of the zodiac and secret Masonic symbols to represent John's involvement with the Freemason organization.

The building's construction began in 1924 and was completed in December 1926 at a cost of $1.5 million. Designed as a private resort for the Ringlings to entertain their many winter guests, Cà d'Zan featured a marble in-ground swimming pool surrounded by lush vegetation and decorated with a life-size marble sculpture of Venus, and also a large clay tennis court framed with dense tree growth to give privacy while the guests played. A 125-foot yacht, *Zalophus*, and a 52-foot cruiser, *Zalophus, Jr.*, were readily available for sightseeing along the Gulf Coast, and Mable also imported a Venetian gondola that was moored off an island directly behind Cà d'Zan, available for boating at any time. And of course, the Ringlings also owned a fleet of luxury automobiles, including Rolls Royces and Pierce-Arrows, which were available to drive the guests to the train or shopping downtown at a moment's notice. John Ringling's success was internationally recognized, not only as a circus owner but also as an investor in oil wells, railroads, banking, and ranch land. In fact, he owned more than one hundred thousand acres in the western United States and established the towns of Ringling, Oklahoma, and Ringling, Montana. John Ringling also became one of the largest land owners in Sarasota. Along with his partner Owen Burns, Ringling developed Longboat Key, Lido Key, St. Armands Key, and Cedar Key as Mediterranean-style resort retreats that would encourage tourism to the area. Cà d'Zan became the symbol of his power and success within the Sarasota community.

Facing Detail from William Andrew Pogany,
John and Mable Ringling, Game Room Ceiling, 1926 (see p. 172). 149

Dwight James Baum

American, 1886–1939

Cà d'Zan, 1926

Bequest of John Ringling, 1936

The main entrance to the Ringling mansion and gardens was through the Venetian-style Gate House. New York architect Dwight James Baum designed the building and ordered brightly glazed terra-cotta ornamentations to be custom-made by the firm of O. W. Ketcham. Seventeenth-century clay roof tiles from Granada, Spain, were installed on the Gate House. The Gothic tracery corollas within frames of scrolling vines were made as exact replicas of those at the fifteenth-century Palazzo Contarini-Fasan located on the Grand Canal in Venice. The property was enclosed by masonry walls, so that the only access to the Ringling Estate was through the wrought-iron gates with scrolling flowers and vines that created a heart with the initial "R."

Cà d'Zan, West Elevation (back)

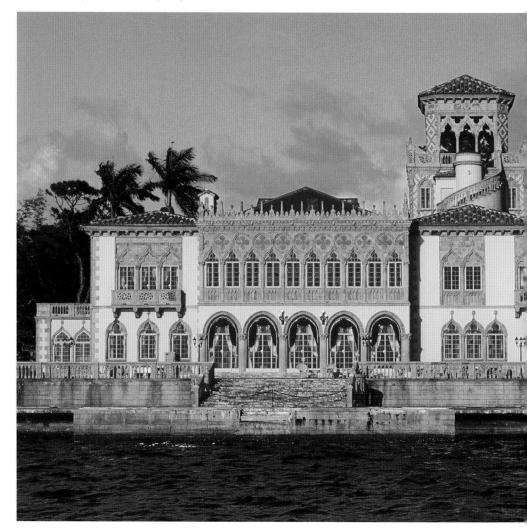

Cà d'Zan,
East Elevation (front)

John H. Phillips

American, 1886–1939

Cà d'Zan, Italianate Caretaker's Cottage, 1926

Bequest of John Ringling, 1936

At the end of the driveway, nestled between exotic trees, stands a Venetian guesthouse designed by the New York architect John H. Phillips. Mable Ringling met Phillips in 1924 through Ralph and Ellen Caples, who had commissioned the architect to design an "Italian Villa" on the adjoining property south of Cà d'Zan.

Prior to this, Phillips had worked for the firm of McKim, Mead, and White, and helped to design the central block of the Metropolitan Museum of Art and New York's Grand Central Station. Impressed by his portfolio, Mable Ringling commissioned Phillips to design a "Venetian Cottage" reminiscent of the modest homes found on the islands of Burano and Murano, Italy. The structure was completed in 1927 and was used by the groundskeeper and his family and then later by the yacht captains and their families. Pleased with his work, the Ringlings also commissioned Phillips to design the Museum of Art, which was completed and first opened to the public in 1930.

The front steps of the cottage lead to an informal front porch with Moorish arches and "Rose of Verona" marble column supports. French doors open into the front room, in which beamed ceilings offer a casual setting with a quaint corner fireplace faced in flagstone. Adjacent to a small dining room is the kitchen and pantry area in the back of the cottage with access to the private bedroom chambers.

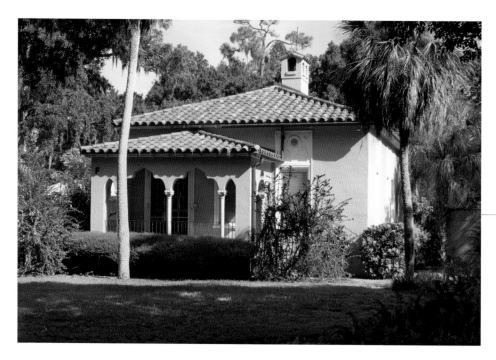

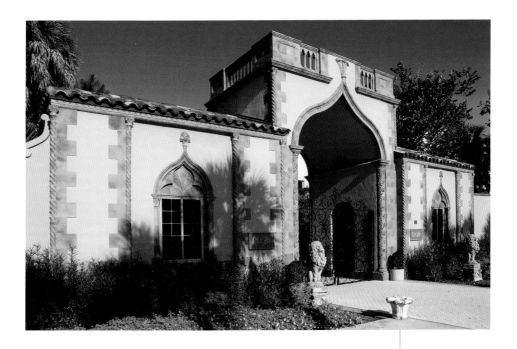

Dwight James Baum

American, 1886–1939

Cà d'Zan, Gate House, 1926

Bequest of John Ringling, 1936

The Gate House also served originally as an apartment for the groundskeeper. Inside the north side of the building there was a comfortable studio apartment with a kitchen, bedroom, and screened porch. A sitting room and full bathroom were also designed for the south side of the structure. Currently the Gate House serves as the main entry point for the 66-acre Museum complex and offers a security station for visitors.

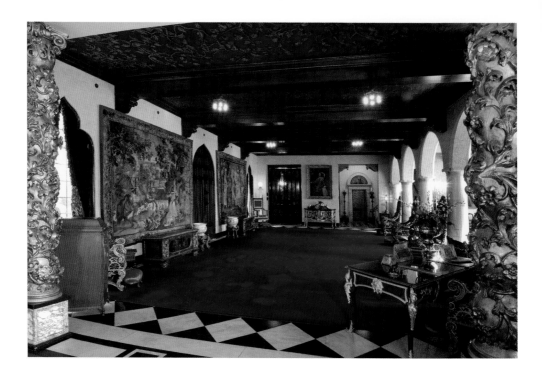

Dwight James Baum
American, 1886–1939

Cà d'Zan, Entrance/Foyer, 1926

Bequest of John Ringling, 1936

Guests of the Ringlings entered Cà d'Zan through a Gothic arched entrance with twelve-foot carved walnut doors that were treated to give an old-world appearance. Dwight James Baum designed the door's copper and wrought-iron gates, incorporating designs of starfish, sea horses, and a grill resembling a knotted-rope pattern. Separate from the doors themselves, the grill could be locked so that the front doors could be left open, allowing a breeze to cool the rooms while keeping the house secure.

With its Venetian atmosphere, the foyer makes a striking impression and sets the formal tone for the rest of the ground-floor rooms. Inside, the front door is flanked by two large seventeenth-century Flemish tapestries, beneath which are two nine-teenth-century *cassone*, or chests, that once held the Ringlings' collection of more than four hundred Aeolian Duo-Art organ rolls. Perhaps most impressive upon entering Cà d'Zan, however, is the ceiling, painted by Robert Webb, Jr., with designs of scrolling grapevines and acanthus leaves in rich earth tones.

The Ringlings also imported a variety of rare materials to decorate this Gilded Age mansion, including veined green onyx columns, marble floors, and the gilded Solomonic columns. Mable sought to replicate the color and texture of travertine marble on the walls throughout the house to give the appearance of an ancient Italian *palazzo*, and placed six carved and gilded throne chairs—from the New Jersey estate of George Jay Gould—in front of each column. A seventeenth-century portrait of Marianna of Austria, second wife to King Philip IV of Spain—painted by Juan Bautista Martinez del Mazo—hangs by the entrance to the formal dining room and grand staircase.

After **Antoine Gaudreux**
French, 1680–1751

Louis XV Style Commode, ca. 1890
Walnut, satin wood, gilt bronze,
and marble
37 × 76 × 28 in. (94 × 184.2 × 71.1 cm)
Bequest of John Ringling, 1936,
SN1131

Dwight James Baum
American, 1886–1939

Cà d'Zan, Grand Staircase, 1926
Bequest of John Ringling, 1936

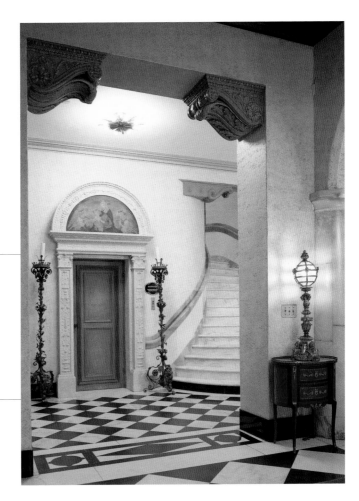

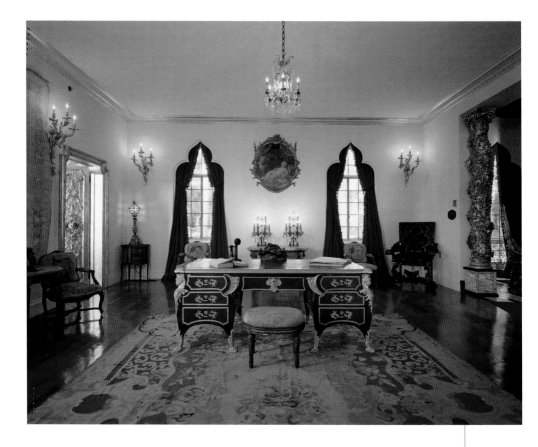

Dwight James Baum

American, 1886–1939

Cà d'Zan, East Ballroom, 1926

Bequest of John Ringling, 1936

The East Ballroom, used mainly as a lounge, includes several of Mable Ringling's most cherished possessions: a French *bureau-plat*, or writing table, a rare Turkish silk carpet, and a suite of chairs with antique tapestry upholstery illustrating Aesop's *Fables*. The gilt-bronze wall sconces were purchased at auction in 1926 from the Fifth Avenue estate of one of New York City's most notable families, Mr. Vincent Astor. The luxurious gilded three-panel screen separating the East Ballroom from the West Ballroom was made by Jules Allard et Fils, and was purchased from the estate of another prominent family, George Jay Gould, son of railroad magnate Jay Gould. Finally, a Napoleon III Aubusson carpet, loomed in the 1870s with depictions of roses in the central cartouche and corners, is centered on the Asian teak floor.

Historic photographs taken in the late 1920s by Mable indicate that the East Ballroom (listed as the "North" Ballroom on the mansion's enunciator) functioned as a lounge as well as an extension to the Ballroom dance floor (on such occasions, the Steinway grand piano was placed where the desk now stands).

156

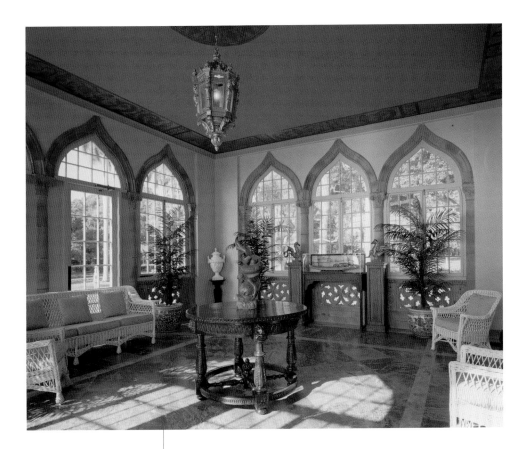

Dwight James Baum

American, 1886–1939

*Cà d'Zan, Ballroom Doors
and Solarium*, 1926

Bequest of John Ringling, 1936

The Ringlings took great interest in purchasing interior and exterior sections from Gilded Age mansions that were sited for demolition during the 1920s—one fine example of which is the pair of carved and gilded doors that opens into the Solarium.

Dwight James Baum

American, 1886–1939

Cà d'Zan, Ballroom, 1926

Bequest of John Ringling, 1936

Although many Gilded Age mansions have ballrooms, perhaps none expresses the individual personality of the owners as vividly as the Ballroom of Cà d'Zan. No doubt the focal point of the room, the gilded coffered ceiling features twenty-two vignettes depicting dancing couples from various nations. Called *Dancers of Nations,* these octagonal canvases were painted by William ("Willy") Andrew Pogany in his New York studio and then transported to Sarasota in 1926. Pogany is perhaps most famous for his illustrated books, costume and set designs for the Metropolitan Opera, murals for William Randolph Hearst, and for his role as the art director for many Hollywood movies. He was introduced to the Ringlings while they were staying in their plush New York apartment on Fifth Avenue by Florenz Ziegfeld, owner of the Ziegfeld Follies.

The arched doors are decorated in an Italian technique called *sgraffito* (a pattern that is scratched out of a dry paint to create a design), illustrating playful figures and scroll designs in a gold-colored paint. Three eighteenth-century Venetian mirrors hang majestically on the south wall, providing light for those dancing during one of Mable's evening parties. An eighteenth-century English gilded settee and chairs surround the room. The modern silk velvet upholstery by Scalamandré was hand-loomed by the American company for the Museum's restoration project from 1999 to 2002.

Tiffany & Co.

American, 1853–

Cigar Box, 1905

Repoussé-chased bronze
with wooden liner
3 × 9 × 6 in. (7.62 × 22.9 × 15.2 cm)
Bequest of John Ringling, 1936, SN11127

William Andrew Pogany

American, 1882–1955

Cà d'Zan, Ballroom Ceiling (detail), 1926

Oil on canvas
Bequest of John Ringling, 1936

Dwight James Baum

American, 1886–1939

Cà d'Zan, Court (view from ground level), 1926

Bequest of John Ringling, 1936

The Ringlings referred to the central living space of Cà d'Zan as "The Court." The room was designed with a classical Northern Italian central court reminiscent of the open-air courtyards of the Renaissance. Architect Dwight James Baum enclosed the courtyard to create a focal point for entertaining. Many large-scale functions were held in this space, as well as intimate card games with friends and family members. Mable hired Robert Webb, Jr., to paint the Court's 31-foot-high pecky cypress ceiling, requesting Venetian-inspired decorations such as *The Winged Lion of Venice*, which dominates the west central wall.

The court space was initially created for musical entertaining. A 2,289-pipe Aeolian Duo-Art organ was installed on the second level mezzanine, concealed behind a seventeenth-century Flemish tapestry purchased from the Vincent Astor estate, and a Steinway grand piano, with an outstanding art-case made of rosewood and kingwood parquetry that dates to 1892, was purchased for the room.

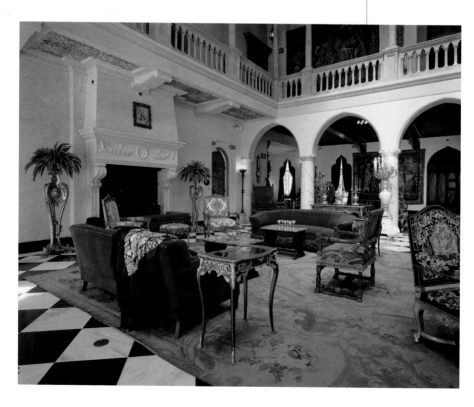

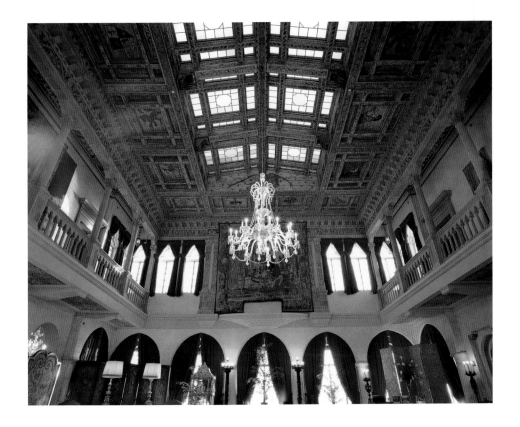

Dwight James Baum

American, 1886–1939

Cà d'Zan, Court (ceiling with chandelier), 1926

Bequest of
John Ringling, 1936

The skylight illuminates the space in five colors of custom-made French lac glass—designed to synchronize with Mable's decorative color scheme throughout the house—while seven sets of French doors along the west side of the room open onto the 12,000-square-foot marble terrace, which contains rare varieties of marble from around the world. The terrace was used for large gatherings and also as a mooring for their yachts. Both the 125-foot yacht and the 52-foot cruiser were used to give tours of Sarasota Bay.

Steinway & Sons

American, 1853–

Grand Piano, 1892

Rosewood, tulipwood veneer, gold leaf
46 × 56 × 86 in.
(91.1 × 146.1 × 213.4 cm)
Bequest of John Ringling, 1936, SN1107

161

Dwight James Baum
American, 1886–1939

Cà d'Zan, Breakfast Room, 1926

Bequest of John Ringling, 1936

Relatively simple in its decorative treatment, the Breakfast Room was used for informal dining. Delicate wrought-iron gates kept the Ringlings' pets from disturbing the guests during the luncheons and card parties, while a full bank of windows on two sides of the space offered a magnificent view of Sarasota Bay and Longboat Key, where Ringling was developing housing and a two-hundred-room Ritz Carlton Hotel.

Mable Ringling's decorative scheme for the room featured a deep green color, having both the frames and the leather on the Renaissance Revival dining chairs and the blinds from the Burlington Venetian Blind Company in Burlington, Vermont, customized and painted green. In fact, blinds from the Vermont company were ordered for all 180 windows in the mansion, with copper screens provided for each. Perhaps the most prominent feature of the room, however, is the bronze chandelier with emerald-green crystals that the Ringlings purchased from the island of Murano. The large carved and gilded Baroque-style console table was purchased at auction from the estate of George Crocker—a renowned art collector who lived near the Ringlings' 100-acre summer estate on the Hudson River in Alpine, New Jersey.

Still Life with Parrots (ca. 1645), by the seventeenth-century Dutch painter Jan Davidsz. de Heem, was originally installed in this room but has since been moved to the Museum of Art.

Landscape with Hunt Scene, Cà d'Zan Tap Room
American, ca. 1910
Enamel-painted leaded glass
45 × 106½ in. (114.3 × 269.24 cm)
Bequest of John Ringling, 1936

Dwight James Baum
American, 1886–1939

*Cà d'Zan, Tap Room
(from the Cicardi Restaurant,
St. Louis, Missouri)*, 1910–1925
Bequest of John Ringling, 1936

John Ringling purchased the interior of Cà d'Zan's Tap Room in 1925 from the owner of the Cicardi Restaurant in St. Louis, Missouri, when he learned the restaurant was slated for demolition in order to build the Roosevelt Hotel. John, who had become familiar with the restaurant during business trips to St. Louis (where he owned several businesses, including the St. Louis-Hannibal Railroad), loved the walnut-paneled walls, massive burl-walnut handrail, and Tiffany-style windows in a grapevine pattern—all of which had to be altered to fit this more intimate space.

Because the 1920s was the era of Prohibition, the Ringlings built a walk-in vault on the third floor of Cà d'Zan in order to store their nearly twelve hundred bottles of wine and liquor. Several of the original bottles are on display on the bar's counter, one of which bears the label, "John Ringling's Reserve Stock Bourbon."

On the north and south walls, two small walnut doors reveal silver sinks where guests could mix their drinks before dinner was served. Another door behind a stained-glass panel reveals an electric Kelvinator for ice and a section behind the lower panel for hors d'oeuvres. A wall safe was also installed outside the Tap Room door to store the Ringling collection of antique silver and Tiffany flatware.

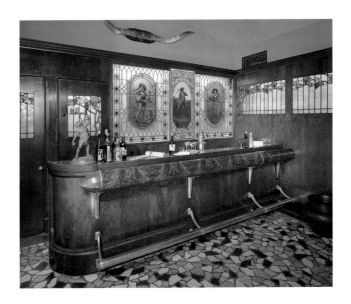

163

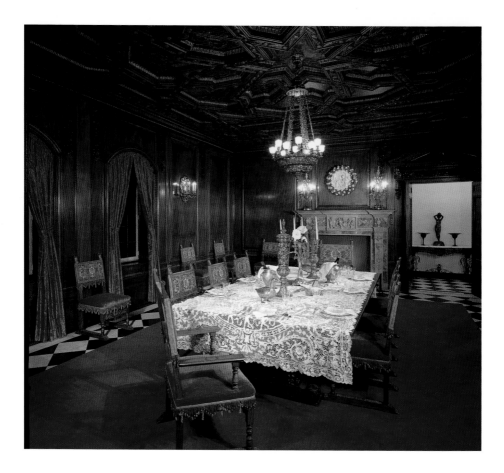

Dwight James Baum
American, 1886–1939

Cà d'Zan, Dining Room, 1926
Bequest of John Ringling, 1936

Mable worked with architect Dwight James Baum to design the dining room to be the most opulent room in the house for entertaining. When the Ringlings planned large dinner parties, the dining table was rolled into the foyer, where twenty leaves could be installed, making the table reach an enormous 30 feet in length. Jules Allard et Fils, known for creating furniture for the Vanderbilt mansions across the United States, designed the table in the late nineteenth century. The firm of Edward F. Caldwell created the silver chandelier and wall sconces that illuminated the intimate space, and the black walnut Neoclassical-style wainscoting came from an American Gilded Age mansion that was dismantled and sold at auction during the 1920s. One of the most impressive features of the room is the ceiling. What appears to be pure wood is actually *trompe l'oeil* cast plaster, a painted illusion created by Robert Webb, Jr.

Mable entertained her guests using only the finest European lace and damask, which often bore her embroidered monogram MBR (Mable Burton Ringling). The mansion's illustrious guest list included Governor Al Smith of New York; Mayor Jimmy Walker of New York City and his movie-star companion Betty Compton; Florenz Ziegfeld and his wife, Billie Burke; and vaudeville theater owner Edward Albee.

Francis and John Booker
Irish, active ca. 1750

One of a Pair of Neoclassical Pier Mirrors,
Cà d'Zan Dining Room, 1755
Carved and gilded wood, glass
81 × 42 × 4½ in. (205.7 × 106.7 × 10.16 cm)
Bequest of John Ringling, 1936, SN1187

Delftware Birdcage
Dutch, ca. 1775
Tin-glazed earthenware
46 × 22 × 22 in. (116.8 × 55.8 × 55.8 cm)
Bequest of John Ringling, 1936, SN7303

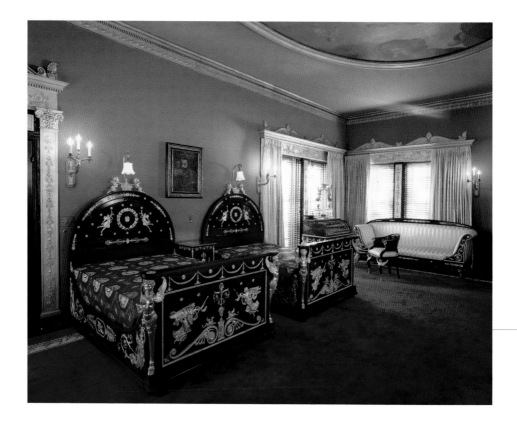

Dwight James Baum

American, 1886–1939

Cà d'Zan, John Ringling's Master Bedroom, 1926

Bequest of John Ringling, 1936

Incorporating a loggia, marble bathroom, private office, and an exercise room complete with another bathroom with a stand-up shower, John Ringling's bedroom suite is the largest and most impressive of the private chambers. On the east side of the suite, a bank of French doors and windows opens to a large marble-paved loggia that overlooks the property's 66 acres of lush gardens, while on the south and west sides are small balconies that offer delightful views of Sarasota Bay.

The room is furnished with a bedroom suite made in 1850 by one of the premier Parisian cabinet makers of the nineteenth century, Antoine Krieger (1800–1860). John Ringling paid $35,000 for the thirteen-piece suite, which includes a pair of double beds and various desks and cabinets, all with gilt-bronze mounts on rich flame mahogany—details inspired by Malmaison, one of Napoléon and Josephine's Parisian palaces.

Mounted overhead on the ceiling is a massive eighteenth-century canvas, *Dawn Driving Away Darkness* by Jacob de Wit (1695–1754), painted in 1735. Opposite the two beds, on the north wall, is a large portrait of Paulina Bonaparte Borghese, painted in 1811 by Louis Benjamin Devouge (1770–1842), and acquired by Ringling from the Saint Nicholas Hotel in Cincinnati, Ohio.

Ferdinand Barbedienne

French, 1810–1892

Sleeping Cleopatra Mantel Clock, ca. 1850

Bronze doré, alabaster, enamel, and glass
34½ × 35 × 15 in. (87.6 × 88.9 × 38.1 cm)
Bequest of John Ringling, 1936, SN1343

Dwight James Baum

American, 1886–1939

Cà d'Zan, John Ringling's Master Bathroom, 1926

Bequest of John Ringling, 1936

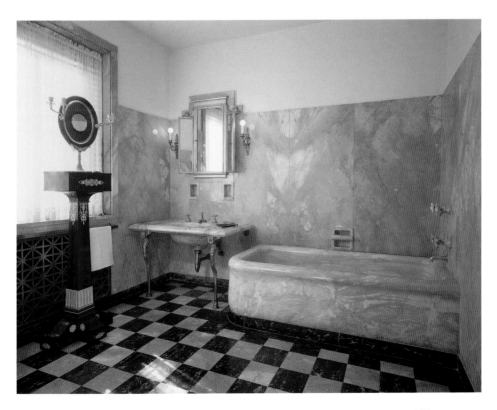

CÀ D'ZAN

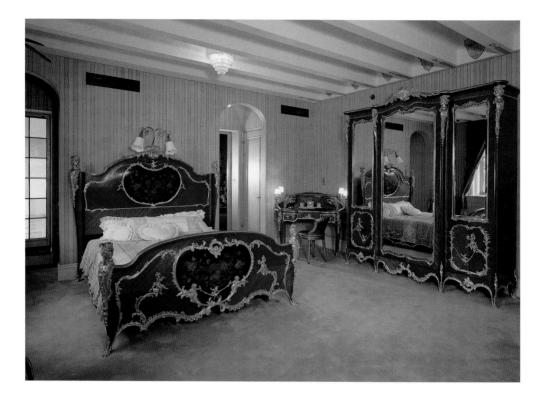

Dwight James Baum

American, 1886–1939

Cà d'Zan, Mable Ringling's Bedroom and Boudoir, 1926

Bequest of John Ringling, 1936

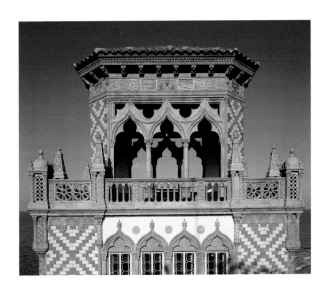

Dwight James Baum

American, 1886–1939

Cà d'Zan, Tower and Tower Bedroom, 1926

Bequest of John Ringling, 1936

169

Five Harbor Scenes (Fan)

Dutch, ca. 1750
Carved, pierced ivory sticks with polychrome
details, watercolor on paper leaf
10 × 15¼ in. (25.4 × 38.7 cm)
Gift of Elsa James Zelley, in memory of
her mother, Elsa Konig Nitzsche, 1988, MF88.14.14

The creation of a folding fan in the eigh-
teenth century was an expensive
endeavor. First, an artist would have
to prepare and paint the paper or
skin leaf. Then a master carver would
be in charge of cutting and piercing the
fan sticks and guards. After this, a fan work-
shop would be in charge of joining the painted leaf
to the ivory sticks. Paper boxes were also created along
with the fan to protect the delicate sticks from damage.

This Dutch fan is a fine example of this complicated production
process. The fan, which depicts harbor scenes through five vignettes, is exquisitely
painted and the ivory sticks are delicately carved to reveal figures, animals, and
painted decorations showing figures, boats, and architecture.

The Four Seasons (Fan)

French, ca. 1770
Carved, pierced, and gilded sticks
with applied silver and gold foil,
watercolor on paper with sequins
10½ × 19³⁄₁₆ in. (26.7 × 48.7 cm)
Gift of Elsa James Zelley, in memory
of her mother, Elsa Konig Nitsche,
1988, MF88.14.10

In the eighteenth century, handheld fans often featured a complex pattern on the
decorative edge of the ivory guard sticks that could only be viewed in a closed state.
This example is decorated with four colorful vignettes representing the four seasons.
At the center of the fan leaf's decoration is a classical urn on a marble pedestal dis-
playing an arrangement of roses. The fan maker applied metal sequins to the decora-
tive borders of the leaf, which both replicates the foil decoration on the ivory stick
and reflects the candlelight that would have illuminated the space of an evening
dance or theatrical production. These elegant folding fans were often used to cover
the face of the owner to coquettishly hide her identity from an admirer.

Court Scene (Fan)

Chinese, ca. 1835
Rounded wooden sticks lacquered, in two
shades of black and gold, silk tassel,
brass rivet and loop
10 × 15¼ in. (25.4 × 38.7 cm)
Gift of Elsa James Zelley, in
memory of her mother, Elsa Konig
Nitzsche, 1988, MF88.14.61

Fans from the Orient were luxury items
that were generally exported by the Honorable
East India Company and the Dutch East India
Company. Highly prized, they were often given
as gifts of friendship. The sticks of a brisé fan
carry no paper or skin leaf, but extend the full
length to provide a continuous surface for decoration. Joined at the top with
an interwoven silk ribbon, they allow the fan to easily fold for holding. In this
example, the surface is lacquered with a profusion of gilded decorations that
illustrate scenes of court life as well as butterflies and flowers. Many Asian
fans were also carved with intricate designs called "frozen lace," used rare and
expensive materials such as ivory and tortoiseshell, and could be personalized
with initials carved into the design.

The Bird Catcher (Fan)

French, ca. 1865
Pierced and gilded mother-
of-pearl sticks, watercolor and
gilt on paper leaf
11¾ × 22 in. (29.8 × 55.9 cm)
Gift of Elsa James Zelley, in memory of her
mother, Elsa Konig Nitzsche, 1988, MF88.14.17

As documented in numerous paintings from the sixteenth to the twentieth centuries, fans have for years been an important fashion accessory. Many were created
to accompany a specific event or celebration, to express a secret testament of love,
or even as a portrait of a favorite pet. This example, which depicts a couple in
eighteenth-century costume set among classical ruins in a forest, is known as a
"courting fan." These were often commissioned by a gentleman to give to his lover.
Symbols of love can be found in the painted decorations: a red rose is the traditional
symbol for passion, the white rose signifies purity, and the violet can symbolize
fidelity and chastity. Fans were also often used to communicate. A fan that is closed
and pointed at the right cheek, for instance, silently indicates "yes," while a closed
fan that points to the left cheek indicates "no." A fan placed against the heart, of
course, means "you have won my love."

Dwight James Baum
American, 1886–1939

Cà d'Zan, Game Room, 1926
Bequest of John Ringling, 1936

William Andrew Pogany
American, 1882–1939

*John and Mable Ringling,
Game Room Ceiling,* 1926
Oil on canvas mounted
on ceiling (detail)
120 × 138 in. (304.8 × 350 cm)
Bequest of John Ringling, 1936

Mable's Rose Garden
1912

Since she installed formal and informal gardens at each of their private residences around the country, it is clear that gardening was one of Mable Ringling's most passionate hobbies. After they purchased Palm Elysian, the original home on the Ringling Estate site, in 1911, Mable's first project was to create a formal rose garden. Drawn out in a classic Italianate wheel design with a centralized limestone gazebo supporting a wrought-iron dome, it was completed in 1913. At the perimeter of the garden are dozens of European figures sculpted in eighteenth-century peasant costumes. Between those figures are 8-foot columns that once supported arched trellises, which would have framed the design with flowering vines.

Featuring almost 1,200 fragrant roses grown from cuttings from plants dating back to the 1700s, the present garden also offers two new "display gardens" that have been installed beside the historic wheel design, making an enormous 27,225 square feet of plantings. Two modern rose gardens have been added in recent years. The "All American Rose Selection" test garden features hybrid teas, floribundas, grandiflora, and climbing roses, and is one of nineteen such official test gardens in the United States. "The Miniature and Mini-Flora Rose Garden" is the second garden. It, too, is recognized by the Rose Society as one of five demonstration test gardens in America.

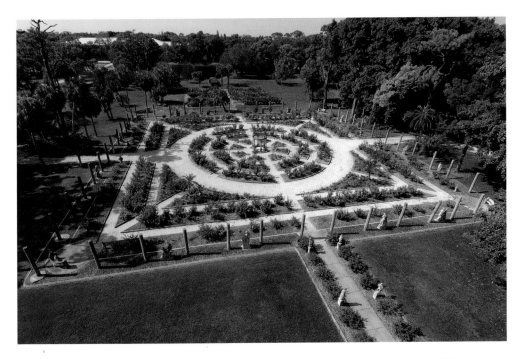

Circus Museum

A. Everett "Chick" Austin, Jr., the first director of the Ringling Museum of Art, established the Circus Museum in 1948. It was the first museum in America to document the rich history of the circus. For Austin, the Circus Museum both aided the visitor's experience and honored the memory of John Ringling. Ringling moved the winter quarters of the Ringling Bros. and Barnum & Bailey show from Bridgeport, Connecticut, to Sarasota, Florida, in 1927. By then Ringling and Sarasota had become practically synonymous. The winter home of the Ringling Circus drew hundreds of thousands of visitors during its time in Sarasota. Performers and workers became a part of the Sarasota community, making their homes there and giving the town a wonderfully exotic air.

The 1927 circus empire of John Ringling was far different from the circus that had been founded in 1884 by the five brothers from Baraboo, Wisconsin: Al, Otto, Alf. T., Charles, and John, sons of August and Marie Salomé (née Juliar) Ringling. Because of their hard work, the Ringling show developed quickly from a small wagon operation into a major railroad circus that competed with the world-renowned Barnum & Bailey Circus. With James A. Bailey's death in 1906, however, the Barnum & Bailey show was left without strong leadership, and on October 22, 1907, the Ringlings purchased the Greatest Show on Earth. Run as two separate units until 1919, the two gigantic circuses joined forces to form the Ringling Bros. and Barnum & Bailey Combined Shows, *The Greatest Show on Earth.*

The Ringling family dominance in the circus world came to an end in 1967 when Judge Roy Hofheinz, Israel S. Feld, and Irvin Feld purchased the Ringling circus from the Norths, nephews of John Ringling. Following in the great traditions of P. T. Barnum and the Ringling brothers, Feld Entertainment is today the largest provider of live action family entertainment in the world.

Over the past sixty years, the Circus Museum has built upon Austin's original vision to present the excitement, glamour, and history of the American circus. The exhibitions at the Circus Museum showcase elaborately carved parade wagons, demonstrate the logistical complexity of moving the colossal canvas city, and reveal the advertising power of the circus poster. The newest chapter in the history of the Circus Museum began in January 2006, when the Tibbals Learning Center was opened. The Howard Bros. Circus Model, the largest miniature circus in the world, is at the heart of the building, serving as an ongoing testimony to the rich history of the American circus.

Facing Detail from *Ringling Bros. and Barnum & Bailey Combined Shows Program,* 1956 (see p. 192).

Tibbals Learning Center

Welcoming visitors to the Circus Museum's Tibbals Learning Center is a replica of a tent that was used by the Ringling Bros. and Barnum & Bailey Combined Shows during the early twentieth century. Above the tent, running along the frieze of the Tibbals building, well-recognized names such as Barnum, Bailey, and Ringling are joined with names of individuals who made equally valuable contributions to the history of the American circus. From W. C. Coup, whose innovations included mechanisms that made it possible for circuses to travel by railroad, to John Bill Ricketts, the father of the American circus, to the Feld family, current owners of the Ringling Bros. and Barnum & Bailey circus, these names represent some of the greatest contributors to the country's most popular form of entertainment, the circus.

The six towering flagpoles that span the distance between the Circus Museum and the Circus Museum's Tibbals Learning Center represent the pole layout of the big tops used by the Ringling Bros. and Barnum & Bailey Combined Shows from 1919 to 1938 and 1946 to 1947. Placed 60 feet apart, at nearly 62 feet tall, the distance between the center poles allowed for multiple performance spaces, including three 42-foot rings and four 32-foot-square platforms. The footprint for the big top tent alone was 85,000 square feet. This colossal canvas structure could easily sit over 12,000 people at a single performance and yet was moved daily for most of the circus season.

Flagpoles at the Circus Museum

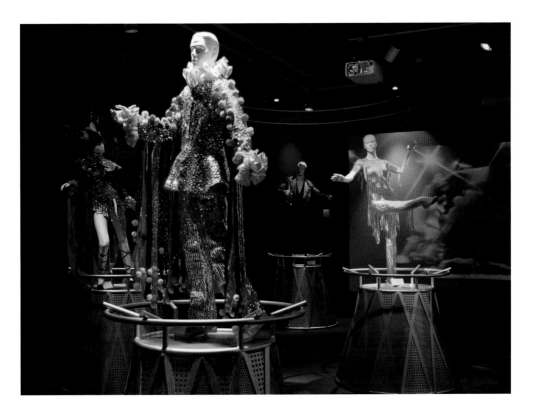

The Contemporary Gallery

The contemporary circus in America has cultivated a unique way to facilitate youth mentoring and community outreach through the circus arts. These dynamic organizations simultaneously pass on the legacy of circus arts to younger generations while providing character-building activities and professional training.

The Contemporary Gallery's youth circus exhibit features some of the innovative American youth circus programs that are currently providing young people with the experience of a lifetime. This colorful exhibit tells the story of how these circuses evolved and how they serve their communities. It features the Fern Street Circus, Circus Center San Francisco, the American Youth Circus Organization, Circus Smirkus, Sarasota Sailor Circus, and the Wenatchee Youth Circus.

Now entering its third century as one of America's most beloved forms of entertainment, the circus continues to evolve to suit the tastes of the time. Contemporary shows range from the artistic imagination of Cirque du Soleil to the one-ring intimacy of the Big Apple Circus out of New York and Sarasota's own Circus Sarasota. The Ringling Bros. and Barnum & Bailey Combined Shows have multiple units touring the country with productions that are updated to include the latest in video and sound technologies. While their differences are pronounced, today's circuses are founded on the same basic principles as those of more than two hundred years ago: the amazing capacity of the human body and the remarkable daring of the human spirit.

Howard C. Tibbals

Howard Tibbals loves everything about the circus: the wagons, the equipment, the performance, the history, and the logistics of moving the colossal "canvas city" from town to town. As a child, with a pair of binoculars, he spent hours watching the activity of the circus from the home of his grandparents' neighbor. By the age of seven, he was raiding the scrap bag for cloth to create his own circus.

Howard C. Tibbals in his workshop, 2006

It was not until 1952, after reading "Here Comes the Circus" in *Popular Mechanics*, that Tibbals decided to embark on his lifelong project: the *Howard Bros. Circus Model*. He began work on his big top in 1956, sewing the canvas and handcrafting the poles and stakes. Tibbals's first wagon was built three years later. In 1958, he met Harold Dunn, creator of the Dunn Model Circus (see page 182), who would become his friend and mentor.

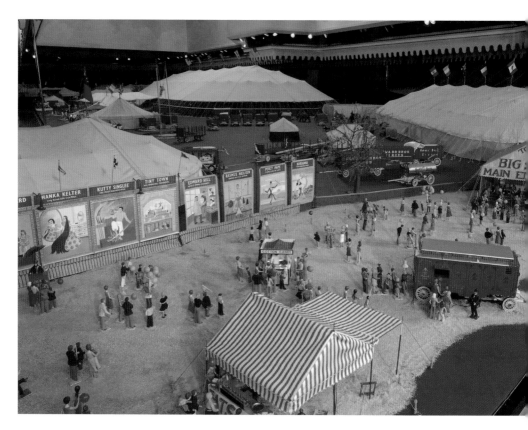

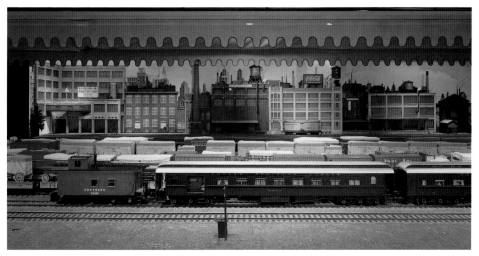

Howard Bros. Circus Model, Railroad Yard

Howard C. Tibbals

American, 1936–

Howard Bros. Circus Model, 1956–2007
Mixed media
¾ in. scale, 1/16 life-size
Collection of Howard C. Tibbals

The *Howard Bros. Circus Model* is a three-quarter-inch scale, 44,000-piece replica of the 1919–1938 Ringling Bros. and Barnum & Bailey Combined Shows, and is also the life-work of circus historian and model builder Howard C. Tibbals, who began constructing the model in 1956. To assure the miniature circus's accuracy down to the smallest detail, Tibbals used historic photographs and other documentation as well as his own meticulous measurements of wagons, focusing on one area of the lot at a time. The big top tent, including all of its wagons and equipment, took more than eighteen years to complete.

Making its public debut at the 1982 World's Fair in Knoxville, Tennessee, the *Howard Bros. Circus Model* was showcased at both The Henry Ford Museum in Dearborn, Michigan, and the Circus World Museum in Baraboo, Wisconsin, before finding its permanent home at the Ringling—the only place where the model has ever been seen in its entirety.

Just like the real circus, the *Howard Bros. Circus Model* came packed on a train—each of the 152 miniature wagons placed carefully on one of the 57 miniature train cars. Before its arrival, however, 996 linear feet of rail needed to be hand-laid, every spike driven individually. Staying true to the actual circus, Tibbals unloaded each wagon in the same order that it would have been rolled off the real train. The wagons that carried the cookhouse tent and equipment were taken off first, followed by the miniature baggage wagons that carried all of the basic components of the model. The 7,000 chairs found in the big top, the performers' wardrobe trunks, poles for all of the tents, the place settings for the dining tent, and the contents of the souvenir stands on the midway were similarly unloaded with historical accuracy.

Howard Bros. Circus Model, Dining Tent

Howard C. Tibbals

American, 1936–

Howard Bros. Circus Model,
1956–2007

Mixed media
¾ in. scale, ¹⁄₁₆ life-size
Collection of Howard C. Tibbals

The backyard of the circus is where the day-to-day life of circus performers and workers took place. In fact, the Ringling show of the early twentieth century was called a "canvas city," as it had all of the amenities the show people could need. The Commissary wagon, for instance, was stocked with toiletries, magazines, and clothing, and a barber's tent provided haircuts—all of which have been faithfully recreated inside the *Howard Bros. Circus Model*. Tibbals's model also includes a dining tent in which the showfolk are served on more than nine hundred individual place settings, including tiny silverware and a variety of condiments. In addition, the model recreates the dressing tent, which would also have been located behind the big top. In a true behind-the-scenes manner, performers can be seen fixing their hair, trying on costumes, and even putting on their makeup with their individually labeled trunks and water buckets beside them.

Traveling circuses brought amazing and sometimes never-before-seen sights to towns across America. This excitement is recreated by the *Howard Bros. Circus Model*, in which sideshows, concession stands, and men hawking souvenir pennants and even lizards on tiny leashes are all included.

Inside the *Howard Bros. Circus* menagerie are hand-carved animals, just as fascinating and beautiful as the animals presented by the historic circus. The small wagons in front of the menagerie represent the Children's Menagerie wagons, which would have featured animals that city children might never have seen; throughout the tent, elaborate caged wagons would have had animals the average American might never have seen. Each of these beautiful wagons replicates an actual wagon used by the Ringling show during that time, and both the ticket wagon and the *Two Jesters Calliope Wagon* are replicas of historic wagons in the Museum's collection.

Howard Bros. Circus Model, Menagerie

Howard Bros. Circus Model, Big Top

The big top and all of its components were the first pieces of the *Howard Bros. Circus* to be created. For eighteen years, Tibbals worked on this tent, meticulously crafting each wagon, hand-turning every tent stake, and even hand-carving the band playing beside the performer's entrance.

With almost one hundred artists performing simultaneously in twenty-one different acts, there would probably be no performance in history to rival the *Howard Bros. Circus*. In an actual performance under the big top, only a few acts would be seen at one time. Moreover, the acts would be similar in nature, so that patrons at one end of the tent saw the same show as those at the opposite end. In the *Howard Bros. Circus Model*, acts take place on four stages and in three rings, including the famous clown Lou Jacobs, who steps out of his miniature car on the front track, and the Flying Wallendas, who walk the wire above ring two.

Harold Dunn

Born in Jet, Oklahoma, in 1908, Harold Dunn grew up with the tented circus and popular circus-themed toys. He was the oldest child in a family of German immigrant woodcarvers, and learned the family trade from his grandfather at a young age. After seeing his first circus at the age of five, Dunn was determined to have one of his own.

His desire to become a "circus owner" intensified as Dunn grew older, and caused him to spend his free time researching the Ringling Bros. and Barnum & Bailey Circus and taking measurements of the actual circus wagons while they were parked at winter quarters in Sarasota, Florida. These materials, along with his own imagination, enabled Dunn, with the help of his talented wife, Barbara, to create a finely crafted, half-inch-scale model circus.

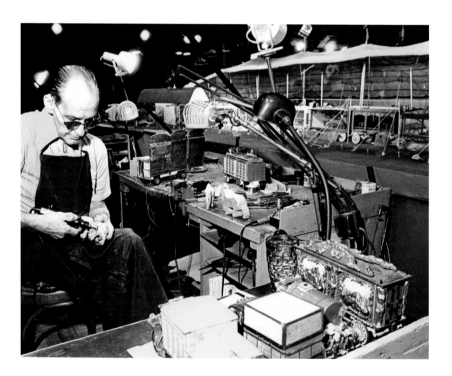

Harold Dunn at the 1982 World's Fair,
Knoxville, Tennessee

American, twentieth century, 1982
Black-and-white photograph
8 × 10 in. (20.3 × 25.4 cm)
Tibbals Digital Collection, 2004

Harold Dunn

American, 1908–1992

Dunn Bros. Circus Model,
1942–1992

Mixed media
½ in. scale
Collection of Howard C. Tibbals

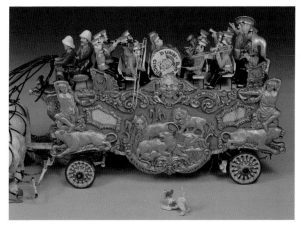

Dunn Bros. Circus Model, Lion and Mirror Bandwagon

As a colorful march of beautiful sights and loud music, the circus parade disrupted everyday life as it marked its arrival into town. By providing a free glimpse into the world of the exotic, the parade enticed citizens to buy tickets to the show. Drawing inspiration from his experiences at real circuses as well as from circus advertisements, Harold Dunn created a world of miniature people, animals, and vehicles—now housed in a remarkable 148-foot-long display.

Although Dunn was careful to take measurements and notes of the historic circus, his interpretation often includes bolder color schemes and units not linked to the historic parade. This may be a result of Dunn's use of historic posters as reference material, which would often depict elements of the circus more extravagantly than they really were.

The spectacle, or "spec," was a parade that took place around the hippodrome track inside the big top, featuring as many of the circus performers and animals as the director was able to costume. With its own elaborate wardrobe and unique musical score, the spec helped bring to life historic events, imaginative themes, and tales of faraway lands. It also gave spectators a hint of the excitement to come.

The handcrafted floats included in the parade display are a selection of Harold Dunn's favorite spectacles from the Ringling Bros. and Barnum & Bailey Circus, especially those designed by Norman Bel Geddes and Miles White from 1938 to 1956. Best known for their whimsical ideas, cutting-edge designs, and striking color palettes, Bel Geddes and White stretched human imagination and forever changed the look of the American circus.

Dunn Bros. Circus Model, Spec Float

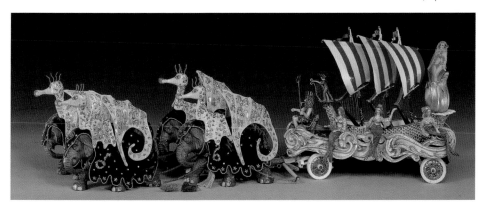

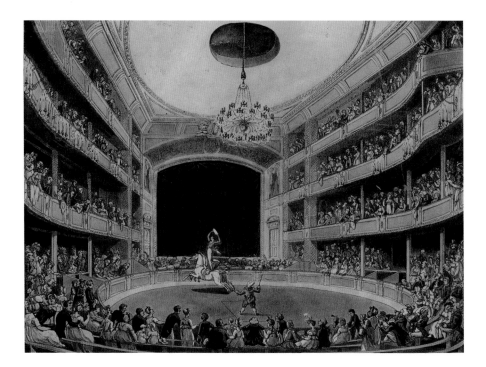

Pugin & Rowlandson

British, nineteenth century

Astley's Amphitheatre, 1808

Engraving
8½ × 10⅝ in. (21.6 × 27 cm)
SN1546.130.35

The circus is an ancient art form with roots that can be found throughout the world. For centuries, humans have performed incredible feats of skill and artistry that have expanded our view of what the human body can do. While the word *circus* comes from the Latin word, meaning a ring or a circle, the circus comes to us by way of the Greek gymnasium and through the troupes of performers who traveled across Europe during the Middle Ages, entertaining at medieval fairs.

The modern circus began in England in the eighteenth century. In 1768, Philip Astley (1742–1814), a retired British cavalry officer, joined together the core elements of the modern circus: equestrian acts interspersed with acrobatic, balancing, and comic acts. Astley revolutionized how the performance was presented. Riding demonstrations of the time were given in straight lines, and Astley instead used a ring that was 42 feet across, which is still used today.

John & Robert Godwin

British, nineteenth century

Van Amburgh Souvenir Mug, ca. 1850

Porcelain
4 × 5¼ × 4 in. (10.2 × 13.3 × 10.2 cm)
Museum purchase, 1966, SN1557.310.1

Born in New York, Isaac Van Amburgh (1808–1865) was the greatest animal trainer of his day. In 1838, Van Amburgh traveled with his animals to Europe and made his European debut at Astley's Royal Amphitheatre. While in England, he performed before Queen Victoria.

Unknown artist

American, nineteenth century

Phineas Taylor Barnum, ca. 1880

Lithograph
30 × 22 in. (76.2 × 55.8 cm)
Tibbals Digital Collection, TR2004.2722.79

Phineas Taylor Barnum (1810–1891) is one of
the most colorful and well-known personalities in
American history. A consummate showman and
entrepreneur, Barnum brought numerous acts to
America, including Jenny Lind, "The Swedish Night-
ingale," and Jumbo, the mammoth elephant. As
proprietor of the American Museum in New York
City, Barnum presented an array of curiosities and wonders, including the giantess
Anna Swan, the diminutive Tom Thumb, and the Siamese Twins. In 1871, he joined
with W. C. Coup to open a tented circus, and later with James A. Bailey to create the
Barnum & Bailey Circus, The Greatest Show on Earth. They were the reigning kings of the
circus world until the Ringling brothers replaced them.

H. A. Thomas, Lithographic Studio

American,
nineteenth century

*P. T. Barnum's Greatest
Show on Earth: Trained
Italian Stallions*, ca. 1878

Lithograph
26 × 34¾ in.
(66 × 87.6 cm)
Museum purchase,
SN1547.203.42

American circus posters from the late nineteenth and early twentieth centuries are
renowned for their remarkable artistry as well as their often outrageous claims regard-
ing the excellence, uniqueness, and costly quality of the acts. Although circuses made
such extraordinary declarations from the beginning of performances in America, no
figure is better recognized for the so-called art of "humbug" as Phineas Taylor Barnum.

Even posters pre-dating the Barnum & Bailey combination show Barnum's affinity
for excessiveness. Claims of the royal history and high cost of such performing horses
could rarely be either challenged or substantiated. As the design and structure of cir-
cus posters evolved to incorporate even more text, playful language became central to
circus advertising, with the common use of hyperbole and alliteration.

The Ringling Family

American, nineteenth
century, ca. 1892–1894
Sepia photograph
31½ × 37½ in. (80 × 95.3 cm)
Gift of F. S. Wynan, 1962,
Arch1564.1000.04

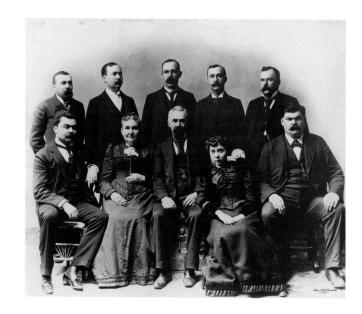

Unknown artist

American, nineteenth century

Untitled, 1896

Black-and-white photograph
7⅜ × 9½ in. (18.7 × 24.1 cm)
Tibbals Digital Collection,
TR2004.2722.11705

Before the Internet, before television, even before radio, American circuses faced the monumental task of advertising their arrival in a town—a job complicated by the fact that the circus would generally be in town for only one day. The poster was a remarkably effective way of communicating key information to potential customers. Weeks before a show rolled into town, bill posters covered walls, windows, and fences. The bright colors, beautiful artwork, and amazing subjects sparked an excitement that would build until the arrival of the show. From their initial design to the way they were hung all over town, circus posters were intended to make certain that no one could fail to know that the circus was coming. Today, the high quality of the printing and the beautifully rendered artwork are evidence of the importance of advertising to the American circus.

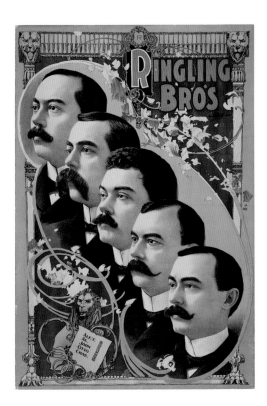

Courier Lithograph Co.

American,
nineteenth century

Ringling Bros., 1898

Lithograph
41¼ × 27¾ in.
(104.8 × 70.5 cm)
Gift of F. S. Wynan,
1962, SN1547.208.14

Russell-Morgan & Co. Printers

American, twentieth century

*Buffalo Bill's Wild West and Pawnee Bill's
Great Far East*, 1907

Lithograph
38¾ × 26 in. (98.4 × 66 cm)
Carey Donation, 1976, SN1547.207.16

A uniquely American phenomenon since
the 1860s, the "Wild West" became one of
the most popular forms of entertainment,
with William Fredrick "Buffalo Bill" Cody
as the most popular showman. Pawnee Bill
(the name given to Gordon William Lillie by
the Pawnee tribe) and six Pawnees joined
Buffalo Bill's show in 1883. As the west-
ern frontier closed, Cody started his Wild
West Show based on frontier celebrations.
The show featured cowboys and Native
Americans recreating daring rescues, heroic
battles, and Native American dances. The
Buffalo Bill Wild West show fascinated audi-
ences over the world.

Frederick W. Glasier

American, 1866–1950

William "Buffalo Bill" Cody, 1907

Contemporary black-and-white print
from glass plate negative
10 × 8 in. (25.4 × 20.3 cm)
Museum purchase, Glasier negative
no. 146

Mademoiselle Octavia, Snake Charmer,
ca. 1901

Contemporary black-and-white print
from glass plate negative
10 × 8 in. (25.4 × 20.3 cm)
Museum purchase, Glasier negative
no. 777

One of the finest collections held by
the Museum is the Frederick Whitman
Glasier Glass Plate Negative Collec-
tion. Glasier was born in Adams, Mas-
sachusetts, in 1866 to Henry and Lucy
Ann (née Whitman) Glasier. By 1900,
Glasier had moved to Brockton, Mas-
sachusetts, and was working as a pho-
tographer. During his career, from 1895
through 1934, he documented all the
major outdoor shows, and many of his
images appear in circus publications of
the day. Circus performers also bought
his photographs of their acts, which
they in turn re-sold to admiring circus
patrons. Glasier photographs draw us
into the world of show life and show
people. William "Buffalo Bill" Cody
gazes up at us from his newspaper with
a look that inquires what we wish of
him, while Mademoiselle Octavia eyes
us coolly as she poses with three writh-
ing snakes. Glasier images capture the
essence of the American circus: colos-
sal, exotic, and magical.

Barnum & Bailey Circus

American, 1907
Albumen print
8 × 10 in. (20.3 × 25.4 cm)
Gift of W. H. Wells, SN1000.182

Documenting outdoor shows from the 1880s to the present, the Ringling collection of circus photographs contains images made by professional photographers and circus enthusiasts. Both share the common bond of wanting to capture the magic, the wonder, and the scale of the circus. During the first half of the twentieth century, circus day was the most looked forward to community event of the year; the circus was unrivaled in its social and cultural impact. Towns turned out in force to see the show and mobbed the entrance to be assured that all the amazing sights and incredible acts would be seen.

Strobridge Lithographing Company

American, twentieth century

Barnum & Bailey: Arenic Wonders, 1907
Lithograph
28 × 42 in. (71.1 × 106.7 cm)
SN1547.204.123

One of the most well-known printers of the late nineteenth and early twentieth centuries, Strobridge Lithographing Company of Cincinnati, Ohio, was just one of numerous companies that created posters for the Ringling Bros. Circus. In the lithographic process, a design is applied in reverse onto limestone, using a grease crayon. An oil-based ink, which is rolled over the stone, adheres to these greased areas and, when run through the press, transfers onto the paper. A different block is used for each color.

Since the 1950s, photo-offset printing has been the dominant process for poster production. In this process, the original image is mechanically color separated, screens are created, and each color is printed individually. The resulting image is actually composed of very small dots of color.

189

Chester Photo Service

American

Circus Marquee, ca. 1940

Black-and-white print
10 × 8 in. (25.4 × 20.3 cm)
Tibbals Digital Collection, TR2004.2722.9046

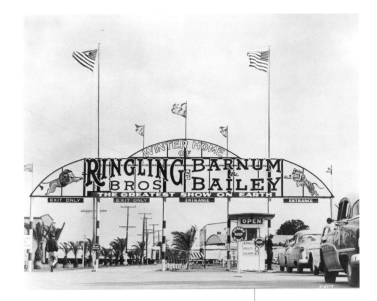

Allen Lester

American,
twentieth century

*Ringling Bros. and
Barnum & Bailey
Winter Quarters,
Sarasota, Florida,* ca. 1945

Black-and-white photograph
7½ × 9⅜ in. (19.1 × 23.8 cm)
Tibbals Digital Collection, TR2004.2722.12031

Paramount Pictures Corporation

American, twentieth century

*Cecil B. DeMille's
The Greatest Show on Earth,* 1952

Lithograph
40¼ × 27¼ in. (102.2 × 69.2 cm)
SN1547.200.84

Ringling Bros. and Barnum & Bailey Combined Shows

American, twentieth century

Ringling Bros. and Barnum & Bailey Combined Shows Program, 1956

Ink on paper
11 × 8½ in. (27.9 × 21.6 cm)
Gift of C. Kinsey, CM1554.270.224

By the 1930s, the circus, once the most popular form of entertainment in America, began to lose audiences to film, radio, and television. Although the change was in part a result of rising labor and operational costs, the public's taste was changing and the circus had problems keeping pace. On July 16, 1956, the financially troubled Ringling Bros. and Barnum & Bailey Circus gave its last performance under the big top in Pittsburgh, Pennsylvania, to a crowd of ten thousand people. According to *Life* magazine, "a magical era had passed forever."

Donald L. "Rusty" Rust

American, 1932–

Portrait of Merle Evans, Bandmaster, 1966

Oil on canvas
64½ × 51½ in. (163.8 × 130.8 cm)
Gift of the artist, 1967, SN810

Called the "Toscanini of the Big Top," Merle Evans was born in Columbus, Kansas. In 1916, Charles Ringling hired Evans as bandmaster for the Ringling Bros. and Barnum & Bailey Circus; he would hold that position for fifty years—more than 18,000 performances with Ringling Bros. and Barnum & Bailey Combined Shows.

Maciej Urbaniec

Polish, 1925–2004

CYRK: Mona Lisa, 1978

Lithograph
47¾ × 32½ in. (121.3 × 82.6 cm)
Museum purchase

Circuses remain a popular form of entertainment in Europe, where some shows have been traveling their small routes for more than one hundred years. The European circus has, for the most part, remained a small one-ring production, performing under canvas or inside small amphitheaters.

The CYRK series of posters represents a unique aesthetic that began when Poland's state-sponsored circus agency began commissioning recognized artists to design one-of-a-kind circus images. Their goal was to modernize the imagery of circus advertising to reflect both changes in circus performance and presentation as well as advances in printing technology. The resulting designs are rendered in a stark, graphic style, relying on simple imagery and bright, bold colors.

Feld Inc.

American, twentieth century

Ringling Bros. and Barnum & Bailey Circus Program, 1989

Ink on paper
13 × 10 in. (33 × 25.4 cm)

John Ringling North, son of Ida Ringling North, oversaw the workings of the circus from 1937 to 1967, during which time, with the exception of several years during World War II, he and his brother, Henry, produced many seasons of spectacular shows.

Although the last tented circus was performed in 1956, the Ringling family continued to dominate the circus world until 1967, when Judge Roy Hofheinz, Israel S. Feld, and Irvin Feld purchased the circus at the Colosseum in Rome, Italy. Today, Irvin's son Kenneth runs the show. "There are no rules and we certainly don't follow any formulas," Kenneth Feld has said. "But we do take the traditional circus to the cutting edge."

Performance Props

Just like other elements of a circus production, performance props were designed to withstand the abuse inherent in their daily use and, at the same time, to be visually striking even from great distances. Every new season brings a new variety of props to the circus, from swords, garlands, and masks to the comic oversized pieces used by clowns in their skits. Many of these props were made by the performers themselves, especially the clowns. Among the most whimsical props created for circuses, the clown props had such specific requirements that the clowns often found it easier to build their own props rather than commission them.

Lou Jacobs

American, 1903–1992

Lou Jacobs's Miniature Clown Car

Wood, steel, and glass
26½ × 35 × 26 in. (67.3 × 88.9 × 66 cm)
Gift of the Jacobs Family, NN27

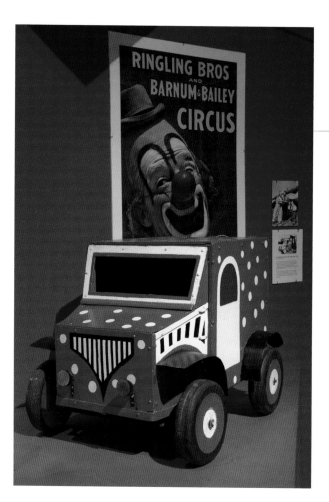

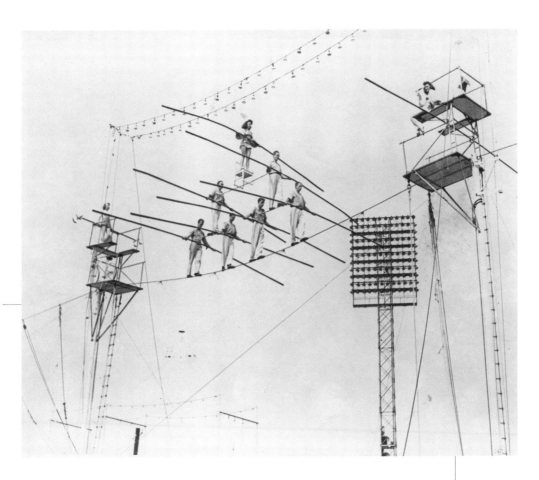

Unknown artist

American, twentieth century

The Flying Wallendas, ca. 1960

Black-and-white photograph
7⅜ × 9⅛ in. (18.5 × 23.1 cm)
Tibbals Digital Collection,
TR2004.2722.13251

Swinging high above the audience, flying through the
air—the wonderful feats of aerial artists have been
among the most beloved circus acts since their intro-
duction in the mid-nineteenth century. These acts,
which require great strength, balance, and speed, also
require proper equipment capable of bearing the forces
generated by twisting, swinging, and jumping. Rigging
for a variety of aerial acts, including the perch, padded
catcher's bar, Roman rings, and a single trapeze bar, are
on display inside the Tibbals Learning Center. At the
far end of the entryway, near the second-floor overlook,
is the platform for a high-wire act similar to that used
by the famous Flying Wallendas, who are shown per-
forming in this photograph from the 1960s.

Spectacle Costumes

Many of the most elaborate costumes and props used by the circus were showcased during the Grand Entry, or spec. Traced back to the earliest circuses in America, the spec was a lavish performance of literary or historical tales, intended to entertain and edify the audience. The costumes created for this event are often lavish and whimsical, turning performers into exotic characters and animals. Even elephants, horses, and other animals were fantastically costumed in highly decorated blankets and headpieces.

The production wardrobe often served to visually unify a show, with colors, textures, and accessories being reused in different ways. The heavy fabrics covered in sequins, spangles, feathers, and any other possible embellishment were designed to overwhelm the audience with their array of textures and colors. The quality of the workmanship and materials is extremely high, since these costumes had to survive constant use and quick changes; spec wardrobe would be worn by a performer twice a day, every day, for the run of the season.

Miles White
American, 1914–2000

Titania, 1950
Ink and watercolor
on paper
14 × 11 in. (35.6 × 27.9 cm)
Tibbals Digital Collection,
TR2004.2722.5753

Gunther
Elephant Blanket

American, 1989
Canvas, lamé,
cotton, and sequins
Donation of Kenneth Feld
and Feld Entertainment,
2002, SN11073

The artistry and extrava-
gance of the circus ward-
robe is not reserved for the
human performers. Main-
stay performing animals like
elephants and horses are often clad with decorative blankets, harnesses, or plumes.
These pieces of wardrobe are as colorful, detailed, and bespangled as any other
performer's costume.

This elephant blanket, designed for the animal trainer Gunther Gebel-Williams's
farewell performance with Ringling Bros. and Barnum & Bailey, illustrates the scale
and quality of animal wardrobe in the major circuses. Such blankets often measure
more than 12 feet in width to drape over the animal's wide body and allow the hem-
line to fall near the ground. Fine yet durable fabrics are layered together and covered
with a field of sequins and decorative elements. In one season, an elephant blanket
in the Ringling show would be used in close to five hundred performances.

Eaves Brooks Costume Co.

American, established 1863

Charly Baumann's Costume, 1983
Velvet, stretch fabric, rhinestones,
and bugle beads
Gift of Mrs. Charly Baumann, 2005, SN11136

Circus wardrobe is one of the most important
elements in setting the atmosphere of a perfor-
mance. It is the first visual indicator of what to
expect from an act, but it must also make sense
with the other visual elements of the show.
Depending on its purpose and the performer
who wears it, a costume may be designed by
the show's designers or even by the performers
themselves.

Baggage Wagon #59

American, ca. 1920

Wood and iron

125 × 238 × 105 in.

(317.5 × 604.5 × 266.7 cm)

SN1862

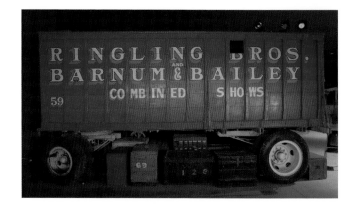

The western movement of the American people in the nineteenth century caused the circus to change its methods of operation. The ritual of exhibiting in a few temporary wooden amphitheaters in major cities for long periods was altered into a season-long series of daily moves, six days per week. The transportation of the big top and performance apparatus from one community to the next required the purchase and use of wagons and horses. As a result, an array of specialized baggage wagons evolved, each suited to the dimensions and weights of specific circus equipment. The Ringling Bros. and Barnum & Bailey Baggage Wagon #59 was constructed in the 1920s and upgraded with dual pneumatic tires by the 1940s. After the contents were unloaded, the vast interior served as an on-site dressing room for equestrian director Fred Bradna and his wife, center ring star Ella Bradna.

Fielding Bros. Company

American, nineteenth century

Adam Forepaugh Five Graces Bandwagon, 1878

Wood and iron

120 × 95 × 265 in.

(304. 8 × 241.3 × 673.1 cm)

SN1860

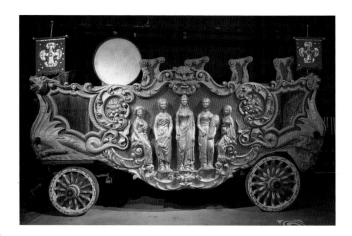

The massive marketing campaign that preceded the scheduled one-day presence of the circus culminated in a daily free street parade through the principal streets of the community. Staged on the morning of arrival, the procession included bandwagons of professional musicians, ornamental tableau wagons, diminutive pony floats, and cage wagons housing exotic beasts. Decorated with a variety of motifs derived from mythology and executed in the Rococo style, these bandwagons were artistic marvels. Scrollwork inspired by acanthus leaves, imposing telescoping tableaus that stretched more than 25 feet high, and gilded figures were among the most popular decorations in the 1870s and 1880s. This bandwagon, misnamed "Five Graces," originated as the giant Gem Bossed Car of Freedom in 1878 and was converted into a bandwagon by 1890. It is the oldest American circus parade wagon in existence.

Charlie Luckey
American, twentieth century

Leonard Aylesworth
American, 1892–1967

Two Jesters Calliope Wagon, 1920–1921
Wood, steel, iron, and brass
120 × 207 × 95 in.
(304.8 × 525.8 × 241.3 cm)
Gift of Ringling Bros. and
Barnum & Bailey Circus, SN1486

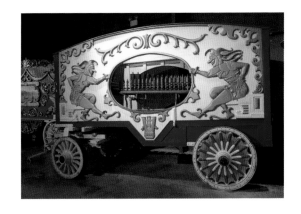

The steam calliope appeared as a technological marvel in three circuses in the 1850s, but it was not until 1872 that it was embraced as the traditional final element of the circus parade. Housed in a wagon decorated with woodcarvings, the calliope was composed of a large steam boiler, water and fuel storage, the instrument, and a seat for the player. The instrument had between twenty and thirty-seven whistles that were placed into action by special valves controlled by a regular piano-style keyboard. The non-chromatic nature of the instrument, coupled with the high forces necessary to depress the keys, made playing it a very difficult task. In the right weather conditions the sounds from the tuned brass whistles could carry for ten miles, reminding everyone that the circus was in town. The Sells-Floto steam calliope was one of the last constructed, fabricated by the show's own craftsmen Charlie Luckey and Leonard Aylesworth, about 1920. With space for thirty-six whistles, the instrument is the largest in existence.

Ringling Bros. and Barnum & Bailey Ticket Wagon #122
American, 1911
Wood, steel, and iron
118 × 89 × 203 in.
(299.7 × 226.1 × 515.6 cm)
Gift of John Ringling North,
ca. 1968, SN1629

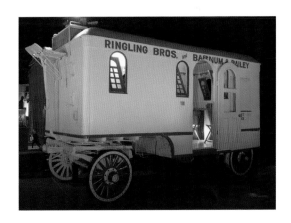

The transportation methods for the circus advanced in 1872, when a train of specialized railroad cars was built for the purpose of moving an entire circus. The abandonment of the overland roads meant that larger wagons, paralleling the stronger commercial wagons found on city streets, could be used to house and convey the show. The largest railroad circuses had more than one hundred specially built wagons, each serving one or more specialized purposes to accomplish the work of the circus. Following the lead of the railroads, the circus embraced a defined management and employee structure that delegated specific responsibilities to a highly disciplined and focused staff, cast, and crew. The ticket wagon often doubled as the office from which as many as twelve hundred people were directed to accomplish the daily tasks necessary to stage the circus. On a typical day, more than ten thousand general admission tickets were sold daily through the multiple sales windows of the Ringling Bros. and Barnum & Bailey Ticket Wagon #122.

Historic Asolo Theater

Given John Ringling's passion for the theatrical movement, color, and emotion of Baroque art, it is apt that the Museum's first director, A. Everett "Chick" Austin, Jr., dramatically expanded the showman's collection by acquiring an eighteenth-century Italian theater. Today, as the only original Baroque playhouse in America, the Historic Asolo serves not only as an accompaniment to Ringling's collection of art, but also as a functioning "exhibit-in-use," providing a unique setting for theater, music, dance, film, and lectures.

The theater's evolution began in the fifteenth century with Caterina Cornaro, the daughter of a Venetian merchant, who became—through an arranged marriage—the Queen of Cyprus. As a reward for her service, she was granted the hilltop village of Asolo, Italy, where (in exile) she reigned over a court renowned for its grace and beauty.

In 1798, architect Antonio Locatelli created the theater in the great hall of Caterina's palace. When Francesco Martignago redesigned the theater in 1855, he preserved the U-shaped form, leading scholars to conclude that the renovation duplicated the original plan. The theater remained in this setting until 1931, when it was dismantled to make way for a film theater. Antiquarian dealer Adolph Loewi purchased the artifact and stored it in Venice for the duration of World War II.

In 1949, the Ringling Museum purchased the theater for $8,000. The theater was opened in its new home in 1952 and remained in the Museum of Art until a new building was constructed for it. When it reopened in 1958, the Asolo became the birthplace for the performing arts in west central Florida. By the close of the twentieth century, however, the theater was under-used and under-funded. It fell into disrepair.

With the Ringling Master Plan in 2000, restoration began. The panels were again dismantled, and the Museum's conservation staff worked for more than two years to conserve and restore their ornate beauty. The 2006 reinstallation in the Museum's Visitors Pavilion adheres to the guidelines of the International Congress of Architects and Technicians of Historic Monuments in the Venice Charter for the Conservation and Restoration of Monuments and Sites. Hence, the structure that envelops the eighteenth-century artifact, along with the auditorium seating and ambient lighting, are all distinctly of the twenty-first century.

Facing Detail from *Asolo Theater, Delight, Merriment, and Love Medallion*, ca. 1855–1857 (see p. 203).

Francesco Martignago

Italian, 1803–1884

Asolo Theater, Stage, ca. 1855–1857

Oil on wood with gilt
Museum purchase, 1952, SN7232

The tiny horseshoe-shaped playhouse (seating fewer than three hundred patrons) is Rococo in style with three rising tiers, each featuring pastel and gold ornaments that reflect the glow of candle-like lamps. Decorative elements simulating precious jewels adorn the third tier, while a frieze of painted portraits graces the parapet of the second tier of boxes.

Asolo Theater, Queen Caterina Medallion

Ca. 1855–1857
Oil on wood with gilt
Overall: 32 × 48 in. (81.28 × 121.92 cm)
Painting: 21½ × 21½ in. (53.34 × 53.34 cm)
Museum purchase, 1952, SN7232

The central figure on the second tier, facing the stage and placed immediately above the "royal box," is that of Queen Caterina Cornaro—positioned to suggest that the village's only queen is seated there to view a command performance. Her portrait, framed by vividly carved silver shells and flowing gold ornamentation, is a copy of a painting (attributed to Giambellino) contemporary to Caterina's time and widely held to be her close likeness.

Asolo Theater, Delight, Merriment, and Love Medallion

Ca. 1855–1857
Oil on wood with gilt
33 × 49½ in. (83.82 × 124.46 cm)
Museum purchase, 1952, SN7232

Although the three flying figures over the royal box are clearly allegorical—each carries a symbol: a lyre, a crystal vase, a bow and quiver—they are somewhat difficult to identify. The figure on the right is most likely a Cupid figure, the God of Love, which suggests that others represent his companions, Delight and Merriment—a most apt and happy trio for a theater. Because such formal symbolism was out of style at the time of the remodeling, this medallion may actually date from the original 1798 decoration.

Asolo Theater, Vittorio Alfieri Medallion

Ca. 1855–1857
Oil on wood with gilt
Overall: 32 × 56 in. (81.28 × 142.24 cm)
Painting: 22½ × 22 in. (56 × 55.88 cm)
Museum purchase, 1952, SN7232

Flanking the image of Caterina are eight *grisaille* portraits celebrating the famous writers of Italy. Believed to be the work of V. de Marchi, each portrait is framed and interspersed with the ornate carving and gilt decorations created by the Asteo Brothers. All of the portraits are identified by their initials, and six of the portraits, dating from the theater's beginnings, form natural pairs: the fourteenth-century poets Dante (D.A.) and Petrarch (F.P.); the epic poets of the Italian Renaissance, Ariosto (L.A.) and Tasso (T.T.); and two of Italy's greatest playwrights, Carlo Goldoni (C.G.) and Pietro Metastasio (P.M.). Of the two portraits added during the mid-nineteenth-century renovation, one depicts playwright Vittorio Alfieri (V.A.) and the other Antonio Canova (A.C.), the great sculptor who was born just five miles from Asolo.

Asolo Theater, Mask Medallions

Ca. 1855–1857
Oil on wood with gilt
Overall: 32 × 41½ in. (81.28 × 121.92 cm)
Painting: 17½ × 19 in. (43.18 × 124.46 cm)
Museum purchase, 1952, SN7232

On each side of the stage is a medallion with three masks. The use of two theatrical masks—comic and tragic—is well known, but the depiction of three is unusual. In the stage right medallion (appropriately next to Carlo Goldoni), a comic mask is in the center. In the other (near Pietro Metastasio), the tragic mask appears in that position. In each, the mask of the opposite genre appears in profile. While the two tragic and two comic masks are quite different from each other, the third mask is identical in each medallion and appears only in profile. It may symbolize the satiric or pastoral play—the third leading type of play in the Italian tradition.

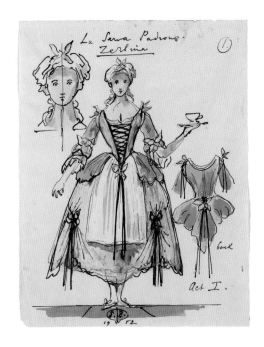

Eugene Berman

Russian, 1899–1972

Costume Design: Zerbina, in Act II,
La Serva Padrona, 1952

Watercolor and India ink
on cream paper
11 × 8½ in. (27.9 × 21.6 cm)
Museum purchase, 1952, SN755

Set Design: La Serva Padrona, 1952

Watercolor and ink on cream paper
10⅞ × 14¹⁵⁄₁₆ in. (27.6 × 37.9 cm)
Museum purchase, 1952, SN759

Two short operas were performed at the 1952 opening of the Asolo Theater, Mozart's
Bastien et Bastienne and Pergolesi's *La Serva Padrona*. Eugene Berman, a famous
stage designer for ballet and opera, designed both the set and costumes for *La Serva*
Padrona. His watercolor sketches for these elegant garments and settings were
superb additions to the Theater collection, which also includes the original sets
and some of the costumes.

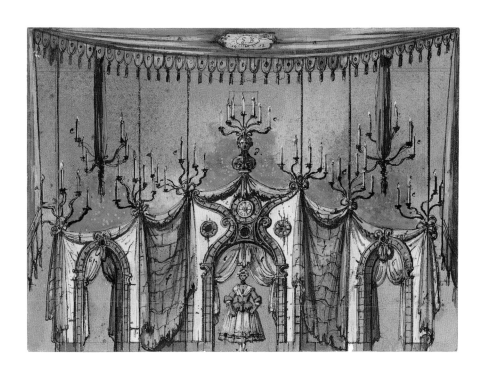

Asolo Theater, Proscenium Lyre Motif

Ca. 1855–1857
Oil on wood with gilt
33 × 49 in. (83.82 × 124.46 cm)
Museum purchase, 1952, SN7232

The broad soffit of the proscenium arch—
supported by four carved corbels—is
richly adorned with musical instruments
in relief with painted bouquets of flowers
clasped by a golden band.

Asolo Theater, Stage Box

Ca. 1855–1857
Oil on wood with gilt
91 × 63 in. (231.14 × 160 cm)
Museum purchase, 1952, SN7232

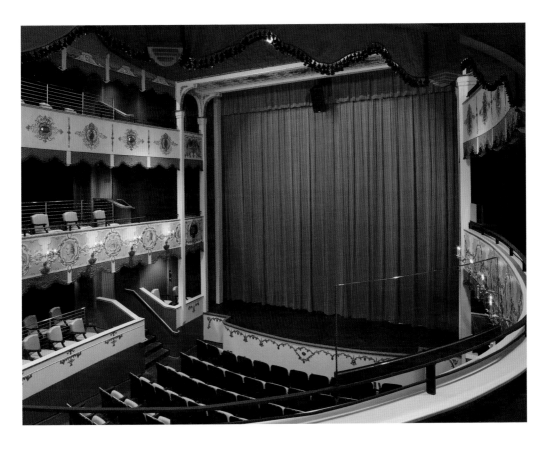

Francesco Martignago

Italian, 1803–1884

Asolo Theater, Interior from House Right, ca. 1855–1857

Oil on wood with gilt

Museum purchase, 1952, SN7232

Selected Museum Publications

The Arts of Europe, 1600–1780: Painting and Decorative Arts from the Ringling Museums. Sarasota, Fla.: The John and Mable Ringling Museum of Art, 1979.

Austin, Arthur Everett. *The Asolo Theater in Sarasota at the John and Mable Ringling Museum of Art.* Sarasota, Fla.: The John and Mable Ringling Museum of Art, 1952.

———. *The John and Mable Ringling Museum of Art: The Art Museum John Ringling Built.* St. Petersburg, Fla.: St. Petersburg Printing Company, n.d.

Ayers, John. *Blanc de Chine: Divine Images in Porcelain.* New York: China Institute Gallery, 2002.

———. *Chinese Ceramics: The Koger Collection.* New York: Sotheby's Publications, 1985.

Borys, Stephen, ed. *Masterworks at the John and Mable Ringling Museum of Art.* iPod Audio Tour. Sarasota, Fla.: The John and Mable Ringling Museum of Art with QMedia Productions, 2007.

———. *Cà d'Zan: The Winter Residence of John and Mable Ringling.* iPod Audio Tour. Sarasota, Fla.: The John and Mable Ringling Museum of Art with QMedia Productions, 2008.

Buck, Patricia Ringling. *Circus Galleries: The John and Mable Ringling Museum of Art.* Sarasota, Fla.: The John and Mable Ringling Museum of Art, 1989.

———. *The John and Mable Ringling Museum of Art.* Sarasota, Fla.: The John and Mable Ringling Museum of Art, 1988.

Ca d'Zan, Ringling Residence. Sarasota, Fla.: The John and Mable Ringling Museum of Art, 1954.

Craven, Roy C. *Indian Sculpture in the John and Mable Ringling Museum of Art.* Gainesville: University of Florida Press, 1961.

Currie, Dwight, and Linda R. McKee, eds. *Encore! A New Life for the Historic Asolo Theater at the John and Mable Ringling Museum of Art.* Sarasota, Fla.: The John and Mable Ringling Museum of Art, 2006.

De Groft, Aaron H. *Ringling and Rubens: The John and Mable Ringling Museum of Art.* Sarasota, Fla.: The John and Mable Ringling Museum of Art, 2003.

De Groft, Aaron H., and David Chapin Weeks. *Ca d'Zan: Inside the Ringling Mansion.* Sarasota, Fla.: The John and Mable Ringling Museum of Art, 2004.

———. *A Pictorial History of John and Mable Ringling.* Sarasota, Fla.: The John and Mable Ringling Museum of Art, 2003.

The Disguises of Harlequin: A Series of Paintings by Giovanni Domenico Ferretti, 1692–1728, belonging to The John and Mable Ringling Museum of Art, Sarasota, Florida. Lawrence: University of Kansas Museum of Art, 1956.

Duval, Cynthia. *500 Years of Decorative Arts from the Ringling Collections, 1350–1850.* Sarasota, Fla.: The John and Mable Ringling Museum of Art, 1982.

Duval, Cynthia, and Walter J. Karcheski, Jr. *Medieval and Renaissance Splendor.* The John and Mable Ringling Museum of Art, 1983.

Fowle, Geraldine E. *Sebastien Bourdon's Acts of Mercy: Their Significance as a Series.* Lawrence: University of Kansas, 1974.

Gaddis, Eugene R. *Magician of the Modern: Chick Austin and the Transformation of the Arts in America.* New York: Alfred A. Knopf, 2000.

Gentele, Glen Peter. *Conceptual Diversity: Selections from the Ringling Museum of Art Post-War Permanent Collection.* Sarasota, Fla.: The John and Mable Ringling Museum of Art, 2001.

Gilbert, Creighton. *The Asolo Theater.* Sarasota, Fla.: The John and Mable Ringling Museum of Art, 1959

Hack-Lof, Françoise. *Sculpture on the Estate of the John and Mable Ringling Museum of Art.* Sarasota, Fla.: The John and Mable Ringling Museum of Art, 2004.

Hack-Lof, Françoise, Teresa A. Koncick, and Linda R. McKee. *Ca d'Zan: The Ringling Winter Residence.* Sarasota, Fla.: The John and Mable Ringling Museum of Art, 2003.

Hack-Lof, Françoise, and Linda R. McKee. *The Art Galleries of the John and Mable Ringling Museum of Art.* Sarasota, Fla.: The John and Mable Ringling Museum of Art, 2003.

Herscher, Ellen. *Ancient Art from Cyprus: The Ringling Collection.* Sarasota, Fla.: The John and Mable Ringling Museum of Art, 1983.

History of the Restoration: The John and Mable Ringling Museum of Art, Sarasota, Florida. Sarasota, Fla.: The John and Mable Ringling Museum of Art, 1992.

The House John and Mable Built: A Short Guide to the Ringling Residence. Sarasota, Fla.: The John and Mable Ringling Museum of Art, 1952.

Janson, Anthony F. *Great Paintings from The John and Mable Ringling Museum of Art.* New York: The John and Mable Ringling Museum of Art in association with Harry N. Abrams, 1986.

———. *Visions of Faith: An Exhibition of Prints and Drawings from the John and Mable Ringling Museum of Art.* Sarasota, Fla.: The John and Mable Ringling Museum of Art Foundation, 1985.

John Ringling's Art Museum at Sarasota, Florida. Sarasota, Fla.: The John and Mable Ringling Museum of Art, 1930.

Marcel Duchamp: Works from the John and Mable Ringling Museum of Art Collection. Sarasota, Fla.: The John and Mable Ringling Museum of Art, 1983.

Merling, Mitchell. *Ringling: The Art Museum.* Sarasota, Fla.: The John and Mable Ringling Museum of Art, 2002.

Miller, Mel. *Ringling Circus Museum: The Collection and Its Relation to the History of the Circus.* Sarasota, Fla.: The John and Mable Ringling Museum of Art, 1963.

Murray, Marion. *A Popular Guide: 50 Masterpieces in the John and Mable Ringling Museum of Art.* Sarasota, Fla.: The John and Mable Ringling Museum of Art, 1955.

———. *The Ringling Museums: A Magnificent Gift to the State of Florida.* Sarasota, Fla.: The John and Mable Ringling Museum of Art, 1951.

Nakimura, Toshiharu, and Michiaki Koshiwaka. *European Baroque Paintings from The John and Mable Ringling Museum of Art and the Bob Jones University Museum and Gallery.* Tokyo: Tokyo Shinbun, 1997.

Ormond, Mark, Aaron De Groft, and Gene Ray, eds. *John Ringling: Dreamer, Builder, Collector.* Sarasota, Fla.: The John and Mable Ringling Museum of Art, 1996.

Price, Vincent. *The John and Mable Ringling Museum of Art and the Asolo Theater.* Sarasota, Fla.: The John and Mable Ringling Museum of Art, 1955.

Ringling Museums. Sarasota, Fla.: The John and Mable Ringling Museum of Art, 1981.

Ringling Museums: 1980–81, 50th Anniversary, John and Mable Ringling Museum of Art. Sarasota, Fla.: The John and Mable Ringling Museum of Art, 1980.

Robinson, Franklin W., William H. Wilson, and Larry Silver. *Catalogue of the Flemish and Dutch Paintings, 1400–1900.* Sarasota, Fla.: The John and Mable Ringling Museum of Art, 1980.

Rosenzweig, Daphne Lange. *Later Chinese Jades from the Yangtze River Collection.* Sarasota, Fla.: Helga Wall-Apelt, 1993.

Scalera, Michelle A. *Ca d'Zan: The Restoration of the Ringling Mansion.* Sarasota, Fla.: The John and Mable Ringling Museum of Art, 2006.

A Short Guide: 50 Masterpieces in the John and Mable Ringling Museum of Art. Sarasota, Fla.: The John and Mable Ringling Museum of Art, 1963.

Spike, John T. *Baroque Portraiture in Italy: Works from North American Collections.* Sarasota, Fla.: The John and Mable Ringling Museum of Art, 1984.

Suida, William E. *A Catalogue of Paintings in The John and Mable Ringling Museum of Art.* Sarasota, Fla.: The John and Mable Ringling Museum of Art, 1949.

Sutton, Denys. *Masterworks from the John and Mable Ringling Museum of Art.* New York: Wildenstein Galleries and the Tampa Museum, 1981.

Tomory, Peter. *Catalogue of the Italian Paintings before 1800.* Sarasota, Fla.: The John and Mable Ringling Museum of Art, 1976.

Vilas, C. N., and N. R. Vilas. *The John and Mable Ringling Museum of Art.* Sarasota, Fla.: The John and Mable Ringling Museum of Art, 1942.

Walk, Deborah W. *A Guide to the Archives of the John and Mable Ringling Museum of Art: The State Art Museum of Florida.* Sarasota, Fla.: The John and Mable Ringling Museum of Art, 1994.

Weber, Joanna. *Of Lions and Red Hats: Saint Jerome at the John and Mable Ringling Museum of Art.* Sarasota, Fla.: The John and Mable Ringling Museum of Art, 2004.

Weeks, David C. *Ringling: The Florida Years, 1911–1936.* Gainesville, Fla.: University Press of Florida, 1993.

Wetenhall, John. *A Museum Once Forgotten: Rebirth of the John and Mable Ringling Museum of Art.* Sarasota, Fla.: The John and Mable Ringling Museum of Art, 2007.

Wilson, William H. *Masterworks on Paper: Prints and Drawings from the Ringling Museums, 1400–1900.* Sarasota, Fla.: The John and Mable Ringling Museum of Art, 1978.